collectors g

$12.95

Kodak
cameras

by Jim & Joan McKeown

Published by Centennial Photo Service

First Edition on press. Published November 4, 1981

Library of Congress 81—71277
ISBN 0—931838—02—9

To my father, Lloyd D. McKeown,
who celebrated his 75th
birthday this year.

CONTENTS

TABLE OF CONTENTS 5
INTRODUCTION . 6
FOLDING KODAK CAMERAS AND GLASS
 PLATE FOLDING KODAK CAMERAS 11
ORDINARY KODAK AND
 DAYLIGHT KODAK CAMERAS 13
KODET CAMERAS 17
THE BIRTH OF THE RED WINDOW 21
POCKET KODAK CAMERAS (1895-1900) 21
BULLET CAMERAS 22
BULL'S-EYE CAMERAS 24
FOLDING POCKET KODAK CAMERAS 29
THE PANORAM KODAK CAMERAS 37
BROWNIE CAMERAS 39
SPEED KODAK CAMERAS 45
VEST POCKET KODAK CAMERAS 50
SIX-THREE KODAK CAMERAS 51
AUTOGRAPHIC KODAK CAMERAS 53
AUTOGRAPHIC KODAK SPECIAL CAMERAS
 WITH COUPLED RANGEFINDER 65
POCKET KODAK CAMERAS (INCLUDING
 SERIES II, SPECIAL, JUNIOR
 AND COLORED MODELS.) 68
A LITTLE CLASS FOR THE COMMON MAN 76
TWO NEW FILMS WHICH
 DIDN'T CHANGE THE WORLD 83
KODAK ENTERS THE FIELD
 OF 35MM PHOTOGRAPHY 90
RETINA CAMERAS 91
BANTAM FILM-
 A SUBSTITUTE FOR 35MM 97
WARTIME PRODUCTION 114
THE KODAPAK CARTRIDGE
 CHALLENGES 35mm 146
INSTAMATIC CAMERAS 147
POCKET INSTAMATIC CAMERAS 157
INSTANT PHOTOGRAPHY 161
RETINA CHRONOLOGICAL SUMMARY 171
BIBLIOGRAPHY . 171
INDEX . 172

INTRODUCTION

In 1980, the Eastman Kodak Co. celebrated the centennial of its founding by George Eastman as the Eastman Dry Plate Company. It would be impossible in a book of this size to list and illustrate all cameras made by all divisions of the Eastman Kodak Company for all markets.

The purpose of this book is to provide an illustrated guide to the Kodak and Brownie cameras which were marketed in the United States and Canada. Within those guidelines, we have tried to include every known model and all significant variations of each camera, and to provide basic historical and technical information. By limiting the book to Kodak and Brownie cameras, we have excluded cameras such as Graflex, Graphic, Cirkut, Hawk-Eye, Premo, view, and special purpose cameras. Fortunately, there are other reference works which will help you with some of the specific families of cameras we have not included:

Graflex- Richard Paine, **A Review of Graflex**
Hawk-Eye- John Addison, **Catalogue of Hawk-Eye Cameras**
Premo- Joan McKeown, **Catalog of Premo Cameras**

We have also excluded cameras made and/or marketed abroad, except for a few instances where they are included for the sake of comparison to similar domestic models.

Descriptions have been kept short to allow the maximum number of cameras and illustrations in a book of comfortable size. For further details on these cameras and their history, please consult the bibliography for other references.

The order of the book is basically chronological, by date of introduction. When two or more cameras were introduced in the same year, they are listed in the order that they were discontinued. Within this basic pattern, some cameras have been grouped into families and inclusive dates of the "family" are used to determine the order in the book. The same pattern is followed for the shutter and lens variations of individual cameras.

The range of original prices generally includes the full range of prices at which all model variations were sold throughout the lifespan of the camera. The specific prices listed with each variation are generally the price of that variation when introduced. In some cases, the price may have been increased or reduced during subsequent years, which could account for discrepancies between the price range and the specific prices. Current prices or values can be found in **Price Guide to Antique and Classic Still Cameras,** available from the dealer where you bought this book.

We would like to thank all who have supplied information, photos, or allowed photos to be made of cameras in their collections, particularly the Eastman Kodak Co., Jack Naylor, and Jay Tepper. We appreciate the thoughtfulness of the many collectors who have called or written to us with information. John Darrow deserves special thanks for the loan of several rare Kodak catalogs. We sincerely thank Lee Anne Byers for compiling the basic information. Her careful attention to detail throughout this entire project has helped reduce the errors to a minimum.

THE EASTMAN DETECTIVE CAMERA

CHARACTERISTICS: Funnel-type shutter. **LENS:** B&L Rapid Rectilinear. **SHUTTER:** Peerless. **FILM TYPE:** rollholder or double plateholder. **IMAGE:** 4x5 in. **BODY:** 6x6x10 in. **WEIGHT:** 4 lb. **DATES:** 1887-1887. **QUANTITY:** 40? **PRICE:** $50.

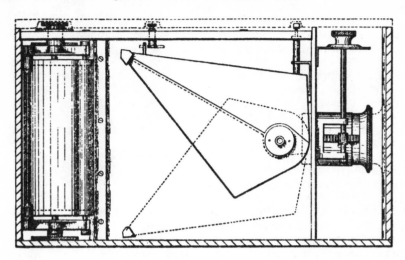

George Eastman's first camera was conceived about 1885, and he had hoped to have it on the market in 1886. He and F. M. Cossitt received a patent on the camera in 1886, and although he had models of the camera displayed at the St. Louis Photographic Convention in June of that year, it would be nearly two more years before it actually reached the market. The shutter design was innovative, but more costly to produce than a simpler shutter would have been. It consisted of a V-shaped funnel behind the lens, with an adjustable slit at the narrow end near the film plane. The funnel pivoted during exposure, the sweeping slit exposing the negative paper to the light. This same effect has been used in many later shutters, particularly in panoramic cameras where the lens and funnel pivot as a unit. The barrel shutter of the Kodak camera of 1888 also retains some of the basic concepts of Eastman's first shutter.

Production problems plagued the development of the camera. Early documents indicate that 75 cameras may have been started, and probably about 40 completed. While a few may have been sold to individuals at the $50.00 price, it is assumed that the majority of the 40 cameras were sold to W. H. Walmsley of Philadelphia about February of 1886 at a net price of $33.75 each when Eastman decided that they would be unprofitable to produce in quantity. The only known survivor is in the Smithsonian.

The difficulties faced in the production of the Eastman Detective Camera must have been a great learning experience for the young inventor, for his next camera, launched in November of that same year, met with fantastic success.

THE KODAK CAMERA (ORIGINAL MODEL)

CHARACTERISTICS: Cylindrical barrel shutter. Not self-capping, so it requires a felt plug to reset. **LENS:** Rapid Rectilinear f9/2¼ in. **SHUTTER:** Barrel (string-set). **FILM TYPE:** Paper stripping film (factory loaded). **IMAGE:** 2½ in. diameter. **BODY:** 3x3¼x7½ in. **WEIGHT:** 26 oz. **DATES:** 1888-1889. **PRICE:** $25. **QUANTITY:** about 5000.

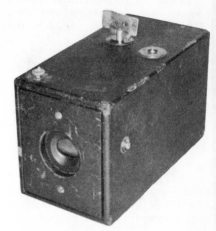

This camera, despite its simple appearance, is truly a landmark achievement in the history of photography. It ushered in the era when the amateur could begin taking photographs without the bother associated with the earlier forms of photography. It was small, lightweight, and used rollfilm instead of the cumbersome plates and plateholders which were the order of the day. Since it came loaded for 100 exposures, it was particularly handy for traveling or any portable use. It would be hard to imagine anyone carrying enough glass plates to make 100 exposures! The simplicity of using the Kodak camera made photography available and attractive to average men, women, and even children. The genius of the camera was not in its innovations, because it did not introduce any novel features. It was rather the combination of the best features of existing technologies to produce a more useful product. The important features of the camera were its simplicity of operation and compactness. George Eastman's ability to recognize a need and create a product to fill it served him well. In this instance it launched a new era.

NO. 1 KODAK CAMERA

CHARACTERISTICS: Sector shutter. Shutter release lower than original Kodak Camera. **LENS:** Rapid Rectlinear f9/2¼ in. **SHUTTER:** Sector (string-set). **FILM TYPE:** Paper stripping film (until replaced by celluloid film). **IMAGE:** 2½ in. diameter. **BODY:** 3¼x3-3/4x6 in. **WEIGHT:** 24 oz. **DATES:** 1889-1895. **QUANTITY:** about 5500. **PRICE:** $25.

Eastman learned his lessons well from the Detective Camera and the original Kodak Camera. Sales were good on the Kodak Camera, but the barrel shutter was expensive to manufacture. The obvious solution was to design a less expensive shutter, and the sector shutter used on this and other later Kodak cameras was the result. Not only was it less expensive to manufacture, but it was soon made self-capping, thus easier to use and eliminating the need for the felt lens plug. Other minor changes

included moving the shutter release button to a lower position on the left side of the camera. Actually this camera was not called the No. 1 until the introduction of the No. 2 in October of 1889.

NO. 2 KODAK CAMERA

CHARACTERISTICS: Round reflex viewfinder. Only camera for round 3.5 in. diameter negatives. **LENS:** Rapid Rectilinear 3¼ in. **SHUTTER:** Sector (string-set). **FILM TYPE:** Paper stripping film and celluloid rollfilm. **IMAGE:** 3.5 in. diameter. **BODY:** 4½x5x9 in. **WEIGHT:** 44 oz. **DATES:** 1889-1897. **QUANTITY:** about 20,000. **PRICE:** $32.50.

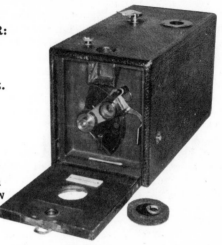

In October of 1889, a larger model of the Kodak Camera was introduced, and it became obvious that the name Kodak was no longer sufficient. The smaller size camera was thus dubbed No. 1, and this new model was called the No. 2. It is essentially the same as the No. 1 Kodak Camera except for its size. It still took circular exposures, but they were 3.5 inches in diameter with 60 exposures per roll. The paper stripping film was soon replaced by the more convenient clear celluloid film. The major technical innovation was the addition of a reflex viewfinder. A paper label inside of the hinged front identifies the camera but these labels are not always present. These labels were used to show the film size to be ordered before film was numbered. The label reads "In ordering supplies for this camera always specify FOR NO. 2 KODAK."

NO. 3 KODAK CAMERA

CHARACTERISTICS: Rectangular image 3¼x4¼ in. Two reflex finders. Knob on top for rack and pinion focusing. Longer proportional size than other early Kodak cameras. **LENS:** Bausch & Lomb Universal 5-5/8 in. **SHUTTER:** String-set sector. **FILM TYPE:** Rollfilm (clear celluloid darkroom loading with 250 exposures). **IMAGE:** 3¼x4¼ in. **BODY:** 4¼x5½x11½ in. **WEIGHT:** 4 lb. **DATES:** 1890-1897. **QUANTITY:** about 8500. **PRICE:** $40.

The No. 3 Kodak Camera, introduced in early 1890, was also called the No. 3 Regular Kodak Camera to distinguish it from the No. 3 Kodak Jr. Camera which was introduced at the same time. Today it is usually called No. 3 Kodak Camera. It was the first of the series to

offer a rectangular format and a focusing lens. Because of the rectangular format, two reflex finders were built in, one for horizontal and the other for vertical orientation. As in the previous models, the roll-holder was an integral part of the camera, and it was not adaptable for glass plates.

NO. 4 KODAK CAMERA

CHARACTERISTICS: Same as the No. 3 Kodak Camera except for the 4x5 in. size. **LENS:** B&L Universal 6½ in. **SHUTTER:** String-set sector. **FILM TYPE:** Celluloid rollfilm in darkroom loading rolls to 250 exposures. **IMAGE:** 4x5 in. **BODY:** 5x6-3/8x12-3/4 in. **WEIGHT:** 4½ lb. **DATES:** 1890-1897. **QUANTITY:** about 10000. **PRICE:** $50.

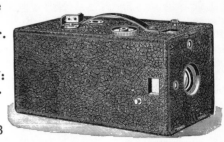

Along with the No. 3 and No. 3 Junior cameras were introduced the No. 4 and No. 4 Junior cameras, which were identical to their counterparts except for the larger 4x5 in. image size. The No. 4 Kodak Camera, like the No. 3, had an integral rollholder with a capacity of 250 exposures.

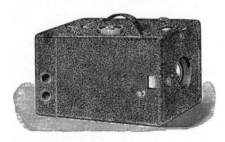

No. 3 Kodak Junior Camera

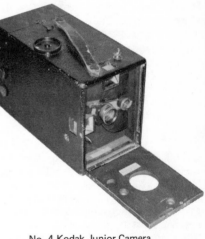

No. 4 Kodak Junior Camera

NO. 3 KODAK JUNIOR CAMERA

CHARACTERISTICS: External, removable rollholder was interchangeable with plate back. Overall length of 9 in. is 2½ in. less than No. 3 Regular, otherwise similar. **LENS:** Bausch & Lomb Universal 5-5/8 in. **SHUTTER:** Sector. **FILM TYPE:** Celluloid rollfilm in 60 or 100 exposure rolls. **IMAGE:** 3¼x4¼ in. **BODY:** 4¼x5½x9 in. **WEIGHT:** 3 lb. **DATES:** 1890-1897. **PRICE:** $40.

Along with the introduction of the No. 3 Kodak Camera this variation was also presented to the public. Although designed as a rollfilm camera, the rollholder was removable and could be replaced with an optional back for glass plates. The basic design was identical to the No. 3 Kodak Camera except for this feature, which resulted also

in a slight reduction in length. It was the first Kodak camera to allow for the use of glass plates and early catalogs offered it also as the "Glass Plate Kodak" when it was sold originally with the plate back instead of the roll back. The film capacity was reduced from 250 to 100 exposures.

NO. 4 KODAK JUNIOR CAMERA

CHARACTERISTICS: Like the No. 3 Junior but in the larger 4x5 in. size. Like the No. 4 "Regular" but removable rollholder. **LENS:** Bausch & Lomb Universal 6½ in. **SHUTTER:** String-set sector. **FILM TYPE:** Celluloid rollfilm in 60 or 100 exposure rolls. **IMAGE:** 4x5 in. **BODY:** 5x6¼x10½ in. **WEIGHT:** 3½ lb. **DATES:** 1890-1897. **PRICE:** $50.

Like the No. 3 Kodak Jr. Camera, the No. 4 was also available with a glass plate back as original equipment. When sold this way, it was called the No. 4 Junior Glass Plate Kodak Camera.

FOLDING KODAK CAMERAS AND GLASS PLATE FOLDING KODAK CAMERAS

Having met with considerable success in the amateur camera market, Eastman turned his attention toward the more serious photographers. Again he relied on the talents of Frank Brownell, who designed this time a good quality series of folding-bed cameras incorporating a rollfilm holder. They were modified in 1892 to accept double plateholders as an alternative to rollfilm. When originally supplied without a rollholder, the catalogs listed these cameras as "Glass Plate Folding Kodaks". Plateholders or rollholders were available at the option of the buyer. Although folding-bed cameras were nothing new, this was a distinct change from the standpoint of style, especially in the new field of rollfilm cameras. When closed, it resembles a carrying case, being covered with heavy leather and having a flap around the hinged top. One side drops down to form the bed, while the top lid opens to reveal the rollholder. This style gradually developed into the more compact plate cameras and rollfilm cameras through a succession of changes as reduced size became a more important marketing consideration. There are three sizes and several variations of the smaller sizes. The shutter type is a significant feature which can be helpful in dating these cameras: Sector shutter 1890-1891 (illus. on No. 4 Folding Kodak), Barker shutter 1892 (illus. on No. 5 Folding Kodak), and B&L Diaphragm shutter on "Improved" models 1893-1897 (illus. on Improved models). The improved models also featured a sliding lensboard which is much wider than the earlier square lens standards. The front bed is hinged on the improved models so that the front half can drop out of the way for a wide-angle lens. The back allows vertical or horizontal swings.

NO. 4 FOLDING KODAK CAMERA

CHARACTERISTICS: Sector shutter (1890-1891), Barker shutter (1892). 4x5 in. image size. **LENS:** B&L Universal. **SHUTTER:** Sector or Barker. **FILM TYPE:** Rollfilm (Walker rollholder). **IMAGE:** 4x5 in. **BODY:** 6-5/8x7½x7-3/4 in. **WEIGHT:** 6¼ lb. **DATES:** 1890-1892. **PRICE:** $55. (illus. next page)

NO. 4 FOLDING KODAK IMPROVED CAMERA

CHARACTERISTICS: B&L Iris Diaphragm shutter. Lens focal length increased. Double swing back, sliding front, drop bed hinged in center. **LENS:** Bausch & Lomb Universal. **SHUTTER:** B&L Iris Diaphragm. **FILM TYPE:** Rollfilm (Walker holder). **IMAGE:** 4x5 in. **BODY:** 6-5/8x7½x7-3/4 in. **WEIGHT:** 6¼ lb. **DATES:** 1893-1897. **PRICE:** $60. Supplied with 48 exp. roll, but will take 100 exp. roll.

No. 4 Folding Kodak Camera
with sector shutter.

No. 4 Folding Kodak Improved Camera
with Bausch & Lomb shutter.

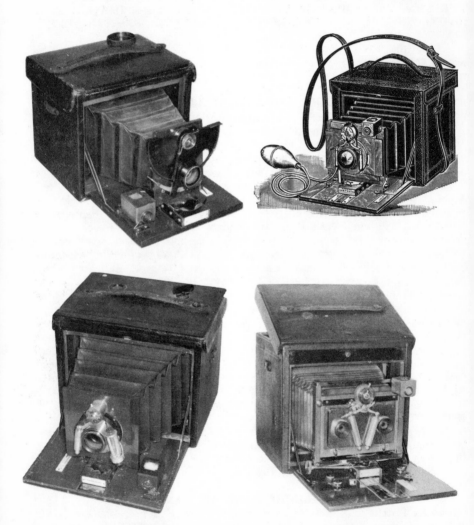

No. 5 Folding Kodak Camera
with Barker shutter.

No. 5 Folding Kodak Improved Camera
equipped for stereo use.

NO. 5 FOLDING KODAK CAMERA

CHARACTERISTICS: Sector shutter (1890-1891), Barker shutter (1892). 5x7 in. image size. **LENS:** Bausch & Lomb Universal. **SHUTTER:** Sector or Barker. **FILM TYPE:** Rollfilm (Walker holder). **IMAGE:** 5x7 in. **DATES:** 1890-1892. **PRICE:** $65. (illus. previous page)

NO. 5 FOLDING KODAK IMPROVED CAMERA

CHARACTERISTICS: B&L Iris diaphragm shutter. Lens focal length increased. Double swing back, sliding front, drop bed hinged in center. **LENS:** Bausch & Lomb Universal. **SHUTTER:** B&L Iris Diaphragm. **FILM TYPE:** Rollfilm (Walker holder). **IMAGE:** 5x7 in. **BODY:** 7½x9¼x10-1/8 in. **WEIGHT:** 9 lb. 5 oz. **DATES:** 1893-1897. **PRICE:** $75.

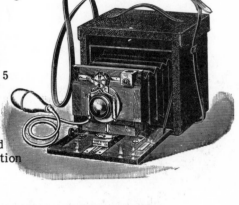

Originally supplied with 32 exposure roll, but will accept 100 exposure rolls. Could also be used for stereoscopic work with a partition and an extra lensboard that was supplied. (illus. previous page)

NO. 6 FOLDING KODAK IMPROVED CAMERA

CHARACTERISTICS: Like the No. 5 Improved model, but has 6½x8½ in. image size. **LENS:** Bausch & Lomb Universal. **SHUTTER:** Bausch & Lomb Iris Diaphragm. **FILM TYPE:** Rollfilm (Walker holder). **IMAGE:** 6½x8½ in. **BODY:** 8-3/4x11½x12 in. **WEIGHT:** 11 lb. 11 oz. **DATES:** 1893-1895. **PRICE:** $100.

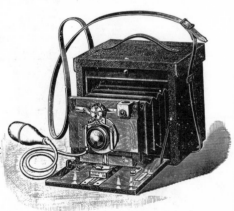

The No. 6 was not introduced until 1893, so all models are the "Improved" version with the Bausch & Lomb shutter. It was originally supplied with a 24 exposure roll of film, but could also use 48 exposure rolls.

ORDINARY KODAK AND DAYLIGHT KODAK CAMERAS

Having appeased the more advanced photographers in 1890 with the Folding Kodak series of cameras, Eastman returned to the amateur market with two new lines of cameras at low prices. The lower priced series called "Ordinary" cameras did not require factory loading as did the other "string-set" Kodak cameras. However, a darkroom was still necessary to load the celluloid film which did not yet have opaque leaders or backing. The "Daylight" cameras were very similar to the ordinary models, but with two obvious differences. The first difference is purely cosmetic - they were leather covered. The main difference gave them their name - they could be loaded in daylight. Lightproof cardboard boxes with velvet light traps were used for both supply and takeup, thus permitting daylight loading and unloading of the camera. In a way, this is a forerunner of the rapid-cassette system. Each of the two types of cameras was made in three sizes, designated A, B, and C. Two additional models of the "C" were marketed with the glass plate back as standard equipment and the roll back as an option. These were called the "C Ordinary Glass Plate Kodak" and "C Special Glass Plate Kodak" in the catalogs. All models were equipped with a string-set sector shutter.

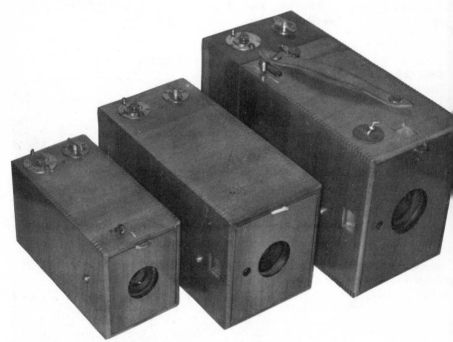

A, B, and C Ordinary Kodak Cameras

"A" ORDINARY KODAK CAMERA

CHARACTERISTICS: String-set box with natural wood body. Early models have V-lines for sighting. Later with reflex finder. For rollfilm only. **LENS:** Achromatic (single element) 4 in. **SHUTTER:**

String-set sector. **FILM TYPE:** Rollfilm (darkroom loading). **IMAGE:** 2-3/4x3¼ in. **BODY:** 3½x4x7¼ in. **WEIGHT:** 17 oz. **DATES:** 1891-1895. **QUANTITY:** about 3000. **PRICE:** $6.

"B" ORDINARY KODAK CAMERA

CHARACTERISTICS: String-set box with natural wood body. For rollfilm only. Reflex finder. **LENS:** Achromatic (single element) 6 in. **SHUTTER:** String-set sector. **FILM TYPE:** Rollfilm (darkroom loading). **IMAGE:** 3½x4 in. **BODY:** 4½x4-3/4x9½ in. **WEIGHT:** 29 oz. **DATES:** 1891-1895. **QUANTITY:** about 3000. **PRICE:** $10.

"C" ORDINARY KODAK CAMERA

CHARACTERISTICS: Natural wood body. Interchangeable backs for rollfilm or plates. Lever focusing. Revolving stops. Two reflex finders. **LENS:** Achromatic (single element) 7 in. **SHUTTER:** String-set sector. **FILM TYPE:** Rollfilm (plate back available). **IMAGE:** 4x5 in. **BODY:** 5x6½x11¼ in. **WEIGHT:** 55 oz. **DATES:** 1891-1895. **QUANTITY:** about 3000. **PRICE:** $15.

This was the largest of the Ordinary Kodak series, and the only one with an interchangeable back system to allow the use of rollfilm or plates. When it was originally sold with the plate back instead of the rollfilm back, it was listed in the catalog as the "C Ordinary Glass Plate Kodak".

"C" ORDINARY GLASS PLATE KODAK CAMERA

LENS: Achromatic (single element) 7 in. **SHUTTER:** String-set sector. **FILM TYPE:** Plate back (rollfilm back available). **IMAGE:** 4x5 in. **BODY:** 5x6½x11¼ in. **WEIGHT:** 55 oz. **DATES:** 1891-1895. **PRICE:** $15.

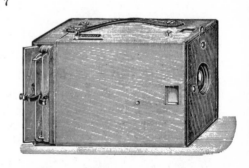

This camera is identical to the previous model, but was supplied originally with a back for glass plates. It could also accept the rollfilm back. Specifications, date, and price are all the same.

"A" DAYLIGHT KODAK CAMERA

CHARACTERISTICS: Leather covered box camera for special film in light-proof boxes. Fixed diaphragm. Single finder. **LENS:** Achromatic (single element) 4 in. **SHUTTER:** String-set sector. **FILM TYPE:** Celluloid rollfilm in daylight-loading boxes. **IMAGE:** 2-3/4x3¼ in. **BODY:** 3½x4x7¼ in. **WEIGHT:** 17 oz. **DATES:** 1891-1895. **QUANTITY:** about 2500. **PRICE:** $8.50.

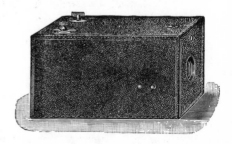

"B" DAYLIGHT KODAK CAMERA

CHARACTERISTICS: Leather covered. Fixed focus. Revolving stops. Single finder. $3\frac{1}{2}$x4 in. image size. **LENS:** Achromatic (double combination) 6 in. **SHUTTER:** String-set sector. **FILM TYPE:** Rollfilm in daylight-loading boxes. **IMAGE:** $3\frac{1}{2}$x4 in. **BODY:** $4\frac{1}{2}$x4-3/4x$9\frac{1}{2}$ in. **WEIGHT:** 29 oz. **DATES:** 1891-1895. **QUANTITY:** about 2500. **PRICE:** $15.

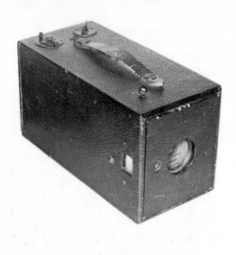 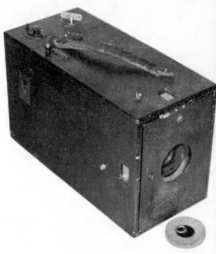

Above: B Daylight Kodak Camera
Right: C Daylight Kodak Camera

"C" DAYLIGHT KODAK CAMERA

CHARACTERISTICS: Interchangeable backs for rollfilm or plates. Leather covered. Two finders. Lever focusing. Revolving stops. **LENS:** Achromatic (double combination) 7 in. **SHUTTER:** String-set sector. **FILM TYPE:** Rollfilm in daylight-loading boxes. **IMAGE:** 4x5 in. **BODY:** 5x$6\frac{1}{2}$x$11\frac{1}{4}$ in. **WEIGHT:** 55 oz. **DATES:** 1891-1895. **QUANTITY:** about 2500. **PRICE:** $25.

"C" SPECIAL GLASS PLATE KODAK CAMERA

CHARACTERISTICS: Leather covering and plate back. **LENS:** Achromatic (double combination) 7 in. **SHUTTER:** String-set sector. **FILM TYPE:** plates (optional rollfilm back). **IMAGE:** 4x5 in. **BODY:** 5x$6\frac{1}{2}$x$11\frac{1}{4}$ in. **WEIGHT:** 55 oz. **DATES:** 1891-1895. **PRICE:** $25.

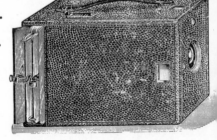

Despite Eastman's knack for producing the right product at the right time, and in spite of the creativity in coining the name "Kodak", he seemed to fall short occasionally in finding logical, sequential names for his deluge of new

models. This is one of the early examples where he painted himself into a corner. With the "Ordinary Kodak", there was no problem in naming the glass plate model. But alas, when you add the glass plate back to the "Daylight" Kodak Camera, the key name no longer applies. As you recall, it referred to the ability to load rollfilm in daylight. There could not be a "Daylight Glass Plate Kodak" so it was called the "Special Glass Plate Kodak" instead. It could be described as a "C" Daylight with a plate back, or as a "C" Ordinary Glass Plate model with leather covering.

FLAT FOLDING KODAK CAMERA

CHARACTERISTICS: Similar to No. 4 Cartridge Kodak Camera, but built-in shutter, reversible finder on lensboard, rack and pinion focus. **LENS:** Rapid Rectilinear. **SHUTTER:** built into lensboard. **FILM TYPE:** rollfilm (48 exp. per roll). **IMAGE:** 4x5 in. **BODY:** $3\frac{1}{2}$x$6\frac{1}{2}$x$8\frac{1}{2}$ in. **WEIGHT:** 3 lb. 4 oz. loaded. **DATES:** 1894-1895. **QUANTITY:** about 400.

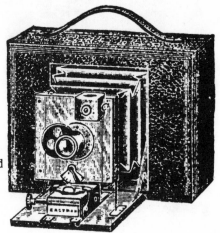

This is a very rare camera, having been marketed only in England for about two years. We can only wonder why it was not marketed in the United States. It is contemporary with the No. 4 and No. 5 Folding Kodak cameras which were enjoying a long life here, and pre-dates the No. 4 Cartridge Kodak Camera which is remarkably similar. Perhaps it was a market test for the compact Cartridge Kodak cameras which were introduced in 1897. The Flat Folding Kodak Camera was small and light but with a capacity for 48 exposures. It used rollfilm only and had an exposure counter. It was well-finished in mahogany with black morocco leather covering and brass fittings. It featured rack and pinion focusing and revolving stops.

KODET CAMERAS

The Kodet cameras were designed as a lower priced line of glass plate cameras which could also be adapted for rollfilm. The box model, or Regular Kodet as it was called in the early catalogs, had features similar to the C Daylight Kodak Camera, but at a lower price. The back of the Kodet Camera provided room for a rollholder or for storage of extra plateholders. The Folding Kodet cameras were considerably less expensive than the Folding Kodak cameras. The simple Kodet shutter built into the lensboard was more economical than the B&L diaphragmatic shutters concurrently supplied with the Folding Kodak cameras. This and simplifications of the body design made the camera less expensive to produce. In a highly competitive market, this camera offered customers another choice in favor of Eastman.

NO. 4 KODET CAMERA

CHARACTERISTICS: The only Kodet box model. Kodet shutter built into interior lensboard. **LENS:** Achromatic 6 in. or Rapid Rectilinear. **SHUTTER:** Kodet (built-in). **FILM TYPE:** plates or rollfilm. **IMAGE:** 4x5 in. **BODY:** 5-11/16x6½x10-7/8 in. **WEIGHT:** 51 oz. **DATES:** 1894-1897. **PRICE:** $15 with Achromatic. 20 with RR.

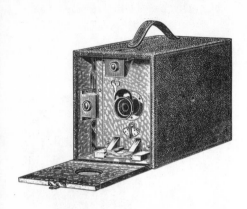

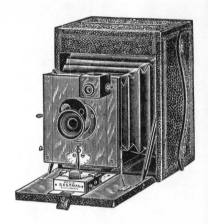

Above: No. 4 Kodet Camera
Right: No. 4 Folding Kodet Camera

NO. 4 FOLDING KODET CAMERA

CHARACTERISTICS: Kodet built-in shutter (1894-1897), Gundlach shutter (1896), B&L Kodak shutter (1896-1897). **LENS:** Achromatic 6 in. or Rapid Rectilinear double combination. **SHUTTER:** Kodet, Gundlach, or B&L Kodak. **FILM TYPE:** plate or optional rollholder. **IMAGE:** 4x5 in. **BODY:** 5¼x5¼x6½ in. **WEIGHT:** 32 oz. **DATES:** 1894-1897. **PRICE:** $15 with achromatic. $20 with RR.

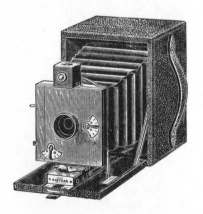

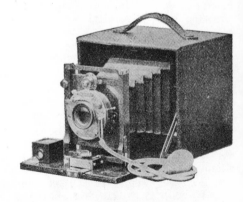

No. 4 Folding Kodet Junior Camera
showing built-in shutter

No. 4 Folding Kodet Special Camera
(showing B&L Kodak shutter)

NO. 4 FOLDING KODET JUNIOR CAMERA

CHARACTERISTICS: Similar to the No. 4 Folding Kodet Camera, but not available with a double lens. The built-in shutter is slightly different. **LENS:** Achromatic 6 in. **SHUTTER:** Kodet. **FILM TYPE:** plate (optional rollholder). **IMAGE:** 4x5 in. **BODY:** 5¼x5¼x6½ in. **WEIGHT:** 32 oz. **DATES:** 1894-1897. **PRICE:** $12.

NO. 4 FOLDING KODET SPECIAL CAMERA

CHARACTERISTICS: Kodet shutter (1895-1897), Gundlach shutter (1896), B&L shutter (1896-1897). **LENS:** Achromatic or Rapid Rectilinear. **SHUTTER:** Kodet, Gundlach, or Bausch & Lomb. **FILM TYPE:** plate (optional rollholder). **IMAGE:** 4x5 in. **BODY:** 5-3/4x6¼x7 in. **WEIGHT:** 2¼ oz. **DATES:** 1895-1897. **PRICE:** $20 with RR. $15 with Achromatic.

NO. 5 FOLDING KODET CAMERA

CHARACTERISTICS: Kodet built-in shutter (1895-1897), Gundlach shutter (1896), B&L shutter (1896-1897). **LENS:** Achromatic or Rapid Rectilinear. **SHUTTER:** Kodet, Gundlach, or Bausch & Lomb. **FILM TYPE:** plate (optional rollholder). **IMAGE:** 5x7 in. **BODY:** 6-7/8x7x9 in. **WEIGHT:** 3½ lb. **DATES:** 1895-1897. **PRICE:** $30 with RR. $22 with Achromatic.

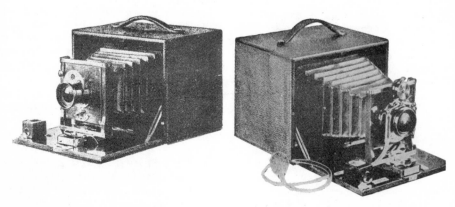

Above: No. 5 Folding Kodet camera with Kodet shutter.
Right: No. 5 Folding Kodet Special camera with B&L shutter.

NO. 5 FOLDING KODET SPECIAL CAMERA

CHARACTERISTICS: Kodet built-in, B&L iris diaphragm, and Gundlach shutters (1895-1897), B&L Kodak shutter (1896-1897). **LENS:** Rapid Rectilinear. **SHUTTER:** Kodet, Gundlach, or Bausch & Lomb. **FILM TYPE:** plate (optional rollholder). **IMAGE:** 5x7 in. **BODY:** 6-7/8x7-1/8x9 in. **WEIGHT:** 3 lb. 9 oz. **DATES:** 1895-1897. **PRICE:** $35-48 depending on shutter.

THE BIRTH OF THE RED WINDOW

Some of the things we take so much for granted could prove to be very interesting if we looked a little deeper. The little red window on the back of countless cameras was born about 90 years ago. As with many inventions of the era, it was developed as a further improvement of another recent idea, that of moving the film spools forward of the focal plane. This spool position was relatively new in the U.S.A. although it had been patented and produced by Redding in London at about the same time as Eastman's first Kodak camera. Originally conceived to make the camera more compact, this design was a necessary basis for the invention of the red window, since it was only in a camera incorporating this principle that the film would move along the back of the camera where a window could logically be located.

S. N. TURNER.
PHOTOGRAPHIC FILM ROLL.

The latest improvement of 1892, a brainchild of Samuel Turner, put a long length of black paper behind a somewhat shorter length of celluloid film. The leading and trailing ends of the paper sealed the film from light during the loading in daylight without the need for an external container such as that used in the Daylight Kodak cameras. Of equal significance was the idea of printing white numbers on the back to count and space the exposures, these numbers being visible through a small window in the back of the camera. The window was covered with red celluloid to help reduce the chance of fogging the film. Turner's invention was first marketed by the Boston Camera Mfg. Co. in the new Bull's-Eye camera of 1892.

If one thing is certain in the history of photography, it is that George Eastman recognized a good idea when he saw one. In this instance, he produced a similar camera for rollfilm with a numbered paper backing and called it the Bullet. Even the name sounded similar to Turner's Bull's-Eye. At the same time, Eastman introduced another camera for paper-backed rollfilm which did not just imitate the competition. Justifiably dubbed the Pocket Kodak, it was a very small box camera with a simple sector shutter (soon replaced by an even simpler rotary shutter). Probably due to its convenient size and low price, it sold very well. Soon after Sam Turner was issued a patent for his "red window" invention, George Eastman bought the Blair and Boston camera companies to acquire the patent and avoid any further royalty payments to them. His uncanny ability to recognize potential and put it on his side again served him well. Eastman considered himself to be lucky. He may well have been, but the more accurately he predicted the market for photographic products, the luckier he got.

POCKET KODAK CAMERAS (1895-1900)

The Pocket Kodak camera series holds a unique position in the development of the amateur camera. It was this series which directly

bridged the gap between the original Kodak cameras and the first Brownie, adhering to the criteria of portability, simplicity of operation, and low cost. It offered the amateur essentially the same convenience and simplicity as did the original Kodak Camera, plus the advantage of smaller size and daylight loading. Perhaps even more significant was the price of only $5. Who could resist the magic of photography when it was made so simple and inexpensive.

There were several design changes in 1895, but from 1896-1900 it remained essentially unchanged. The earliest models of 1895 had the shutter mounted on a separate, removable board not attached to the transport mechanism. Later 1895 models had the shutter attached to the film transport section. On any of the Pocket Kodak cameras, the removable panel with the red window could be replaced with a single plateholder, which was a $.25 optional accessory.

To identify any of these cameras, the name and model year may be read from the inside if the bottom. Pulling out the small tab at the bottom of the front face releases the bottom. The cameras are all marked by year except the 1900 model which is labeled "Model D".

POCKET KODAK CAMERA MODEL 1895

IDENTIFICATION: "Pocket Kodak" inside bottom. **CHARACTER-ISTICS:** Aluminum interior frame. Round viewfinder screen. 1885 and 1889 patents. Sector shutter requires cocking by lateral motion of release lever. Early models have separate shutter board. **LENS:** Meniscus f10/2½ in. **SHUTTER:** sector. **FILM SIZE:** 102 (introduced in 1895 for this camera). **FILM TYPE:** rollfilm with numbered paper backing. **IMAGE:** 1½x2 in. **BODY:** 2-3/16x3x4 in. **WEIGHT:** 6 oz. **DATES:** 1895-1895. **PRICE:** $5.

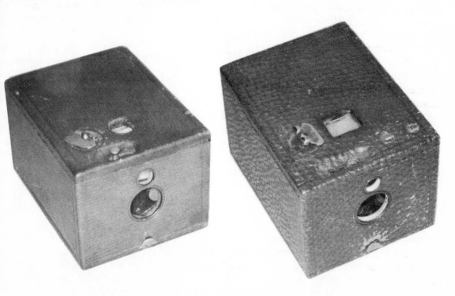

Pocket Kodak camera, 1895 model.
(note round finder on top.)

Pocket Kodak camera, Model D.

21

POCKET KODAK CAMERA
MODEL 1896 (ALSO '97-'99 AND MODEL D)

IDENTIFICATION: "96 Model Pocket Kodak" inside bottom. **CHARACTERISTICS:** Wooden interior frame. Rectangular viewing screen. 1885 and 1891 patents. Rotary shutter does not need cocking. **LENS:** Meniscus f10/2¼ in. **SHUTTER:** rotary. **FILM SIZE:** 102. **FILM TYPE:** rollfilm with numbered paper backing. **IMAGE:** 1½x2 in. **BODY:** 2-3/16x3x4 in. **WEIGHT:** 6 oz. **DATES:** 1896-1900. **PRICE:** $5.

Models of 1897, 1898, 1899, and Model D (1900) are essentially the same as the 1896 model. Each is marked with its model year and additional patent dates in the bottom section. (Model D illustrated.)

BULLET CAMERAS

George Eastman began the Bullet camera line in 1895 as a counterpart to the Boston Camera Company's Bull's-Eye Camera. Boston's Bull's-Eye had introduced the numbered paper-backed rollfilm in 1892, and had been selling well enough to cause concern in Rochester. Eastman countered with two new cameras in 1895, the innovative Pocket Kodak Camera which we just discussed, and the Bullet Camera. Rather than showing innovative design, the Bullet Camera was surprisingly similar to the rival Boston Bull's-Eye. Within another year, Eastman had purchased the Boston Camera Co. to obtain the patent rights, and the Bullet and Bull's-Eye cameras became part of the same family. Despite the acquisition of the Bull's-Eye line, Eastman continued and expanded the Bullet line until it included the No. 2 Bullet Camera for 3½x3½ in. negatives and the No. 4 Bullet Camera for 4x5 in. photos. Each size boasted a common simple model and a "special" model with a Rapid Rectilinear lens and Triple-action shutter.

NO. 2 BULLET CAMERA

CHARACTERISTICS: Cube-shaped box camera. Round viewfinder identifies 1895 model. **LENS:** fixed focus Achromatic 4¼ in. **SHUTTER:** Rotary. **FILM SIZE:** 101 (introduced in 1895 for this camera). **FILM TYPE:** rollfilm with numbered paper backing. **IMAGE:** 3½x3½ in. **BODY:** 4½x4½x6 in. **WEIGHT:** 21 oz. **DATES:** 1895-1896. **PRICE:** $8.

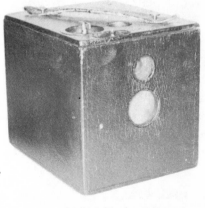

Note: No. 2 refers to the size of the negative and is not an indicator of any production series. The No. 2 Kodak Camera had an image diameter of 3½ inches, and No. 2 became the designation for 3½ inches square. (Don't waste time looking for a No. 1 Bullet.)

NO. 2 BULLET IMPROVED CAMERA

CHARACTERISTICS: Cube-shaped box camera. Square viewfinder. Side door allows use of plateholder for single plates.
LENS: Achromatic fixed focus 4¼ in.
SHUTTER: Rotary.
FILM SIZE: 101. **FILM TYPE:** rollfilm (or single plateholder).
IMAGE: 3½x3½ in.
BODY: 4½x4½x6 in.
WEIGHT: 20 oz.
DATES: 1896-1900. **PRICE:** $10.

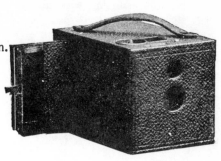

NO. 2 BULLET CAMERA- NEW MODEL

CHARACTERISTICS: Similar to earlier models, but accepts double plateholder as well as rollfilm. **LENS:** Achromatic fixed focus 4¼ in. **SHUTTER:** Rotary. **FILM SIZE:** 101. **FILM TYPE:** rollfilm (or double plateholder). **IMAGE:** 3½x3½ in. **BODY:** 4¼x4¼x6 in. **WEIGHT:** 20 oz. **DATES:** 1900-1902. **PRICE:** $10.

NO. 2 BULLET SPECIAL CAMERA

CHARACTERISTICS: Rapid Rectilinear lens in Triple Action shutter. Otherwise, similar to No. 2 Bullet Camera. **LENS:** Rapid Rectilinear. **SHUTTER:** Eastman Triple Action. **FILM SIZE:** 101. **FILM TYPE:** rollfilm (or double plateholder). **IMAGE:** 3½x3½ in. **BODY:** 4¼x4¼x6 in. **DATES:** 1898-1904. **PRICE:** $18.

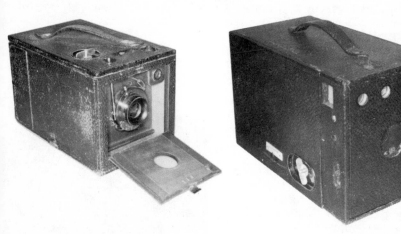

No. 2 Bullet Special Camera

No. 4 Bullet camera

NO. 4 BULLET CAMERA

IDENTIFICATION: Name and year model marked inside. **CHARACTERISTICS:** Side-loading box camera. **LENS:** Achromatic. **SHUTTER:**

Rotary. **FILM SIZE:** 103. **FILM TYPE:** rollfilm (or single plateholder). **IMAGE:** 4x5 in. **DATES:** 1896-1900. **PRICE:** $15.

The 103 rollfilm was introduced for this camera and the No. 4 Bull's-Eye Camera in 1896.

NO. 4 BULLET SPECIAL CAMERA

CHARACTERISTICS: Rapid
Rectilinear in Triple Action shutter.
LENS: Rapid Rectilinear.
SHUTTER: Eastman Triple Action.
FILM TYPE: cartridge rollholder or
double plateholder. **IMAGE:** 4x5 in.
DATES: 1898-1900. **PRICE:** $20-25.

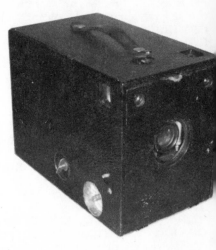

NO. 4 BULLET SPECIAL CAMERA
(MODEL C)

LENS: Rapid Rectilinear.
SHUTTER: Eastman Triple Action.
FILM SIZE: 103. **FILM TYPE:**
rollfilm or double plateholder.
IMAGE: 4x5 in. **DATES:** 1901-1904.
PRICE: $22.50.
(Model C illustrated.)

BULL'S-EYE CAMERAS

Originally made by the Boston Camera Co. After Kodak took over they were designated Bull's-Eye Improved Camera in catalogs, but not on the cameras themselves.

NO. 2 BULL'S-EYE CAMERA

LENS: Meniscus Achromatic 4½ in.
SHUTTER: Eastman Rotary.
FILM SIZE: 101. **FILM TYPE:**
rollfilm. **IMAGE:** 3½x3½ in. **BODY:**
4½x4-5/8x5-3/4 in. **WEIGHT:** 22 oz.
DATES: 1896-1913. **PRICE:** $8.

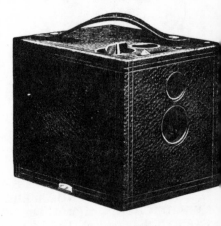

This camera was also called the
No. 2 Bull's-Eye Improved Camera to
distinguish it from the former model
made by the Boston Camera Co.
Some catalogs also call it the No. 2
Bull's-Eye Kodak. Like the Pocket
Kodak cameras, it is identified by
model year or letter (1896, 1897,
1898, C, and D) which are marked
inside.

NO. 2 BULL'S-EYE SPECIAL CAMERA

CHARACTERISTICS: Rapid Rectilinear lens. Triple Action Shutter. Otherwise, similar to No. 2 Bull's-Eye camera. **LENS:** Rapid Rectilinear. **SHUTTER:** Eastman Triple Action. **FILM SIZE:** 101. **FILM TYPE:** rollfilm. **IMAGE:** $3\frac{1}{2}$x$3\frac{1}{2}$ in. **BODY:** 4-3/4x4-3/4x6-3/4 in. **WEIGHT:** 28 oz. **DATES:** 1898-1904. **PRICE:** $15.

This is a more expensive version of the No. 2 Bull's-Eye camera.

NO. 4 BULL'S-EYE CAMERA

CHARACTERISTICS: Side-loading box camera. Side lever with scale focuses internal bellows. **LENS:** Achromatic $6\frac{1}{4}$ in. **SHUTTER:** Eastman Rotary. **FILM SIZE:** 103. **FILM TYPE:** rollfilm. **IMAGE:** 4x5 in. **BODY:** 5x5-7/8x9$\frac{1}{4}$ in. **WEIGHT:** 42 oz. **DATES:** 1896-1904. **PRICE:** $12.

This camera was also called No. 4 Bull's-Eye Improved Camera and No. 4 Bull's-Eye Kodak. It is identified inside by model year or letter: 1896, 1897, 1898, C, and D. The 103 rollfilm was introduced for this camera and the No. 4 Bullet Camera in 1896.

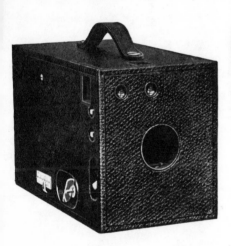 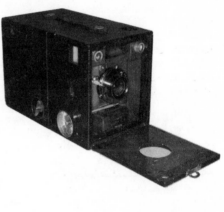

Left: No. 4 Bull's-Eye camera
Right: No. 4 Bull's-Eye Special camera

NO. 4 BULL'S-EYE SPECIAL CAMERA

CHARACTERISTICS: Rapid Rectilinear lens, Triple Action shutter. Otherwise, similar to No. 4 Bull's-Eye Camera. **LENS:** Rapid Rectilinear. **SHUTTER:** Eastman Triple Action. **FILM SIZE:** 103. **FILM TYPE:** rollfilm. **IMAGE:** 4x5 in. **BODY:** 5-1/8x5-7/8x8-7/8 in. **WEIGHT:** 44 oz. **DATES:** 1898-1904. **PRICE:** $20.

This is a more sophisticated version of the No. 4 Bull's-Eye Camera.

NO. 3 BULL'S-EYE CAMERA

LENS: Achromatic. **SHUTTER:** Rotary. **FILM SIZE:** 124. **FILM TYPE:** rollfilm. **IMAGE:** $3\frac{1}{4}$x$4\frac{1}{4}$ in. **BODY:** 4-5/8x5$\frac{1}{2}$x6$\frac{1}{2}$ in. **WEIGHT:** 24 oz. **DATES:** 1908-1913. **PRICE:** $8. (illus. next page)

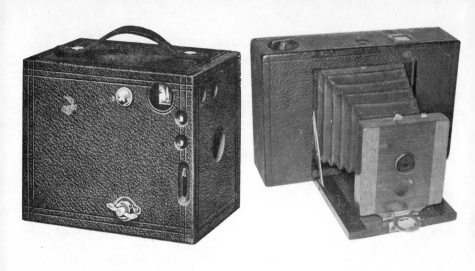

No. 3 Bull's-Eye camera No. 2 Folding Bull's-Eye camera

NO. 2 FOLDING BULL'S-EYE CAMERA

LENS: Achromatic. **SHUTTER:** Rotary. **FILM SIZE:** 101. **IMAGE:** 3½x3½ in. **DATES:** 1899–1901. **PRICE:** $10.
 This is a rare camera, made for only a few years.

THE FALCON CAMERA

IDENTIFICATION: 'Falcon Camera' inside bottom. **CHARACTERISTICS:** Styled like the Pocket Kodak Camera but a larger size. Also known as the No. 1 Falcon Camera. **LENS:** Achromatic. **SHUTTER:** Rotary. **FILM SIZE:** special rollfilm. **IMAGE:** 2x2½ in. **BODY:** 2-3/4x3½x4¼ in. **DATES:** 1897–1898. **PRICE:** $6.

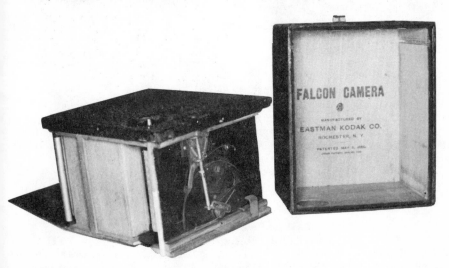

NO. 2 FALCON CAMERA

CHARACTERISTICS: Early model: Top and sides removable as a unit from bottom and film transport. "No. 2 Falcon" inside top. Improved model: Front hinges down and sides remove in the same manner as the better known Flexo Camera. "Improved No. 2 Falcon Kodak" printed inside. **LENS:** Achromatic $4\frac{1}{2}$ in. **SHUTTER:** Rotary "Safety" shutter. **FILM SIZE:** 101. **IMAGE:** $3\frac{1}{2}$x$3\frac{1}{2}$ in. **BODY:** $4\frac{1}{2}$x$4\frac{1}{2}$x5-3/4 in. **WEIGHT:** 19 oz. **DATES:** 1897-1899. **PRICE:** $5. This camera was replaced in December 1899 by the No. 2 Flexo Kodak Camera.

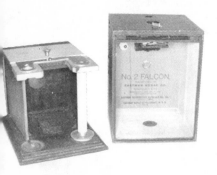
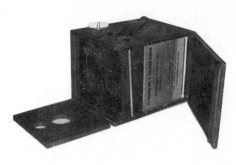

No. 2 Falcon camera (early model) No. 2 Falcon camera (improved model)

NO. 4 CARTRIDGE KODAK CAMERA

IDENTIFICATION: "No. 4 Cartridge Kodak" on round ivory plate inside back. **CHARACTERISTICS:** Wood front, sliding focus 1897-1900. Metal front with rise and shift movements Nov. 1900-1907. Bed extension with rack and pinion focusing. Longer bellows permits focusing to 18 in. Lettered models thru Model F. **LENS:** $6\frac{1}{2}$ in. (see variations below). **SHUTTER:** (see variations below). **FILM SIZE:** 104 (introduced in 1897 for this camera). **FILM TYPE:** rollfilm (12 exp.) or plates with accessory back. **IMAGE:** 4x5 in. **BODY:** $3\frac{1}{4}$x6-3/8x$8\frac{1}{4}$ in. **WEIGHT:** 3 lb. 2 oz. **DATES:** 1897-1907. **PRICE:** $25-83.

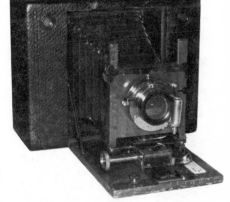

The Flat Folding Kodak Camera, a rare but surprisingly similar camera marketed in England by Kodak in 1894-1895, is nearly identical to the No. 4 Cartridge Kodak Camera in style, size, and weight.

DATES	LENS	SHUTTER	PRICE
1897-1900	Rapid Rectilinear f8	Eastman Triple Action pneumatic valve on side	25
1900-1900	B&L Zeiss Anast. f8	B&L Iris Diaphragm	66
1900-1900	B&L Zeiss Anast. f8	Unicum	66

DATES	LENS	SHUTTER	PRICE
1900-1903	Rapid Rectilinear f8	East. Triple Action (bottom valve)	25
1901-1901	Goerz Anast. f6.8	B&L Iris Diaphragm	79
1901-1902	B&L Plastigmat f6.8	B&L Iris Diaphragm	73
1902-1902	Rapid Rectilinear f8	B&L Automatic	30
1902-1905	B&L Plastigmat f6.8	B&L Automatic	68
1902-1905	Goerz Anast. f6.8	B&L Automatic	57
1902-1905	Goerz Anast. f6.8	Volute	64
1902-1907	B&L Plastigmat f6.8	Volute	77
1904-1906	Goerz Anast. f6.8	Kodak Automatic	63
1904-1907	Rapid Rectilinear f8	Kodak Automatic	25
1904-1907	B&L Plastigmat f6.8	Kodak Automatic	63
1905-1907	B&L Zeiss Tessar f6.3	Volute	83
1907-1907	Cooke Anast. f6.5	Volute	77

NO. 5 CARTRIDGE KODAK CAMERA

CHARACTERISTICS: Early models before Nov. 1900 have wooden front and slide focus. After Nov. 1900, improved metal front with rise and shift and extensible bed with rack and pinion focusing to 18 inches.
LENS: $8\frac{1}{2}$ in. (see variations below).
SHUTTER: (see variations below).
FILM SIZE: 115 (introduced in 1898 for this camera).
FILM TYPE: rollfilm or plateholder. **IMAGE:** 5x7 in. **BODY:** 3-3/8x8½x10 in. **WEIGHT:** 4 lb. 8 oz. **DATES:** 1898-1907. **PRICE:** $35-105.

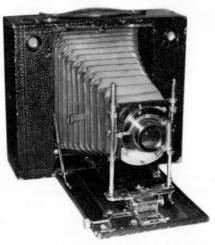

The 5x7 in. image size of this camera was the largest picture area of any conventional rollfilm camera.

DATES	LENS	SHUTTER	PRICE
1898-1900	Rapid Rectilinear f8	Eastman Triple Action (side valve)	35
1900-1900	B&L Zeiss Anast. f8	B&L Iris Diaphragm	86
1900-1900	B&L Zeiss Anast. f8	Unicum	86
1900-1903	Rapid Rectilinear f8	East. Triple Action (bottom valve)	35
1901-1901	Goerz Anast f6.8	B&L Iris Diaphragm	95
1901-1902	B&L Plastigmat f6.8	B&L Iris Diaphragm	90
1902-1902	Rapid Rectilinear f8	B&L Automatic	40
1902-1906	Goerz Anast. f6.8	B&L Automatic	78
1902-1906	Goerz Anast. f6.8	Volute	78
1902-1907	B&L Plastigmat f6.8	B&L Automatic	85
1903-1907	B&L Plastigmat f6.8	Volute	94
1904-1907	Rapid Rectilinear f8	Unicum	35
1904-1907	Rapid Rectilinear f8	B&L Automatic	40
1905-1907	B&L Zeiss Tessar f6.3	Volute	105
1907-1907	Cooke Anast. f6.3	Volute	102

NO. 3 CARTRIDGE KODAK CAMERA

CHARACTERISTICS: Early examples (1900) have sliding focus. Improved metal front and rack and pinion focus beginning January 1901. **LENS:** 6 in. (see variations below). **SHUTTER:** (see variations below). **FILM SIZE:** 119 (introduced in 1900 for this camera). **FILM TYPE:** 12 exp. rollfilm (adapter for glass plates). **IMAGE:** $3\frac{1}{4}$x$4\frac{1}{4}$ in. **BODY:** $3\frac{1}{4}$x5-3/4x$7\frac{1}{2}$ in. **WEIGHT:** 44 oz. **DATES:** 1900-1907. **PRICE:** $20-72.

DATES	LENS	SHUTTER	PRICE
1900-1900	Rapid Rectilinear f8	Eastman Triple Action (side valve)	20
1900-1900	B&L Zeiss Anast. f8	Unicum	51
1901-1901	Goerz Anast. f6.8	Unicum	60
1901-1902	B&L Plastigmat f6.8	Unicum	55
1901-1903	Rapid Rectilinear f8	East. Triple Action (bottom valve)	20
1902-1902	Rapid Rectilinear f8	B&L Automatic	25
1902-1905	B&L Plastigmat f6.8	B&L Automatic	57
1902-1905	Goerz Anast. f6.8	B&L Automatic	61
1902-1906	Goerz Anast. f6.8	Volute	70
1903-1907	B&L Plastigmat f6.8	Volute	66
1904-1906	Goerz Anast. f6.8	Kodak Automatic	52
1904-1907	Rapid Rectilinear f8	Kodak Automatic	20
1904-1907	B&L Plastigmat f6.8	Kodak Automatic	52
1906-1907	B&L Zeiss Tessar f6.3	Volute	72
1907-1907	Cooke Anast. f6.5	Volute	67

FOLDING POCKET KODAK CAMERAS

By 1897, rollfilm simplicity and compact size were major ingredients in Eastman's recipe for success. They had proved their commercial value with the 1888 Kodak Camera and the 1895 Pocket Kodak Camera. Now it was time to apply these features to the folding camera. Until now, the Folding Kodak Cameras were quite large and boxy. In 1897 the No. 4 Cartridge Kodak Camera cut that bulk in half. But an even more significant development in that year was the Folding Pocket Kodak Camera. It introduced the new 105 film size for $2\frac{1}{4}$X$3\frac{1}{4}$ inch negatives. The smaller image size and the compact aluminum body made this a truly pocketable camera. The first model was called the Folding Pocket Kodak Camera and had no model number. The camera was quite successful, and when the second size was added to the line in 1899, the original size took on the designation of No. 1.

Folding Pocket Kodak cameras led the way to a whole new generation of popular cameras. The basic style evolved and seven new sizes were added. The name was also changed several times. But the camera was on the scene to record the turning of a new century, the World War, and the Great Depression. Other manufacturers around the world followed suit, and for a third of a century the world was inundated with folding rollfilm cameras a la Folding Pocket Kodak.

NO. 1 FOLDING POCKET KODAK CAMERA

CHARACTERISTICS: Earliest models called "Folding Pocket Kodak" without numbers. Marked "No. 1 Folding Pocket Kodak" after 1899. Two major body styles described below. **LENS:** Meniscus Achromatic fixed focus 4 in. **SHUTTER:** Eastman Automatic (built-in) or Pocket Automatic. **FILM SIZE:** 105 (intro. in 1897 for this camera). **FILM TYPE:** roll- film (12 exp.). **IMAGE:** 2¼x3¼ in. **BODY:** 1-5/8x3½x6-3/4 in. **WEIGHT:** 16 oz. **DATES:** 1897-1915. **PRICE:** $10.

Straight pull-out, square-front. Eastman Automatic shutter.

DATES	MODEL	CHARACTERISTICS
ca. 1898	(original type)	Brass struts. Not marked "No. 1".
ca. 1898-1899	(second type)	Nickeled struts. Not marked "No. 1".
ca. 1899-1905	Model B	"No. 1" Folding Pocket Kodak.

Bed-type with self-erecting front. Pocket Automatic shutter.

ca. 1905-1907	Model C	Wooden lensboard. Two finders.
ca. 1907-1909	Model D	Wooden lensboard. Reversible finder.
ca. 1910-1915	Model E	Metal lensboard. Reversible finder.

NO. 1A FOLDING POCKET KODAK CAMERA

IDENTIFICATION: "No. 1A Folding Pocket Kodak" below lens on all models except the first. Name and model also marked inside the removable back. **LENS:** Meniscus Achromatic 5 in. **SHUTTER:** Eastman Automatic or Pocket Automatic. **FILM SIZE:** 116 (introduced in 1899 for this camera). **FILM TYPE:** rollfilm. **IMAGE:** 2½x4¼ in. **BODY:** 1-3/4x3-7/8x7-3/4 in. **WEIGHT:** 20 oz. **DATES:** 1899-1915. **PRICE:** $12.

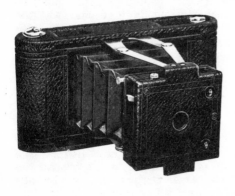
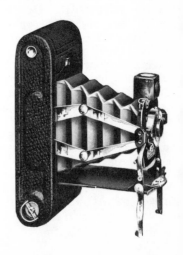

Two main body style variations with the change occuring in 1905.

DATES	MODEL	CHARACTERISTICS
1899-1905	(Model A)	Straight pull-out leather covered front with Eastman Automatic built-in rotary shutter. No bed.
1905-1906	Model B	Bed-type, self-erecting. Pocket Automatic shutter. Wooden lensboard. Two finders.
1907-1909	Model C	Bed-type, self-erecting. Wooden lensboard. Reversible finder.
1910-1915	Model D	Bed-type, self-erecting. Metal lensboard. Reversible finder.

NO. 2 FOLDING POCKET KODAK CAMERA

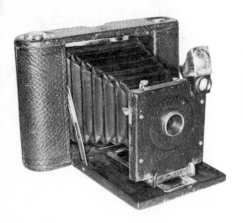 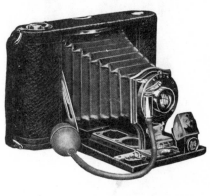

IDENTIFICATION: "No. 2 Folding Pocket Kodak" inside back. **CHARACTERISTICS:** Horizontal body with folding bed. Early models 1899-1903 have built-in Eastman Automatic shutter in leather-covered lensboard. Later models 1904-1909 have F.P.K. Automatic shutter exposed on front of wooden lensboard. **LENS:** $4\frac{1}{2}$ in. (see variations below). **SHUTTER:** (see variations below). **FILM SIZE:** 101. **IMAGE:** $3\frac{1}{2}$x$3\frac{1}{2}$ in. **BODY:** $1\frac{1}{2}$x$4\frac{1}{2}$x6-3/4 in. **WEIGHT:** 18 oz. **DATES:** 1899-1909. **PRICE:** $15.

DATES	LENS	SHUTTER	PRICE
1899-1903	Achromatic	Eastman Automatic	15
1904-1909	Rapid Rectilinear	F.P.K. Automatic	15

NO. 3 FOLDING POCKET KODAK CAMERA

CHARACTERISTICS: Early models 1900-1903 have built-in Eastman Automatic shutter in leather covered lensboard. In 1904-1909, the leading edge of front door is straight. In 1909-1915, leading edge of front door is curved. Rising front with micrometer screw. Bulb release on models before 1914. Cable release beginning 1914. **LENS:** 5 in. (see variations below). **SHUTTER:** (see variations below). **FILM SIZE:** 118 (introduced in 1900 for this camera). **IMAGE:** $3\frac{1}{4}$x$4\frac{1}{4}$ in. **BODY:** 1-5/8x$4\frac{1}{2}$x$7\frac{1}{4}$ in. **WEIGHT:** 23 oz. **DATES:** 1900-1915. **PRICE:** $18-68.

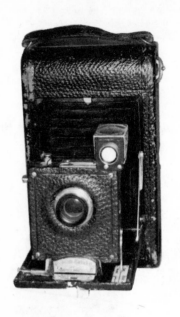
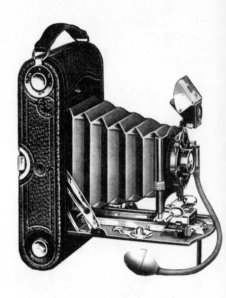

Model designations: A, AB, AB-EX, ABX, B, B-2, B-3, B-4, C, C-2, C-3, C-4, C-5, D, E, E-2, E-3, E-4, F, G, H. Modifications: 1903- 2 tripod sockets. 1904- Rising and sliding front offered for one dollar extra. 1910- Rising and sliding front standard equipment. Continued as No. 3 Autographic Kodak 1914-1926.

DATES	LENS	SHUTTER	PRICE
1900-1903	Rapid Rectilinear	Eastman Auto. Rotary	18
1901-1901	Goerz Anast. f6.8	Unicum	61
1901-1902	Rapid Rectilinear	Unicum	26
1901-1902	B&L Plastigmat f6.8	Unicum	58
1902-1905	Rapid Rectilinear f8	B&L Automatic	25
1902-1905	B&L Plastigmat No. 1	B&L Automatic	57
1902-1905	Goerz Anast. No. 0 Ser. III f6.8	B&L Automatic	61
1902-1906	Goerz Anast. No. 0 Ser. III f6.8	Volute	68
1903-1908	B&L Plastigmat No. 1 f6.8	Volute	64
1903-1908	Rapid Rectilinear f8	F.P.K. Automatic	18
1905-1906	Goerz Anast. No. 0 Ser. III f6.8	Kodak Automatic	61
1905-1908	B&L Plastigmat No. 1 f6.8	Kodak Automatic	57
1905-1914	Rapid Rectilinear f8	Kodak Automatic	25
1906-1909	B&L Zeiss Tessar Ser. IIb f6.3	B&L Volute	64
1907-1909	Cooke Anast. Ser. III f6.5	B&L Volute	65
1908-1908	Beck Isostigmar f6.3	B&L Automatic	38
1908-1908	Beck Isostigmar f6.3	B&L Volute	52
1908-1908	B&L Plastigmat f6.8	Goerz X.L. Sector	64
1908-1908	B&L Zeiss Tessar Ser. IIb f6.3	Goerz X.L. Sector	64
1908-1908	Cooke Anast. Ser. III f6.5	Goerz X.L. Sector	65
1908-1908	Goerz Dagor f6.8	Goerz X.L. Sector	68

DATES	LENS	SHUTTER	PRICE
1908-1908	Goerz Dagor f6.8	B&L Volute	68
1908-1909	Goerz Dagor f6.8	B&L Compound	65
1908-1912	B&L Zeiss Tessar Ser. IIb f6.3	B&L Compound	61
1909-1909	Zeiss Kodak Anast. f6.3	B&L Volute	54
1909-1910	Cooke Anast. Ser. IIIa f6.5	B&L Automatic	56
1909-1910	B&L Zeiss Tessar Ser. IIb f6.3	B&L Automatic	56
1909-1910	Zeiss Kodak Anast. f6.3	B&L Automatic	43
1909-1912	Zeiss Kodak Anast. f6.3	B&L Compound	49
1909-1912	Zeiss Kodak Anast. f6.3	Kodak Automatic	43
1909-1912	B&L Zeiss Tessar Ser. IIb f6.3	Kodak Automatic	56
1909-1912	Cooke Anast. Ser. IIIa f6.5	B&L Compound	62
1909-1912	Cooke Anast. Ser. IIIa f6.5	Kodak Automatic	56
1909-1914	Rapid Rectilinear	Kodak Ball Bearing	18
1914-1915	Kodak Anast. f8	Kodak Ball Bearing	

NO. 3 FOLDING POCKET KODAK DELUXE CAMERA

CHARACTERISTICS: Persian Morocco covering, brown silk bellows, solid silver nameplate. **LENS:** B&L Plastigmat f6.8. **SHUTTER:** B&L Automatic. **FILM SIZE:** 118. **IMAGE:** 3¼x4¼ in. **BODY:** 1-5/8x4½x7½ in. **WEIGHT:** 23 oz. **DATES:** 1901-1903. **PRICE:** $75.

NO. 0 FOLDING POCKET KODAK CAMERA

CHARACTERISTICS: Strut-type folding camera. **LENS:** Meniscus. **SHUTTER:** Automatic (built-in). **FILM SIZE:** 121 (introduced in 1902 for this camera). **FILM TYPE:** rollfilm. **IMAGE:** 1-5/8x2½ in. **BODY:** 1-3/8x3-1/8x5-5/8 in. **WEIGHT:** 12 oz. **DATES:** 1902-1906. **PRICE:** $6.

Available in two models: Model A and Model AB.

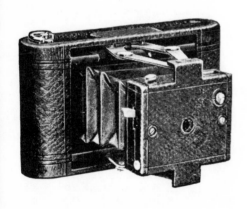 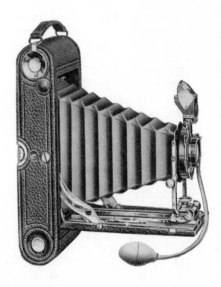

Left: No. 0 Folding Pocket Kodak camera
Right: No. 3A Folding Pocket Kodak camera

NO. 3A FOLDING POCKET KODAK CAMERA

IDENTIFICATION: "No. 3A Folding Pocket Kodak" inside back. **CHARACTERISTICS:** Vertically styled folding rollfilm camera. Removable back with two side catches. **LENS:** $6\frac{1}{2}$ in (see variations below). **SHUTTER:** (see variations below). **FILM SIZE:** 122 (introduced in 1903 for this camera). **IMAGE:** $3\frac{1}{4}$x$5\frac{1}{2}$ in. **BODY:** 1-7/8x4-3/4x$9\frac{1}{2}$ in. **WEIGHT:** 41 oz. loaded. **DATES:** 1903-1915. **PRICE:** \$20-78.

With the introduction of the Autographic feature in 1914, the 3A F.P.K. Camera was changed to become the 3A Autographic Kodak Camera. This change took place from September 1914 to April 1915, with different variations of this camera changing over to Autographic at different times. However, even after the introduction of the Autographic back, the cameras were still identified on the camera as "No. 3A Folding Pocket Kodak Model C" and not as "Autographic Kodak". This leads to much confusion over the names and dates of these cameras. Models available were: B, B-2, B-3, B-4, B-5, C, G.

DATES	LENS	SHUTTER	PRICE
1903-1904	Rapid Rectilinear	B&L Automatic	28
1903-1904	B&L Plastigmat No. 2 f6.8	B&L Automatic	65
1903-1904	Goerz Anast. No. 1 Ser. III f6.8	B&L Automatic	70
1903-1906	Goerz Anast. No. 1 Ser. III f6.8	Volute	77
1903-1908	Rapid Rectilinear f8	F.P.K. Automatic	20
1903-1908	B&L Plastigmat No. 2 f6.8	Volute	72
1905-1906	Goerz Anast. No. 1 Ser. III f6.8	Kodak Automatic	70
1905-1908	B&L Plastigmat No. 2 f6.8	Kodak Automatic	65
1905-1914	Rapid Rectilinear f8	Kodak Automatic	28
1906-1909	B&L Zeiss Tessar Ser. IIb f6.3	Volute	78
1907-1909	Cooke Anast. Ser. III f6.5	Volute	72
1908-1908	Beck Isostigmar f6.3	B&L Automatic	46
1908-1908	Beck Isostigmar f6.3	Volute	61
1908-1908	B&L Plastigmat f6.8	X.L. Sector	72
1908-1908	B&L Zeiss Tessar Ser. IIb f6.3	X.L. Sector	78
1908-1908	Cooke Anast. Ser. III f6.5	X.L. Sector	72
1908-1908	Goerz Dagor f6.8	X.L. Sector	77
1908-1908	Goerz Dagor f6.8	Volute	77
1908-1908	Goerz Dagor f6.8	B&L Compound	75
1908-1912	Zeiss Kodak Anast. f6.3	B&L Compound	61
1908-1912	B&L Zeiss Tessar Ser. IIb f6.3	B&L Compound	77
1909-1909	Zeiss Kodak Anast. f6.3	Volute	64
1909-1910	Cooke Anast. Ser. IIIa f6.5	B&L Automatic	63
1909-1912	Cooke Anast. Ser. IIIa f6.5	B&L Compound	70
1909-1912	Cooke Anast. Ser. IIIa f6.5	Kodak Automatic	63
1909-1914	Rapid Rectilinear	Kodak Ball Bearing	20
1914-1915	Kodak Anast. f8	Kodak Automatic	30
1914-1915	Kodak Anast. f8	Kodak Ball Bearing	25

NO. 4A FOLDING KODAK CAMERA

IDENTIFICATION: "No. 4A Folding Kodak" inside back. **CHARACTERISTICS:** Very large folding rollfilm camera. **LENS:** $8\frac{1}{2}$ in (see variations below). **SHUTTER:** (see variations below). **FILM SIZE:** 126 (introduced in 1906 for this camera). **IMAGE:** $4\frac{1}{4}$x$6\frac{1}{2}$ in. **BODY:**

2-5/8x6½x11 in. **WEIGHT:** 4 lb. 4 oz. **DATES:** 1906-1915. **PRICE:** $35-110.

The original model had a wooden front. This was changed to a metal front on the Model B. The 4A size used 126 rollfilm which was introduced for this camera and later also used by the No. 4A Speed Kodak Camera. This camera was not available in the autographic style, but a retrofit autographic back was available in 1915 and was marked "4-A Autographic Kodak" on the outside and "No. 4A Folding Kodak" inside.

DATES	LENS	SHUTTER	PRICE
1906-1909	B&L Zeiss Tessar Ser. IIb f6.3	Volute	107
1906-1906	Goerz Anast. f6.8	Kodak Automatic	94
1906-1906	Goerz Anast. f6.8	Volute	103
1906-1915	Rapid Rectilinear f8	B&L Automatic	35
1907-1907	B&L Plastigmat No. 3 f6.8	B&L Automatic	79
1907-1907	B&L Plastigmat No. 3 f6.8	Volute	95
1907-1909	Cooke Anast. Ser. III f6.5	Volute	100
1908-1908	Beck Isostigmar f6.3	B&L Automatic	71
1908-1908	Beck Isostigmar f6.3	Volute	87
1908-1908	B&L Zeiss Tessar f6.3	X.L. Sector	107
1908-1908	Cooke Anast. Ser. III f6.5	X.L. Sector	100
1908-1908	Goerz Dagor f6.8	X.L. Sector	110
1908-1908	Goerz Dagor f6.8	Volute	110
1909-1909	Zeiss Kodak Anast. f6.3	Volute	86
1909-1912	B&L Zeiss Tessar Ser. IIb f6.3	B&L Compound	105
1909-1912	B&L Zeiss Tessar Ser. IIb f6.3	B&L Automatic	94
1909-1912	Cooke Anast. Ser. IIIa f6.5	B&L Compound	96
1909-1912	Cooke Anast. Ser. IIIa f6.5	B&L Automatic	86
1909-1915	Zeiss Kodak Anast. f6.3	B&L Automatic	73
1909-1915	Zeiss Kodak Anast. f6.3	B&L Compound	83

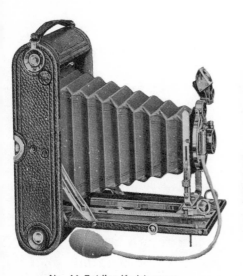

No. 4A Folding Kodak camera

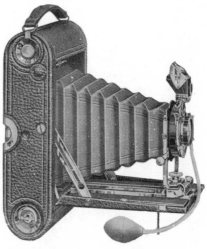

No. 4 Folding Pocket Kodak camera

NO. 4 FOLDING POCKET KODAK CAMERA

IDENTIFICATION: "No. 4 Folding Pocket Kodak" in film chamber and inside back. **CHARACTERISTICS:** Large vertically styled folding bed rollfilm camera. **LENS:** 6½ in (see variations below). **SHUTTER:** (see variations below). **FILM SIZE:** 123. **IMAGE:** 4x5 in. **BODY:** 2¼x5-3/4x9 in. **WEIGHT:** 2 lb. 11 oz. **DATES:** 1907-1915. **PRICE:** $20-83. (illus. previous page)

The No. 4 Folding Pocket Kodak Camera was discontinued in 1915 at the same time that the other F.P.K. models were becoming "Autographic Kodak" Cameras. (A retrofit back was available for this camera in 1915.) The No. 4 size was discontinued completely and never re-appeared. By this time, the 3A "Postcard size" was much more popular than the 4x5 in. format. This was the last Kodak camera made for 123 rollfilm, which had been introduced in 1904 for the No. 4 Screen Focus Kodak Camera.

DATES	LENS	SHUTTER	PRICE
1907-1908	Rapid Rectilinear	F.P.K. Automatic	20
1907-1908	B&L Plastigmat No. 2 f6.8	Volute	72
1907-1909	B&L Zeiss Tessar Ser. IIb f6.3	Volute	78
1907-1909	B&L Plastigmat No. 2 f6.8	Kodak Automatic	58
1907-1909	Cooke Anast. Ser. III f6.5	Volute	72
1907-1914	Rapid Rectilinear f8	Kodak Automatic	25
1908-1908	Beck Isostigmar f6.3	B&L Automatic	44
1908-1908	Beck Isostigmar f6.3	Volute	61
1908-1908	B&L Plastigmat f6.8	X.L. Sector	72
1908-1908	B&L Zeiss Tessar Ser. IIb f6.3	X.L. Sector	78
1908-1908	Cooke Anast. Ser. III f6.3	X.L. Sector	72
1908-1908	Goerz Dagor f6.8	X.L. Sector	77
1908-1908	Goerz Dagor f6.8	Volute	77
1908-1908	Goerz Dagor f6.8	B&L Compound	75
1908-1912	B&L Zeiss Tessar Ser. IIb f6.3	B&L Compound	77
1909-1909	Zeiss Kodak Anast. f6.3	Volute	64
1909-1910	Cooke Anast. Ser. III f6.5	B&L Automatic	63
1909-1912	Cooke Anast. Ser. IIIa f6.5	B&L Compound	70
1909-1912	Cooke Anast. Ser. IIIa f6.5	Kodak Automatic	63
1909-1915	Rapid Rectilinear f8	Kodak Ball Bearing	20

NO. 3 ZENITH KODAK CAMERA

CHARACTERISTICS: Like the Eureka cameras but in the 3¼x4¼ in. size. For plates only. **SHUTTER:** Rotary. **FILM TYPE:** plates. **IMAGE:** 3¼x4¼ in. **DATES:** 1898-1899. Made in England.

NO. 2 EUREKA CAMERA

CHARACTERISTICS: Box camera for glass plates in standard double plateholders which insert through side-opening. Internal storage space for additional holders. **LENS:** Achromatic. **SHUTTER:** Rotary. **FILM SIZE:** 106 (with optional rollholder). **FILM TYPE:** plates or optional rollholder. **IMAGE:** 3½x3½ in. **DATES:** 1898-1899. **PRICE:** $4.

The 106 rollfilm was introduced in 1898 for this camera.

NO. 2 EUREKA JUNIOR CAMERA

CHARACTERISTICS: Similar to No. 2 Eureka Camera but for plates only. **LENS:** Achromatic. **SHUTTER:** Rotary. **FILM TYPE:** plates. **IMAGE:** 3½x3½ in. **DATES:** 1898-1899. **PRICE:** $2.50.

NO. 4 EUREKA CAMERA

CHARACTERISTICS: Like No. 2 Eureka Camera, but larger size for 4x5 in. plates. **LENS:** Achromatic. **SHUTTER:** Rotary. **FILM SIZE:** 109 (introduced in 1899 for this camera). **FILM TYPE:** plates (optional rollholder). **IMAGE:** 4x5 in. **DATES:** 1899-1899. **PRICE:** $6.

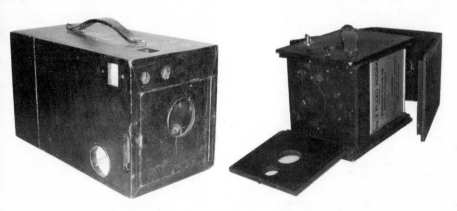

No. 4 Eureka camera No. 2 Flexo Kodak camera

NO. 2 FLEXO KODAK CAMERA

IDENTIFICATION: Identified on the strap. **CHARACTERISTICS:** Box camera, similar to Bull's-Eye. Sides and back are removable for film loading and are held together only by the leather covering which also serves as a hinge. **LENS:** Single Achromatic fixed focus 4½ in. **SHUTTER:** Eastman Rotary. **FILM SIZE:** 101. **FILM TYPE:** rollfilm (12 exp.). **IMAGE:** 3½x3½ in. **BODY:** 4-3/8x4-5/8x5-7/8 in. **WEIGHT:** 19 oz. **DATES:** 1899-1913. **PRICE:** $5.

The Flexo Kodak Camera is very similar to the No. 2 Bull's-Eye Camera in outward appearance. Opening the camera to load the film shows the major difference. To open the Flexo camera, a small catch in the viewfinder lens opening releases the front. The sides and back which are held together only by the leather covering, may then be removed from the camera. The Flexo replaced the No. 2 Falcon Camera in December 1899 and remained the lower-priced alternative to the Bull's-Eye Camera until they were both discontinued in 1913. In foreign markets, the Flexo was called "Plico".

THE PANORAM KODAK CAMERAS

Wide-angle and panoramic cameras have always had a certain amount of popularity, and many earlier designs had appeared on the market. Successful panoramas were made as early as 1845 by Frederic

37

Martens using a camera with curved daquerreotype plates and a clockwise-driven pivoting lens to cover an angle of 150 degrees. This same principle was used by Moessard's Cylindrographe of 1889. Eastman's contribution to panoramic photography was therefore not a new concept, but a simplification of existing technology. Martens' camera required a clockwork mechanism to move the lens slowly enough to expose a daguerreotype plate. Eastman's camera relied on a simple spring to pivot the lens for the more rapid rollfilm. Simplified design allowed low production cost, which in turn opened up a wider market. In 1902, the Panoram Kodak cameras were further simplified by using Meniscus lenses instead of the more expensive Rapid Rectilinear lenses. Again Eastman met with success by making a good idea into a simple, low-cost, easy-to-use camera. Various sizes were made, and they remained in production for 29 years.

NO. 4 PANORAM KODAK CAMERA (ORIGINAL MODEL)

CHARACTERISTICS: No hinged lens cover nor brilliant finder. Single speed shutter. **LENS:** Rapid Rectilinear f10/5 in. **SHUTTER:** Panoram (pivoting lens and light channel). **FILM SIZE:** 103. **FILM TYPE:** rollfilm (5 exposures). **IMAGE:** $3\frac{1}{2}$x12 in. **BODY:** 4-3/4x5$\frac{1}{2}$x10-1/8 in. **WEIGHT:** 46 oz. **DATES:** 1899-1900. **PRICE:** $20.

The No. 4 size covers an angle of 142 degrees.

NO. 4 PANORAM KODAK CAMERA MODELS B, C, AND D

CHARACTERISTICS: Similar to the original model, but with a hinged lens cover, brilliant finder, and two speed shutter. Name and model printed inside camera. **LENS:** Rapid Rectilinear (1900-1901) or Meniscus (1902-1924). **SHUTTER:** Panoram (pivoting lens with light channel). **FILM SIZE:** 103. **FILM TYPE:** rollfilm. **IMAGE:** $3\frac{1}{2}$x12 in. **BODY:** 4-3/4x5$\frac{1}{2}$x10-1/8 in. **WEIGHT:** 46 oz. **DATES:** 1900-1924. **PRICE:** $20.

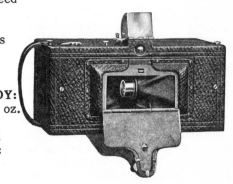

No. 4 Panoram Kodak Camera continued essentially unchanged as: Model C (1903-1907), Model D (1907-1914), and Model D with 6-18-14 patent (1914-1924).

NO. 1 PANORAM KODAK CAMERA

LENS: Rapid Rectilinear (1900-1901) or Meniscus (1902-1926). **SHUTTER:** Panoram (pivoting lens with light channel). **FILM SIZE:** 105. **FILM TYPE:** rollfilm (6 exposures). **IMAGE:** $2\frac{1}{4}$x7 in. **BODY:** 3-3/8x4$\frac{1}{4}$x7-3/8 in. **WEIGHT:** 24 oz. **DATES:** 1900-1926. **PRICE:** $10.

The No. 1 Panoram Kodak Camera made its debut in 1900, the year after the No. 4 was introduced. Although it followed the same basic pattern as the No. 4, this new model covered an angle of only 112 degrees rather than 142 degrees. Despite the narrower coverage, the No. 1 size remained popular because it could be purchased for half

the price of the larger model, and was more compact. The No. 1 Panoram Kodak Camera continued essentially unchanged (except for change to Meniscus lens in 1902) as: Model B (1901-1903), Model C (1903-1907), Model D (1907-1914), and Model D with 6-18-14 patent (1914-1926).

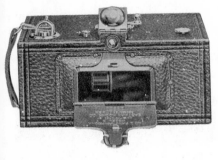 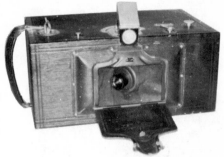

No. 1 Panoram Kodak camera No. 3A Panoram Kodak camera

NO. 3A PANORAM KODAK CAMERA

IDENTIFICATION: "3A Panoram Kodak" on inside of hinged lens cover. **LENS:** Meniscus. **SHUTTER:** Panoram (pivoting lens with light channel). **FILM SIZE:** A122. **FILM TYPE:** rollfilm (5 exposures). **IMAGE:** 3¼x10-3/8 in. **BODY:** 5¼x6¼x10½ in. **WEIGHT:** 3 lb. 14 oz. **DATES:** 1926-1928. **PRICE:** $40.

The larger No. 4 Panoram Kodak Camera was discontinued in 1924 and only the smaller No. 1 was offered in 1925. In 1926, this new size was offered which took the popular 122 "postcard size" rollfilm. The No. 3A Panoram Kodak Camera was the last of the series, and was like the others in design but covering an angle of 120 degrees. It remained in production only until 1928.

BROWNIE CAMERAS

With the new century rapidly approaching, photography and George Eastman's products had grown together. As photography increased in popularity, film sales increased, and Eastman's profits grew. Now in an attempt to further popularize photography, Eastman wanted a camera at the lowest possible price, realizing that the ultimate profit from film sales was a more important consideration than the profits from the camera sales.

Frank Brownell, Eastman's camera designer, produced the extremely simple Brownie box camera. Constructed of cardboard with a simple rotary shutter, it cost only $1.00 and was promoted as a camera for children. The name Brownie was a product of the times. Children delighted in the little elf-like characters created by Palmer Cox for the popular childrens' books and magazines. The association of the Brownie name and the colorful package were a great attraction for the young people of 1900 and the new camera sold so well that it started a new trend in low-cost cameras.

THE BROWNIE CAMERA

CHARACTERISTICS: Back removes like shoe-box cover. Detachable accessory waist-level finder. **LENS:** Meniscus. **SHUTTER:** Rotary. **FILM SIZE:** 117 (introduced in 1900 for this camera). **IMAGE:** $2\frac{1}{4}$x$2\frac{1}{4}$ in. **BODY:** 3x3-1/8x5 in. **WEIGHT:** 8 oz. **DATES:** 1900-1900. **PRICE:** $1.

Note: The same name, "The Brownie Camera" reappeared in 1981 on a totally new plastic camera made by Kodak Ltd. in England.

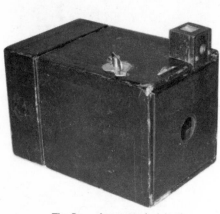

The Brownie camera (original) No. 1 Brownie camera

NO. 1 BROWNIE CAMERA
CHARACTERISTICS: Similar to original model but with hinged back. Detachable accessory finder. Sighting lines on top in shape of "X". **LENS:** Meniscus. **SHUTTER:** Rotary. **FILM SIZE:** 117. **IMAGE:** $2\frac{1}{4}$x$2\frac{1}{4}$ in. **BODY:** 3x3-1/8x4-7/8 in. **WEIGHT:** 8 oz. **DATES:** 1900-1915. **PRICE:** $1.

NO. 2 BROWNIE CAMERA
IDENTIFICATION: Model name and letter on hinged pressure plate. **CHARACTERISTICS:** Box camera with cardboard body. **LENS:** Meniscus. **SHUTTER:** Rotary. **FILM SIZE:** 120 (introduced in 1901 for this camera). **IMAGE:** $2\frac{1}{4}$x$3\frac{1}{4}$ in. **BODY:** $3\frac{1}{4}$x4x5-5/8 in. **WEIGHT:** 13 oz. **DATES:** 1901-1924. **PRICE:** $2.

Model identification is on the hinged pressure plate. Variations: Model B, Model C - Oval red window. Flat blades on winding key. Model D - Round red window. Round rod on winding key. ca. 1921- Metal guard around shutter lever. (illus. on next page)

NO. 2 BROWNIE CAMERA (ALUMINUM) MODEL F
IDENTIFICATION: Model name printed inside back. **CHARACTERISTICS:** Aluminum body covered with imitation leather. Removable back 1924-1925. Hinged back 1927-1933. **LENS:** Meniscus. **SHUTTER:** Rotary. **FILM SIZE:** 120. **IMAGE:** $2\frac{1}{4}$x$3\frac{1}{4}$ in. **BODY:** 3x4x5-7/16 in. **WEIGHT:** $16\frac{1}{2}$ oz. **DATES:** 1924-1933. **PRICE:** $2.75. Replaced by Six-20 Brownie Camera (1933-1941). (illus. on next page)

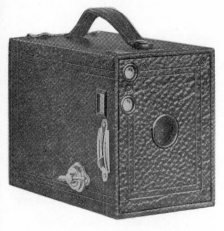

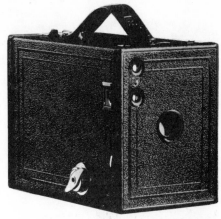

No. 2 Brownie camera No. 2 Brownie camera, Model F

NO. 2 BROWNIE CAMERA (COLORS)

CHARACTERISTICS: Available in blue, brown, gray, green, or red. Matching cases also available. **LENS:** Meniscus. **SHUTTER:** Rotary. **FILM SIZE:** 120. **IMAGE:** $2\frac{1}{4}$x$3\frac{1}{4}$ in. **BODY:** 3x4x5-7/16 in. **WEIGHT:** $16\frac{1}{2}$ oz. **DATES:** 1929-1933. **PRICE:** $3.

NO. 2 STEREO KODAK CAMERA

CHARACTERISTICS: Kodak's only stereo box camera. Resembles the Bull's-Eye Camera, but for stereo photos. **LENS:** Rapid Rectilinear 4-3/4 in. **SHUTTER:** Special (modified form of Eastman Automatic shutter). **FILM SIZE:** 101. **IMAGE:** $3\frac{1}{2}$x6 in. **BODY:** 4-3/4x6x8-1/8 in. **WEIGHT:** 35 oz. **DATES:** 1901-1905. **PRICE:** $15.

NO. 4 SCREEN FOCUS KODAK CAMERA

LENS: $6\frac{1}{2}$ in. (see variations below). **SHUTTER:** (see variations below). **FILM SIZE:** 123 (12 exposures). The 123 rollfilm was introduced in 1904 for this camera. **IMAGE:** 4x5 in. **BODY:** 3-1/8x5-3/4x10 in. **WEIGHT:** 3 lb. 14 oz. **DATES:** 1904-1910. **PRICE:** $30-88.

The unique feature of this camera is that it allows for rack and pinion focusing on a ground glass back without removing the rollfilm from the camera. The rollfilm holder stores a dark slide and a ground glass for ready availability if the photographer wishes to focus or compose on a ground glass, yet the conveniences of rollfilm are

41

retained. A glass plate adapter was available as an option.

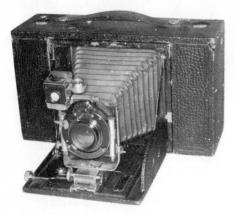

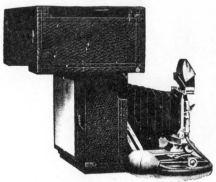

No. 4 Screen Focus Kodak camera

DATES	LENS	SHUTTER	PRICE
1904-1905	B&L Plastigmat No. 2 f6.8	B&L Automatic	73
1904-1905	Goerz Anast. No. 1 Ser. III f6.8	B&L Automatic	78
1904-1906	Goerz Anast. No. 1 Ser. III f6.8	Kodak Automatic	73
1904-1906	Goerz Anast. No. 1 Ser. III f6.8	Volute	87
1904-1908	B&L Plastigmat No. 2 f6.8	Kodak Automatic	68
1904-1908	B&L Plastigmat No. 2 f6.8	Volute	82
1904-1909	Rapid Rectilinear	Kodak Automatic	30
1906-1909	B&L Zeiss Tessar Ser. IIb f6.3	Volute	88
1907-1909	Cooke Anast. Ser. III f6.5	Volute	82
1908-1908	Beck Isostigmar f6.3	Volute	71
1908-1908	Beck Isostigmar f6.3	B&L Automatic	56
1908-1909	B&L Zeiss Tessar f6.3	B&L Compound	86
1908-1908	Goerz Dagor f6.8	Volute	87
1908-1909	Goerz Dagor f6.8	B&L Compound	85
1909-1909	Zeiss Kodak Anast. f6.3	Volute	72
1909-1909	Cooke Anast. Ser. IIIa f6.5	Kodak Automatic	68

NO. 2 FOLDING BROWNIE CAMERA

CHARACTERISTICS: Horizontally styled folding camera with wooden body covered with imitation leather. Wooden lensboard. **LENS:** Meniscus Achromatic. **SHUTTER:** (see variations below). **FILM SIZE:** 120. **IMAGE:** $2\frac{1}{4}$x$3\frac{1}{4}$ in. **BODY:** 2-1/8x3-5/8x6-7/8 in. **WEIGHT:** 16 oz. **DATES:** 1904-1907. **PRICE:** $5.

Replaced by No. 2 Folding Pocket Brownie Camera in 1907.

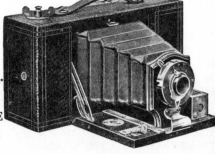

DATES	SHUTTER	PRICE
1904-1905	Brownie Automatic	5
1906-1907	Pocket Automatic	5

NO. 2 FOLDING POCKET BROWNIE CAMERA (MODEL B)

CHARACTERISTICS: Horizontally styled folding camera. Metal lensboard. **LENS:** Meniscus Achromatic. **SHUTTER:** Pocket Automatic. **FILM SIZE:** 120. **IMAGE:** 2¼x3¼ in. **BODY:** 2-1/8x3-5/8x6-7/8 in. **WEIGHT:** 16 oz. **DATES:** 1907-1915. **PRICE:** $5.

Replaced the No. 2 Folding Brownie Camera (1904-1907). Continued as No. 2 Folding Autographic Brownie Camera (1915-1926).

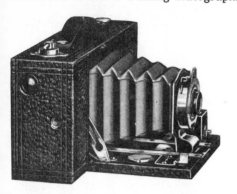 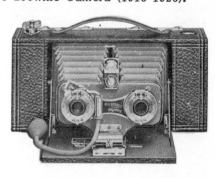

Left: No. 2 Foiding Pocket Brownie camera, Mod. B
Above: No. 2 Stereo Brownie camera

NO. 2 STEREO BROWNIE CAMERA

IDENTIFICATION: "No. 2 Stereo Brownie" on lensboard and inside back. **CHARACTERISTICS:** Folding-bed stereo camera. **LENS:** Meniscus Achromatic. **SHUTTER:** (see variations below). **FILM SIZE:** 125 (introduced in 1905 for this camera). **IMAGE:** 3¼x2½ in. **BODY:** 2½x4½x9-3/4 in. **WEIGHT:** 29 oz. **DATES:** 1905-1910. **PRICE:** $12.

DATES	LENS	SHUTTER	PRICE
1905-1905	Meniscus Achromatic	Brownie Automatic	12
1906-1910	Meniscus Achromatic	Pocket Automatic	12

NO. 3 FOLDING BROWNIE CAMERA

IDENTIFICATION: Identified inside back. Models include A and B. **LENS:** (see variations below). **SHUTTER:** (see variations below). **FILM SIZE:** 124 (introduced in 1905 for this camera). **IMAGE:** 3¼x4¼ in. **BODY:** 2-5/8x4-5/8x8-3/8 in. **WEIGHT:** 25 oz. **DATES:** 1905-1915. **PRICE:** $9-11.

Through 1909, wooden lensboard and F.P.K. Automatic shutter is without a pneumatic release. Metal lensboard and pneumatic release on the shutter began in 1910.

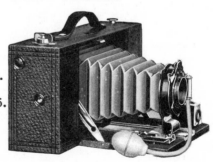

DATES	LENS	SHUTTER	PRICE
1905-1913	Meniscus Achromatic	F.P.K. Automatic	9
1909-1913	Rapid Rectilinear	F.P.K. Automatic	11

DATES	LENS	SHUTTER	PRICE
1913-1915	Meniscus Achromatic	Brownie Ball Bearing	9
1913-1915	Rapid Rectilinear	Brownie Ball Bearing	11

NO. 3B QUICK FOCUS KODAK CAMERA

CHARACTERISTICS: Focus can be pre-set and camera front pops out to correct position at the touch of a button. **LENS:** Meniscus Achromatic 6½ in. **SHUTTER:** Eastman Rotary. **FILM SIZE:** 125. **IMAGE:** 3¼x5½ in. **BODY:** 4-5/8x6-7/8x8-1/8 in. **WEIGHT:** 2 lb. 9 oz. **DATES:** 1906-1911. **PRICE:** $12. Models A, B, and C.

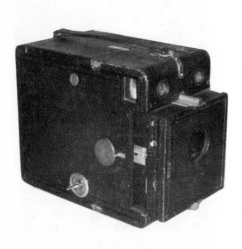

No. 3B Quick Focus Kodak camera No. 2A Brownie camera

NO. 2A BROWNIE CAMERA

IDENTIFICATION: Name and model letter stamped inside. **CHARACTERISTICS:** Box camera of cardboard construction. **LENS:** Meniscus. **SHUTTER:** Rotary. **FILM SIZE:** 116. **IMAGE:** 2½x4¼ in. **BODY:** 3½x5-1/8x6-1/8 in. **WEIGHT:** 21 oz. **DATES:** 1907-1924. **PRICE:** $3.
Model (A)- "No. 2A Brownie" stamped inside with no model letter. Model B- "No. 2A Brownie Model B" stamped on metal inside. Model C- "No. 2A Brownie Model C" inside back.

NO. 2A BROWNIE CAMERA (ALUMINUM)

CHARACTERISTICS: Removable back to 1927. Hinged back 1927 on. **LENS:** Meniscus. **SHUTTER:** Rotary. **FILM SIZE:** 116. **IMAGE:** 2½x4¼ in. **BODY:** 3¼x5x6 in. **WEIGHT:** 21½ oz. **DATES:** 1924-1933. **PRICE:** $3.75. Replaced by the Six-16 Brownie Camera (1933-1941).

NO. 2A BROWNIE CAMERA (COLORS)

CHARACTERISTICS: Available in blue, brown, gray, green or red. Matching cases also available. **LENS:** Meniscus. **SHUTTER:** Rotary. **FILM SIZE:** 116. **IMAGE:** 2½x4¼ in. **BODY:** 3¼x5x6 in. **WEIGHT:** 21½ oz. **DATES:** 1929-1933. **PRICE:** $4.

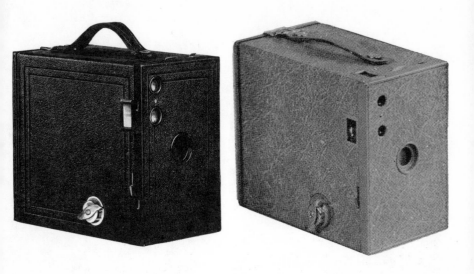

No. 2A Brownie cameras. Left: Aluminum Model C. Right: Colored model.

SPEED KODAK CAMERAS

Both the No. 4A and 1A Speed Kodak Cameras derive their name from the speed of their focal plane shutters. The more common use for focal plane shutters was in single lens reflex cameras where it was necessary to use a rear shutter. The added advantage of speeds to 1/1000 sec. had been a good selling point for the Graflex cameras made by the Folmer and Schwing Co. Eastman Kodak Co. acquired the Folmer and Schwing Co. and by 1908 it was the Folmer and Schwing Division of Eastman Kodak Company. With Folmer and Schwing, Eastman acquired patent rights to the Graflex shutter, which led to the development of the Speed Kodak cameras. They combine the advantages of the fast focal plane shutter with the convenience and compactness of a folding rollfilm camera. They paved the way for the Speed Graphic and were discontinued at approximately the same time that the Speed Graphic cameras were introduced.

NO. 4A SPEED KODAK CAMERA

CHARACTERISTICS: Large folding bed camera with focal plane shutter. Square body ends. **LENS:** (see variations below). **SHUTTER:** Kodak Focal Plane. **FILM SIZE:** 126. **IMAGE:** 4¼x6½ in. **BODY:** 3-7/16x6½x11-3/4 in. **WEIGHT:** 6 lb. **DATES:** 1908-1913. **PRICE:** $50-113. (illustrated on next page)

DATES	LENS	PRICE
1908-1908	Goerz Dagor f6.8	113
1908-1913	None	50
1908-1913	B&L Zeiss Tessar f6.3	110
1909-1913	Zeiss Kodak Anast. f6.3	90
1909-1913	Cooke Anast. Ser. IIIa f6.5	103

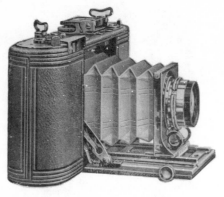

No. 1A Speed Kodak camera

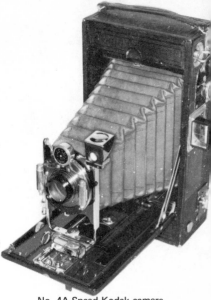

No. 4A Speed Kodak camera

NO. 1A SPEED KODAK CAMERA
IDENTIFICATION: "1A Speed Kodak" below lens. **CHARACTERISTICS:** Folding bed camera with focal plane shutter. Horizontal body style with rounded ends. **LENS:** (see variations below). **SHUTTER:** Graflex Focal Plane. **FILM SIZE:** 116. **IMAGE:** 2½x4¼ in. **BODY:** 2¼x4½x9-3/4 in. **WEIGHT:** 3 lbs. **DATES:** 1909-1913. (All lenses were available in all years.) **PRICE:** $38-79.

LENS	PRICE	LENS	PRICE
None	38		
Zeiss Kodak Anast. f6.3	60	Cooke Anast. Ser. IV f5.6	76
B&L Zeiss Tessar Ser.IIb f6.3	73	B&L Zeiss Tessar Ser. Ic f4.5	79

NO. 3 FLUSH BACK KODAK CAMERA
CHARACTERISTICS: Special version of the No. 3 Folding Pocket Kodak Camera for the European market. Recessed plate back takes single metal plateholder. **LENS:** B&L Rapid Rectilinear. **SHUTTER:** B&L Automatic. **FILM SIZE:** 118. **FILM TYPE:** rollfilm or plates. **IMAGE:** 3¼x4¼ in. **DATES:** 1908-1915. Not marketed in the U.S.A.

NO. 1A FOLDING POCKET KODAK SPECIAL CAMERA
CHARACTERISTICS: Bed-type camera. Not self-erecting. **LENS:** (see variations below). **SHUTTER:** (see variations below). **FILM SIZE:** 116. **FILM TYPE:** rollfilm. **IMAGE:** 2½x4¼ in. **BODY:** 2x3-3/4x8 in. **WEIGHT:** 23 oz. **DATES:** 1908-1912. **PRICE:** $15-62.

Continued as the No. 1A F.P.K., RR Type 1912-1915, then as the No. 1A Autographic Kodak Camera 1914-1924. This camera was re-named in 1912 to avoid confusion with the newly introduced No. 1A Kodak Special Camera.

46

DATES	LENS	SHUTTER	PRICE
1908-1908	B&L Isostigmar f6.3	B&L Automatic	35
1908-1908	B&L Plastigmat f6.8	Kodak Automatic	47
1908-1908	Goerz Dagor f6.8	Kodak Automatic	51
1908-1908	Goerz Dagor f6.8	B&L Automatic	51
1908-1908	Goerz Dagor f6.8	B&L Compound	62
1908-1909	Rapid Rectilinear f8	F.P.K. Automatic	15
1908-1910	B&L Zeiss Tessar Ser. IIb f6.3	B&L Automatic	47
1908-1912	B&L Zeiss Tessar Ser. IIb f6.3	B&L Compound	58
1909-1910	Cooke Anast. Ser. IIIa f6.5	B&L Automatic	54
1909-1910	Zeiss Kodak Anast. f6.3	B&L Automatic	41
1909-1912	Zeiss Kodak Anast. f6.3	Kodak Automatic	41
1909-1912	Zeiss Kodak Anast. f6.3	B&L Compound	46
1909-1912	B&L Zeiss Tessar Ser. IIb f6.3	Kodak Automatic	53
1909-1912	Cooke Anast. Ser. IIIa f6.5	B&L Compound	59
1909-1912	Cooke Anast. Ser. IIIa f6.5	Kodak Automatic	54
1910-1912	Rapid Rectilinear f8	Kodak Ball Bearing	15

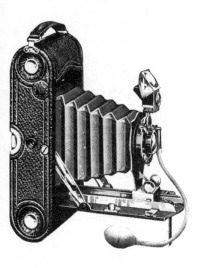

No. 1A Folding Pocket Kodak Special camera.

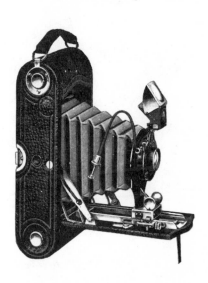

No. 1A F.P.K. camera, R.R. Type

NO. 1A FOLDING POCKET KODAK CAMERA RR TYPE

IDENTIFICATION: "No. 1A Folding Pocket Kodak" inside back. **CHARACTERISTICS:** Flat front door, unlike earlier Folding Pocket Kodak Cameras. Front not self-erecting. Some are marked "R.R. lens type" inside back. **LENS:** 5 in (see variations below). **SHUTTER:** (see variations below). **FILM SIZE:** 116. **IMAGE:** 2½x4¼ in. **BODY:** 2x3-3/4x8 in. **WEIGHT:** 23 oz. **DATES:** 1912-1915. **PRICE:** $15-20.

Formerly called No. 1A F.P.K. Special Camera 1908-1912. Continued as No. 1A Autographic Kodak Camera 1914-1924.

DATES	LENS	SHUTTER	PRICE
1912-1913	Zeiss Kodak Anast. f6.3	B&L Compound	46
1912-1913	Zeiss Kodak Anast. f6.3	Kodak Automatic	41

DATES	LENS	SHUTTER	PRICE
1912–1913	B&L Zeiss Tessar Ser. IIb f6.3	B&L Compound	59
1912–1913	B&L Zeiss Tessar Ser. IIb f6.3	Kodak Automatic	53
1912–1913	Cooke Anast. Ser. IIIa f6.3	B&L Compound	59
1912–1913	Cooke Anast. Ser. IIIa f6.3	Kodak Automatic	54
1912–1914	Rapid Rectilinear f8	Kodak Ball Bearing	15
1913–1914	Rapid Rectilinear f8	Kodak Automatic	20
1914–1915	Kodak Anast. f8	Kodak Ball Bearing	

NO. 3 BROWNIE CAMERA

IDENTIFICATION: Model name stamped in metal inside body. **CHARACTERISTICS:** Box camera. Coarse-grained imitation leather covering before 1926. Pin-grain covering after 1926. **LENS:** Meniscus Achromatic. **SHUTTER:** Rotary. **FILM SIZE:** 124. **IMAGE:** 3¼x4¼ in. **BODY:** 4-3/8x5-1/8x6-1/8 in. **WEIGHT:** 24 oz. **DATES:** 1908–1934. **PRICE:** $4.

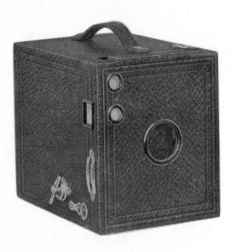 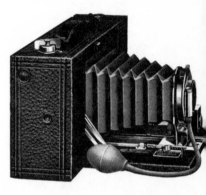

Left: No. 3 Brownie camera
Right: No. 3A Folding Brownie camera

NO. 3A FOLDING BROWNIE CAMERA

IDENTIFICATION: Identified inside back. **LENS:** Meniscus Achromatic and Rapid Rectilinear. **SHUTTER:** F.P.K. Automatic 1909–1913, Brownie Ball Bearing 1914–1915. **FILM SIZE:** 122. **IMAGE:** 3¼x5½ in. **BODY:** 2-5/8x4-5/8x9-7/8 in. **WEIGHT:** 34 oz. **DATES:** 1909–1915. **PRICE:** $10 with the Automatic. $12 with the Ball Bearing.
Replaced by the No. 3A Folding Autographic Brownie Camera (1916–1926).

NO. 2A FOLDING POCKET BROWNIE CAMERA

IDENTIFICATION: Identified inside back including model letter. **LENS:** Meniscus Achromatic. **SHUTTER:** Pocket Automatic. **FILM SIZE:** 116. **IMAGE:** 2½x4¼ in. **BODY:** 2x3-5/8x8½ in. **WEIGHT:** 23 oz. **DATES:** 1910–1915. **PRICE:** $7. (illus. next page.)
Replaced by the No. 2A Folding Autographic Brownie Camera (1915–1926).

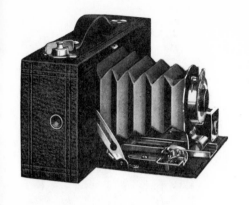
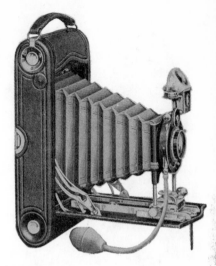

Above: No. 2A Folding
 Pocket Brownie camera.
Right: No. 3A Special Kodak camera.

NO. 3A SPECIAL KODAK CAMERA

LENS: 6½ in. (see variations below). **SHUTTER:** B&L Compound.
FILM SIZE: 122. **IMAGE:** 3¼x5½ in. **BODY:** 2x4-3/4x9½ in.
WEIGHT: 42 oz. **DATES:** 1910-1914. **PRICE:** $65-81.
 Continued as No. 3A Autographic Kodak Special Camera 1914-1934.

DATES	LENS	SHUTTER	PRICE
1910-1914	Zeiss Kodak Anast. f6.3	B&L Compound	65
1910-1914	B&L Zeiss Tessar Ser. IIb f6.3	B&L Compound	81
1910-1914	Cooke Anast. Ser. IIIa f6.5	B&L Compound	74

NO. 3 SPECIAL KODAK CAMERA

LENS: 5 in. (see variations below). **SHUTTER:** B&L Compound. **FILM
SIZE:** 118. **IMAGE:** 3¼x4¼ in. **BODY:** 1-7/8x4½x8 in. **WEIGHT:** 32
oz. **DATES:** 1911-1914. **PRICE:** $52-65. (illus next page)
 Continued as No. 3 Autographic Kodak Special Camera 1914-1934.

DATES	LENS	SHUTTER	PRICE
1911-1914	Zeiss Kodak Anast. f6.3	B&L Compound	52
1911-1914	B&L Zeiss Tessar Ser. IIb f6.3	B&L Compound	65
1911-1914	Cooke Anast. Ser. IIIa f6.5	B&L Compound	65

NO. 1A SPECIAL KODAK CAMERA

CHARACTERISTICS: Covered with morocco leather. Rising and
shifting front. **LENS:** 5 in. (see variations below). **SHUTTER:** B&L
Compound. **FILM SIZE:** 116. **IMAGE:** 2½x4¼ in. **BODY:** 2x3-3/4x8
in. **WEIGHT:** 30 oz. **DATES:** 1912-1914. **PRICE:** $50-63. (illus next page)
 Continued as No. 1A Autographic Kodak Special Camera 1914-1926.

DATES	LENS	SHUTTER	PRICE
1912-1914	Zeiss Kodak Anast. f6.3	B&L Compound	50
1912-1914	B&L Zeiss Tessar Ser. IIb f6.3	B&L Compound	63
1912-1914	Cooke Anast. Ser. IIIa f6.5	B&L Compound	63

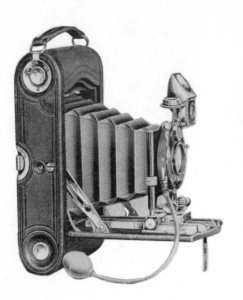

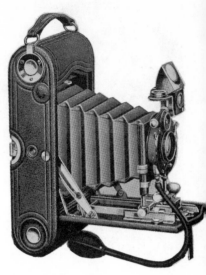

VEST POCKET KODAK CAMERAS

A new film size was introduced in 1912 for the Vest Pocket Kodak Camera, and it was numbered 127 (27th rollfilm size since Kodak began numbering with 101 in 1895). The new film was designed for eight 1-5/8x2½ in. exposures per roll. Later cameras used this film for twelve 1-5/8 in. square format exposures or sixteen half-frame photos 1-3/16x1-5/8 and the film is still manufactured today.

The vest pocket cameras made by Kodak and other manufacturers were quite popular during the World War because soldiers found them to be of a small enough size to be carried easily. Civilians, of course, enjoyed that same advantage.

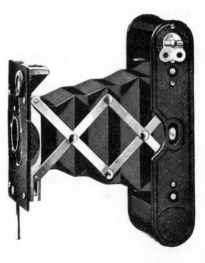

VEST POCKET KODAK
CAMERA

IDENTIFICATION: "Vest Pocket Kodak" on front or side of most models. **CHARACTERISTICS:** Side-loading type with trellis struts to support front. No bed. **LENS:** 3 in. (see variations below). **SHUTTER:** Kodak Ball Bearing. **FILM SIZE:** 127. **IMAGE:** 1-5/8x2½ in. **BODY:** 1x2-3/8x4-3/4 in.

WEIGHT: 9 oz. **DATES:** 1912-1914. **PRICE:** $6-12.

Continued as V.P. Autographic Kodak Camera 1915-1926. The Vest Pocket Kodak Camera was introduced 17 years after the original Pocket Kodak box camera and was the most widely popular camera since 1895.

DATES	LENS	PRICE
1912-1914	Meniscus Achromatic	6
1914-1914	Kodak Anast. f8	12

VEST POCKET KODAK SPECIAL CAMERA (EARLY TYPE)

CHARACTERISTICS: Like the Vest Pocket Kodak Camera, but with Zeiss Kodak Anast. lens. Side-loading type. Trellis struts and no bed. **LENS:** Zeiss Kodak Anast. f6.9. **SHUTTER:** Kodak Ball Bearing. **FILM SIZE:** 127. **IMAGE:** 1-5/8x2½ in. **BODY:** 1x2-3/8x4-3/4 in. **WEIGHT:** 9 oz. **DATES:** 1912-1914. **PRICE:** $25.

THE SIX-THREE KODAK CAMERAS

For the collector who is perfectly organized and orderly, this mini-series of cameras presents a minor problem. The name is logical enough, taken from the aperture of the Cooke Kodak Anast. lens which distinguishes these cameras from the other Folding Pocket Kodak cameras. These cameras are really just another lens and shutter variation of the Folding Pocket Kodak cameras in the 1A, 3, and 3A sizes, and we would list them as such, but the original catalogs listed them separately under the "Six-Three" heading, and the instruction book for the camera also used the "Six-Three" nomenclature. The problem is with the identification on the camera itself. Apparently the manufacturing department never used the "Six-Three" name at all, so all such cameras are still labeled as Folding Pocket Kodak cameras.

SIX-THREE KODAK NO. 1A CAMERA

CHARACTERISTICS: Same as No. 1A Folding Pocket Kodak Camera, but with f6.3 Cooke Kodak Anast. lens. **LENS:** Cooke Kodak Anast. f6.3. **SHUTTER:** B&L Compound with cable release. **FILM SIZE:** 116. **IMAGE:** 2½x4¼ in. **BODY:** 1-3/4x3-7/8x7-3/4 in. **WEIGHT:** 22 oz. **DATES:** 1913-1915. **PRICE:** $38.

Continued as a variation of the No. 1A Autographic Kodak Special Camera. This camera is identified as the "No. 1A Folding Pocket Kodak Camera" but the catalogs and instruction books called it a "Six-Three Kodak Camera".

SIX-THREE KODAK NO. 3 CAMERA

CHARACTERISTICS: Same as No. 3 Folding Pocket Kodak Camera, but with f6.3 Cooke Kodak Anast. lens. **LENS:** Cooke Kodak Anast. f6.3. **SHUTTER:** B&L Compound. **FILM SIZE:** 118. **IMAGE:** 3¼x4¼ in. **BODY:** 1-5/8x4½x7½ in. **WEIGHT:** 23 oz. **DATES:** 1913-1915. **PRICE:** $40.

Continued as a variation of the No. 3 Autographic Kodak Special Camera.

SIX-THREE KODAK NO. 3A CAMERA

CHARACTERISTICS: Same as No. 3A Folding Pocket Kodak Camera, but with f6.3 Cooke Kodak Anast. lens. **LENS:** Cooke Kodak Anast. f6.3. **SHUTTER:** B&L Compound. **FILM SIZE:** 122. **IMAGE:** 3¼x5½ in. **BODY:** 1-7/8x4-3/4x9½ in. **WEIGHT:** 41 oz. **DATES:** 1913-1915. **PRICE:** $50. Continued as a variation of the No. 3A Autographic Kodak Special Camera.

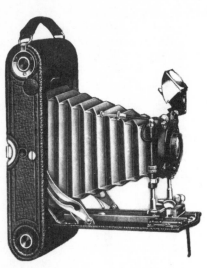 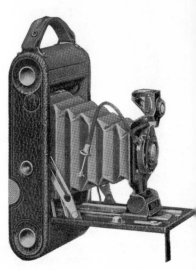

Six-Three Kodak No. 3A camera No. 1 Kodak Junior camera

NO. 1 KODAK JUNIOR CAMERA

IDENTIFICATION: "No. 1 Kodak Junior" below lens. **CHARACTER-ISTICS:** Kodak Junior Cameras are identifiable by the "J" shaped back with two side catches. **LENS:** 4¼ in. (see variations below). **SHUTTER:** Kodak Ball Bearing. **FILM SIZE:** 120. **IMAGE:** 2¼x3¼ in. **BODY:** 1-7/16x3-5/8x6-5/8 in. **WEIGHT:** 23 oz. **DATES:** 1914-1914. **PRICE:** $8-9.

Continued as No. 1 Autographic Kodak Jr. Camera 1914-1922.

DATES	LENS	SHUTTER	PRICE
1914-1914	Meniscus Achromatic	Kodak Ball Bearing	8
1914-1914	Rapid Rectilinear	Kodak Ball Bearing	9

NO. 1A KODAK JUNIOR CAMERA

IDENTIFICATION: "No. 1A Kodak Jr." below lens. **CHARACTER-ISTICS:** J-shaped removable back with 2 side catches. **LENS:** 5 in. (see variations below). **SHUTTER:** Kodak Ball Bearing. **FILM SIZE:** 116. **IMAGE:** 2½x4¼ in. **BODY:** 1-5/8x3-3/4x8 in. **WEIGHT:** 28 oz. **DATES:** 1914-1914. **PRICE:** $9-11. (illustrated on next page)

Continued as No. 1A Autographic Kodak Jr. Camera 1914-1922.

DATES	LENS	SHUTTER	PRICE
1914-1914	Meniscus Achromatic	Kodak Ball Bearing	9
1914-1914	Rapid Rectilinear	Kodak Ball Bearing	11

No. 1A Kodak Junior camera

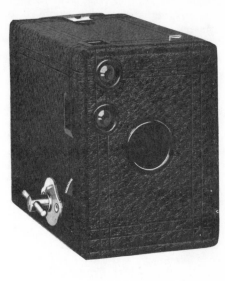

No. 0 Brownie camera

NO. 0 BROWNIE CAMERA

IDENTIFICATION: "No. 0 Brownie Camera" and model letter inside back. **CHARACTERISTICS:** Small box camera. **LENS:** Meniscus. **SHUTTER:** Rotary. **FILM SIZE:** 127. **IMAGE:** 1-5/8x2½ in. **BODY:** 2-5/8x3-3/8x4-1/8 in. **WEIGHT:** 8 oz. **DATES:** 1914-1935. **PRICE:** $1.25.

One early variation has strap sewn to sides of body. Imitation leather covering from coarse grain to pin grain ca. 1926.

AUTOGRAPHIC CAMERAS

In 1914, Kodak introduced a novel feature which was soon added to the majority of the Kodak cameras. The Autographic feature consisted of a small door on the back of the camera which could be opened to write on the film with a special stylus supplied with the camera. It could be used for signatures as the name suggests, but could also record dates, places, or other notes. Special Autographic films were made in the popular sizes and cameras were redesigned to use the new film. The film used a tissue between the film and backing paper which became transparent under pressure from a pen or stylus.

The popular Folding Pocket Kodak cameras soon became Autographic Kodak cameras, with various models changing at different times. This accounts for the apparent overlap of production dates of these two lines. The Autographic feature was a Kodak exclusive, with no other manufacturers making compatible cameras or films. This gave Kodak a marketing advantage. Autographic cameras could use regular or autographic films, but only with Kodak film could the Autographic feature

be used. Autographic films could be used in any camera, but only a Kodak camera had the door to allow use of the autographic feature.

Judging from the number of autographed photos found today relative to the number of autographic cameras, we must assume that the feature was not used regularily by all photographers. Despite this apparent indifference among some users, the idea of recording data on the negative was further expanded in later years on many special-purpose cameras which record the date, time, and other information on the edge of the negative. The autographic films were discontinued in 1934 when new higher speed panchromatic films were introduced which were too sensitive for this application.

Some of the earliest Autographic cameras were not identified below the lens, probably because Eastman was using up the old Folding Pocket Kodak camera bodies with the new Autographic backs.

NO. 1A AUTOGRAPHIC KODAK CAMERA

IDENTIFICATION: "1A Autographic Kodak" at base of lens standard.
LENS: 5 in. (see variations below). **SHUTTER:** (see variations below).
FILM SIZE: A116. **IMAGE:** 2½x4¼ in. **BODY:** 2x3-3/4x8 in.
WEIGHT: 26 oz. **DATES:** 1914-1916. **PRICE:** $18-40.

Formerly, the No. 1A F.P.K. Camera RR Type 1912-1915, and No. 1A F.P.K. Special Camera 1908-1912. Variation with the Cooke Kodak lens continued as a No. 1A Autographic Kodak Special Camera in 1915. (The Kodak Anast. f7.7 lens was originally announced in 1914 as f8.)

DATES	LENS	SHUTTER	PRICE
1914-1914	Cooke Kodak Anast. f6.3	B&L Compound	40
1914-1916	Rapid Rectilinear	Kodak Ball Bearing	18
1914-1916	Rapid Rectilinear	Kodak Automatic	23
1915-1916	Kodak Anast. f7.7	Kodak Ball Bearing	23

NO. 1A AUTOGRAPHIC KODAK CAMERA
(NEW MODEL OR 1917 MODEL)

IDENTIFICATION: "1A Autographic Kodak" below lens and/or inside back. **CHARACTERISTICS:** No rising front. Folding brilliant finder without hood. **LENS:** 5¼ in. Rapid Rectilinear or Kodak Anast. f7.7.
SHUTTER: Kodak Ball Bearing. **FILM SIZE:** A116. **IMAGE:** 2½x4¼ in. **BODY:** 1-5/8x3-3/4x8 in. **WEIGHT:** 27½ in. **DATES:** 1917-1924.
PRICE: $16 with RR. $21 with Kodak Anast. (illus. next page)

A continuation of the No. 1A Autographic Kodak Camera.

NO. 3 AUTOGRAPHIC KODAK CAMERA

LENS: (see variations below). **SHUTTER:** (see variations below).
FILM SIZE: A118. **IMAGE:** 3¼x4¼ in. **BODY:** 1-3/4x4½x7½ in.
WEIGHT: 23 oz. **DATES:** 1914-1926. **PRICE:** $20-42. (illus next page)

(The Kodak Anast. f7.7 lens was orignally announced in 1914 as f8.)

DATES	LENS	SHUTTER	PRICE
1914-1914	Cooke Kodak Anast. f6.3	B&L Compound	42
1914-1917	Rapid Rectilinear	Kodak Automatic	25
1914-1925	Rapid Rectilinear	Kodak Ball Bearing	20
1915-1925	Kodak Anast. f7.7	Kodak Ball Bearing	25
1925-1926	Kodak Anast. f7.7	Diomatic	28
1925-1926	Kodar f7.9	Kodex	20

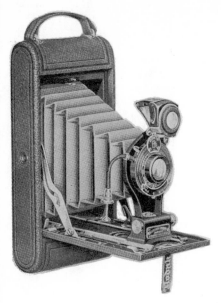
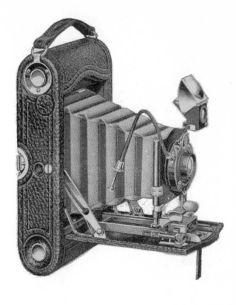

Left: No 1A Autographic Kodak camera, 1917 model.
Right: No. 3 Autographic Kodak camera.

NO. 3A AUTOGRAPHIC KODAK CAMERA

IDENTIFICATION: "No. 3A Autographic Kodak" and model designation below lens and/or inside back. **CHARACTERISTICS:** Early models through Model C (1920) have hood on finder. Later models after 1920 lack hood. **LENS:** (see variations below). **SHUTTER:** (see variations below). **FILM SIZE:** A122. **IMAGE:** 3¼x5½ in. **BODY:** 2x4-3/4x9½ in. **WEIGHT:** 41 oz. **DATES:** 1914-1934. **PRICE:** $23-51.

Formerly, the No. 3A F.P.K. Camera 1903-1915, and apparently some were manufactured through the 1920's with the "3A Folding Pocket Kodak Model C" designation. Officially, if they have a post-1914 patent date, they should be considered Autographic cameras. Cameras with pre-1914 patent dates, even if retrofitted with Autographic backs, should be considered Folding Pocket Kodak cameras. (The Kodak Anast. f7.7 lens was originally announced in 1914 as f8.)

DATES	LENS	SHUTTER	PRICE
1914-1914	Cooke Kodak Anast. f6.3	B&L Compound	51
1914-1917	Rapid Rectilinear	Kodak Automatic	28
1914-1924	Rapid Rectilinear	Kodak Ball Bearing	23
1915-1917	Kodak Anast. f7.7	Kodak Automatic	33
1915-1924	Kodak Anast. f7.7	Kodak Ball Bearing	28
1922-1923	Kodak Anast. f7.7	Ilex Universal	32
1924-1924	Kodak Anast. f7.7	Multiple Speed	32
1924-1926	Kodak Anast. f7.7	Diomatic	32
1925-1925	Rapid Rectilinear	Kodex	23
1925-1933	Kodar f7.9	Kodex	24
1926-1931	Kodak Anast. f6.3	Ilex Universal	30
1932-1934	Kodak Anast. f6.3	Multi-Speed	30

AUTOGRAPHIC KODAK SPECIAL CAMERAS

Not all Autographic Kodak Special Cameras have rangefinders:
No. 1 1915-1926 none have rangefinders.
No. 1A 1914-1916 no rangefinder. 1917-1926 with rangefinder.
No. 2C 1923-1928 all have rangefinders.
No. 3 1914-1924 none have rangefinders.
No. 3A 1914-1916 no rangefinder. 1917-1933 with rangefinder.

NO. 3A AUTOGRAPHIC KODAK SPECIAL CAMERA

CHARACTERISTICS: Similar to the No. 3A Autographic Kodak Camera, but has reversible finder with spirit level, rack and pinion focusing, and covered with Persian morocco leather. **LENS:** 6-3/4 in. (see variations below). **SHUTTER:** B&L Compound. **FILM SIZE:** A122. **IMAGE:** $3\frac{1}{4}$x$5\frac{1}{2}$ in. **BODY:** 2x4-3/4x9$\frac{1}{2}$ in. **WEIGHT:** 42 oz. **DATES:** 1914-1916. **PRICE:** $46-74.

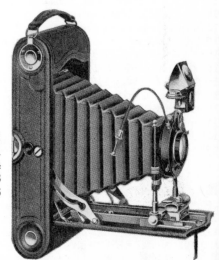

DATES	LENS	PRICE
1914-15	Cooke Ser. IIIa f6.5	71
1914-15	B&L Zeiss Tessar f6.3	74
1914-16	Zeiss Kodak Anast. f6.3	63
1915-15	Cooke Kodak Anast. f6.3	46

NO. 1A AUTOGRAPHIC KODAK SPECIAL CAMERA

CHARACTERISTICS: Like No. 1A Autographic Kodak Camera, but with better shutter and lens combinations. **LENS:** (see variations below). **SHUTTER:** (see variations below). **FILM SIZE:** A116. **IMAGE:** $2\frac{1}{2}$x$4\frac{1}{4}$ in. **BODY:** 2x3-3/4x8 in. **WEIGHT:** 30 oz. **DATES:** 1914-1916. **PRICE:** $40-60.

Formerly the No. 1A Special Kodak Camera 1912-1914. Continued

with a rangefinder 1917-1926.

DATES	LENS	SHUTTER	PRICE
1914-1915	Zeiss Kodak Anast. f6.3	B&L Compound	49
1914-1915	Cooke Ser. IIIa f6.5	B&L Compound	60
1914-1915	B&L Zeiss Tessar Ser. IIb f6.3	B&L Compound	60
1915-1915	Cooke Kodak Anast. f6.3	B&L Compound	40
1916-1916	Cooke Kodak Anast. f6.3	B&L Compur	40
1916-1916	B&L Kodak Anast. f6.3	B&L Compur	49
1916-1916	Kodak Anast. f6.3	B&L Compur	45
1916-1916	B&L Tessar Ser. IIb f6.3	B&L Compur	60

NO. 3 AUTOGRAPHIC KODAK SPECIAL CAMERA

CHARACTERISTICS: Not made in a rangefinder model as were the No. 1A, No. 2C, and No. 3A. Like the No. 3 Autographic Kodak Camera but has reversible finder with spirit level, rack and pinion focusing, and Persian morocco covering. **LENS:** (see variations below). **SHUTTER:** (see variations below). **FILM SIZE:** A118. **IMAGE:** $3\frac{1}{4}$x$4\frac{1}{4}$ in. **BODY:** 1-7/8x$4\frac{1}{2}$x8 in. **WEIGHT:** 32 oz. **DATES:** 1914-1926. **PRICE:** $42-86. (illustrated on next page)

DATES	LENS	SHUTTER	PRICE
1914-1915	Zeiss Kodak Anast. f6.3	B&L Compound	51
1914-1915	Cooke Ser. IIIa f6.5	B&L Compound	62
1914-1915	B&L Zeiss Tessar Ser. IIb f6.3	B&L Compound	62
1915-1915	Cooke Kodak Anast. f6.3	B&L Compound	42
1916-1916	Cooke Kodak Anast. f6.3	B&L Compur	42
1916-1916	B&L Kodak Anast. f6.3	B&L Compur	51
1916-1916	Kodak Anast. f6.3	B&L Compur	47
1916-1916	B&L Tessar Ser. IIb f6.3	B&L Compur	62
1917-1924	B&L Tessar Ser. IIb f6.3	Optimo	62
1917-1924	Kodak Anast. f6.3	Optimo	47
1917-1924	B&L Kodak Anast. f6.3	Optimo	51
1921-1924	B&L Kodak Anast. f6.3	Ilex	70
1921-1924	Kodak Anast. f6.3	Ilex	55
1921-1924	B&L Tessar Ser. IIb f6.3	Ilex	81
1921-1925	B&L Tessar Ser. IIb f6.3	Kodamatic	86
1921-1925	Kodak Anast. f6.3	Kodamatic	60
1921-1926	B&L Kodak Anast. f6.3	Kodamatic	75

NO. 1 AUTOGRAPHIC KODAK SPECIAL CAMERA (MODEL A)

IDENTIFICATION: "1 Autographic Kodak Special Model A" below lens on some. **CHARACTERISTICS:** Bakelite side panels. Optimo shutter. Radial lever focus. Earlier models may not be identified as Model A. Later, ca. 1919 models say "Model A" at base of lens standard. (see illustration.) **LENS:** $4\frac{1}{4}$ in. (see variations below). **SHUTTER:** Optimo. **FILM SIZE:** A120. **IMAGE:** $2\frac{1}{4}$x$3\frac{1}{4}$ in. **BODY:** 1-3/8x3-3/8x6-5/8 in. **WEIGHT:** $26\frac{1}{2}$ oz. **DATES:** 1915-1920. **PRICE:** $36-56.

The No. 1 size was a new addition to the "Special" line of cameras in 1915, and therefore does not exist in a non-autographic model as do the 3A, 3, and 1A sizes which were introduced in 1910, 1911, and 1912 respectively. (illustrated on next page)

DATES	LENS	SHUTTER	PRICE
1915-1916	Cooke Kodak Anast. f6.3	Optimo	36
1915-1920	B&L (Zeiss) Kodak Anast. f6.3	Optimo	45
1915-1920	B&L (Special) Anast. f6.3	Optimo	36
1915-1920	B&L (Zeiss) Tessar Ser. IIb f6.3	Optimo	54
1915-1920	B&L (Zeiss) Tessar Ser. Ia f4.5	Optimo	56
1915-1920	Kodak Anast. f6.3	Optimo	40

Autographic Kodak Special cameras:

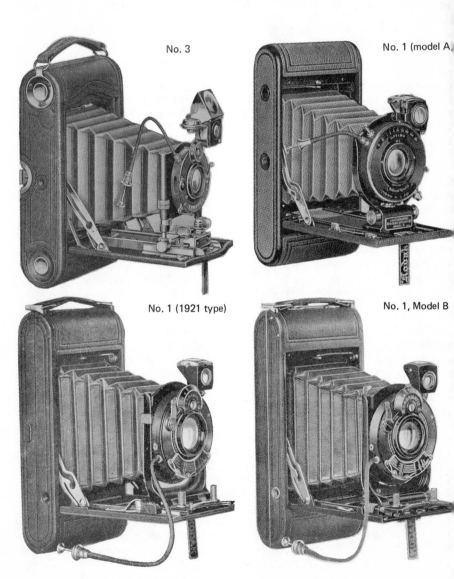

No. 3 No. 1 (model A)

No. 1 (1921 type) No. 1, Model B

NO. 1 AUTOGRAPHIC KODAK SPECIAL CAMERA
(1921 TYPE OR "NEW MODEL")

CHARACTERISTICS: Back overlaps sides. New lens standard. LENS: $\frac{1}{2}$ in. (see variations below). SHUTTER: (see variations below). FILM SIZE: A120. IMAGE: $2\frac{1}{4}$x$3\frac{1}{4}$ in. BODY: 1-5/16x3-1/16x6-7/16 in. WEIGHT: 15 oz. DATES: 1921-1921. PRICE: $45-79. (illus. p. 58)
This 1921 model was produced for only a short time. The 1921 catalog illustration seems to show rack and pinion focusing mechanism, but the description still indicates lever focusing. Later Model B has micrometer screw focusing. The 1921 model is closer in construction to the Model B than the Model A.

DATES	LENS	SHUTTER	PRICE
1921-1921	Kodak Anast. f6.3	Kodamatic	50
1921-1921	Kodak Anast. f6.3	Ilex	45
1921-1921	B&L Kodak Anast. f6.3	Kodamatic	67
1921-1921	B&L Kodak Anast. f6.3	Ilex	62
1921-1921	B&L Tessar Ser. IIb f6.3	Kodamatic	79
1921-1921	B&L Tessar Ser. IIb f6.3	Ilex	74
1921-1921	B&L Tessar Ser. Ic f4.5	Kodamatic	79
1921-1921	B&L Tessar Ser. Ic f4.5	Ilex	74

NO. 1 AUTOGRAPHIC KODAK SPECIAL CAMERA MODEL B

CHARACTERISTICS: Back overlaps sides like the 1921 Type, but has micrometer screw focusing, not rack and pinion. LENS: (see variations below). SHUTTER: Kodamatic. FILM SIZE: A120. IMAGE: $2\frac{1}{4}$x$3\frac{1}{4}$ in. BODY: 1-5/16x3-1/16x6-7/16 in. WEIGHT: 18 oz. DATES: 1922-1926. PRICE: $50-74. (illus. p. 58)

DATES	LENS	SHUTTER	PRICE
1922-1924	B&L Kodak Anast. f6.3	Kodamatic	62
1922-1924	B&L Tessar Ser. IIb f6.3	Kodamatic	74
1922-1926	Kodak Anast. f6.3	Kodamatic	50
1922-1926	B&L Tessar Ser. Ic f4.5	Kodamatic	71

NO. 1 AUTOGRAPHIC KODAK JUNIOR CAMERA

IDENTIFICATION: "No. 1 Autographic Kodak Junior" at base of lens standard and in take-up spool chamber. CHARACTERISTICS: J-shaped removable back with 2 side catches. LENS: $4\frac{1}{4}$ in. (see variations below). SHUTTER: (see variations below). FILM SIZE: A120. IMAGE: $2\frac{1}{4}$x$3\frac{1}{4}$ in. BODY: 1-7/16x3-5/8x6-5/8 in. WEIGHT: 23 oz. DATES: 1914-1927. PRICE: $9-23. (illus. p. 60)
Formerly, the No. 1 Kodak Jr. Camera April- Dec. 1914.

DATES	LENS	SHUTTER	PRICE
1914-1924	Meniscus Achromatic (fixed focus)	Kodak Ball Bearing	9
1914-1924	Rapid Rectilinear	Kodak Ball Bearing	11
1915-1925	Kodak Anast. 7.7	Kodak Ball Bearing	15
1916-1924	Meniscus Achromatic (focusing)	Kodak Ball Bearing	9
1924-1926	Kodak Anast. f7.7	Diomatic	23
1925-1925	Rapid Rectilinear	Kodex	14
1925-1926	Kodar f7.9	Kodex	15
1925-1927	Meniscus Achromatic (focusing)	Kodex	12
1925-1927	Meniscus Achromatic (fixed focus)	Kodex	12

No. 1 Autographic
Kodak Junior camera

No. 1A Autographic
Kodak Junior camera

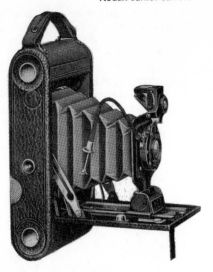

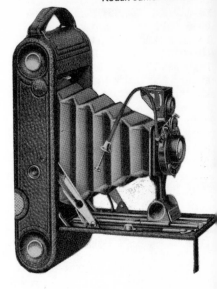

NO. 1A AUTOGRAPHIC KODAK JUNIOR CAMERA

IDENTIFICATION: "No. 1A Autographic Kodak Jr." below lens and/or inside back. **CHARACTERISTICS:** J-shaped removable back with 2 side catches. Some have a model letter inside back in take-up spool chamber. **LENS:** 5¼ in (see variations below). **SHUTTER:** (see variations below). **FILM SIZE:** A116. **IMAGE:** 2½x4¼ in. **BODY:** 1-5/8x3-3/4x8 in. **WEIGHT:** 28 oz. **DATES:** 1914-1927. **PRICE:** $11-24. Formerly, the No. 1A Kodak Jr. Camera 1914.

DATES	LENS	SHUTTER	PRICE
1914-1924	Meniscus Achromatic (fixed focus)	Kodak Ball Bearing	11
1914-1925	Rapid Rectilinear	Kodak Ball Bearing	13
1915-1925	Kodak Anast. f7.7	Kodak Ball Bearing	18
1916-1924	Meniscus Achromatic (focusing)	Kodak Ball Bearing	11
1923-1923	Kodak Anast. f7.7	Ilex Universal	24
1924-1924	Kodak Anast. f7.7	Multiple Speed	24
1925-1925	Rapid Rectilinear	Kodex	15
1925-1926	Kodar f7.9	Kodex	16
1925-1927	Meniscus Achromatic (fixed focus)	Kodex	13
1925-1927	Meniscus Achromatic (focusing)	Kodex	13
1925-1927	Kodak Anast. f7.7	Diomatic	24

NO. 2C AUTOGRAPHIC KODAK JUNIOR CAMERA

IDENTIFICATION: "No. 2C Autographic Kodak Jr." below lens and/or inside back. **CHARACTERISTICS:** J-shaped back with 2 side catches. **LENS:** (see variations below). **SHUTTER:** (see variations below). **FILM SIZE:** A130. **IMAGE:** 2-7/8x4-7/8 in. **BODY:** 1-3/4x4-3/8x8-3/4 in. **WEIGHT:** 38 oz. **DATES:** 1916-1927. **PRICE:** $12-27.
Minor change in strut's shape: straight through 1919, curved 1920-on.

DATES	LENS	SHUTTER	PRICE
1916-1924	Meniscus Achromatic	Kodak Ball Bearing	12
1916-1924	Rapid Rectilinear	Kodak Ball Bearing	14
1916-1924	Kodak Anast. f7.7	Kodak Ball Bearing	19
1922-1923	Kodak Anast. f7.7	Ilex Universal	27
1924-1924	Kodak Anast. f7.7	Multiple Speed	27
1925-1925	Rapid Rectilinear	Kodex	18
1925-1926	Kodak Anast. f7.7	Diomatic	27
1925-1927	Meniscus Achromatic	Kodex	16
1925-1927	Kodar f7.9	Kodex	19

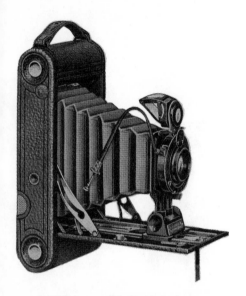 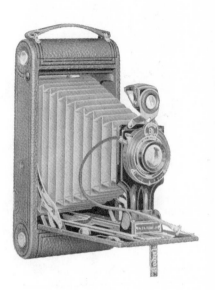

No. 2C Autographic Kodak Junior camera No. 3A Autographic Kodak Junior camera

NO. 3A AUTOGRAPHIC KODAK JUNIOR CAMERA

IDENTIFICATION: "No. 3A Autographic Kodak Jr." below lens and/or inside back. **CHARACTERISTICS:** J-shaped back with side catches. Nameplate at base of lens standard does not include the word "Autographic" on some of the models before 1920. **LENS:** (see variations below). **SHUTTER:** (see variations below). **FILM SIZE:** A122. **IMAGE:** $3\frac{1}{4}x5\frac{1}{2}$ in. **BODY:** 1-15/16x5-1/8x9-3/4 in. **WEIGHT:** 35 oz. **DATES:** 1918-1927. **PRICE:** $18-29.

DATES	LENS	SHUTTER	PRICE
1918-1924	Meniscus Achromatic	Kodak Ball Bearing	18
1918-1924	Rapid Rectilinear	Kodak Ball Bearing	20
1918-1924	Kodak Anast f7.7	Kodak Ball Bearing	26
1922-1923	Kodak Anast f7.7	Ilex Universal	29
1924-1924	Kodak Anast f7.7	Multiple Speed	29
1925-1925	Rapid Rectilinear	Kodex	20
1925-1926	Meniscus Achromatic	Kodex	18
1925-1927	Kodak Anast. f7.7	Diomatic	29
1925-1927	Kodar f7.9	Kodex	21

VEST POCKET AUTOGRAPHIC KODAK CAMERA

IDENTIFICATION: "Vest Pocket Autographic Kodak" on the autographic door of some models. **CHARACTERISTICS:** Early models 1915-1919 have black enamel finish. "Japan crystal" crackle finish starts in 1920. Side-loading type. Trellis struts and no bed. **LENS:** (see variations below). **SHUTTER:** Kodak Ball Bearing. **FILM SIZE:** 127. **IMAGE** 1-5/8x2½ in. **BODY:** 1x2-3/8x4-3/4 in. **WEIGHT:** 9 oz. **DATES** 1915-1926. **PRICE:** $6-10.

Formerly V.P. Kodak Camera 1912-1914. From 1916-on this camera with the Kodak Anast. f7.7 lens was called the Vest Pocket Autographic Kodak Special Camera.

DATES	LENS	PRICE
1915-1915	Kodak Anast. f7.7 (fixed focus)	10
1915-1926	Meniscus Achromatic	6
1917-1926	Rapid Rectilinear	9

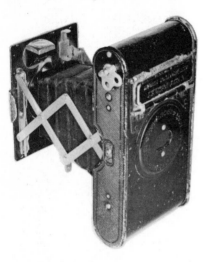 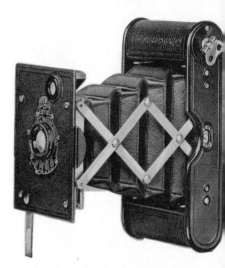

Vest Pocket Autographic Kodak camera Vest Pocket Autographic Kodak Special camera

VEST POCKET AUTOGRAPHIC KODAK SPECIAL CAMERA

CHARACTERISTICS: Like regular model but with Persian morocco covering and special lenses. Side-loading type. Trellis struts and no bed. **LENS:** 3½ in. (see variations below). **SHUTTER:** Kodak Ball Bearing. **FILM SIZE:** 127. **IMAGE:** 1-5/8x2½ in. **BODY:** 1x2-3/8x4-3/4 in. **WEIGHT:** 9 oz. **DATES:** 1915-1926. **PRICE:** $10-23.

Although two variations have focusing lenses, the majority of these cameras found today seem to be fixed-focus models.

DATES	LENS	PRICE
1915-1921	B&L (Zeiss) Kodak Anast. f6.9	23
1916-1921	Kodak Anast. f6.9 (fixed focus)	20
1916-1923	Kodak Anast. f7.7 (fixed focus)	10
1921-1926	Kodak Anast. f6.9 (focusing)	21
1924-1926	Kodak Anast. f7.7 (focusing)	13
1926-1926	Zeiss Tessar f4.9 (focusing) in Compur	EUR

NO. 2 FOLDING AUTOGRAPHIC BROWNIE CAMERA

IDENTIFICATION: "No. 2 Folding
Autographic Brownie" on lens
standard. **CHARACTERISTICS:**
Vertically styled folding camera with
metal body. Changed from square
ends to round ends in 1917.
LENS: (see variations below).
SHUTTER: (see variations below).
FILM SIZE: A120. **IMAGE:** $2\frac{1}{4}$x$3\frac{1}{4}$
in. **BODY:** $1\frac{1}{4}$x3-1/8x$6\frac{1}{2}$ in.
WEIGHT: 19 oz. **DATES:** 1915-1926.
PRICE: $6-12.
 Replaced the No. 2 Folding
Pocket Brownie Camera (1907-1915).

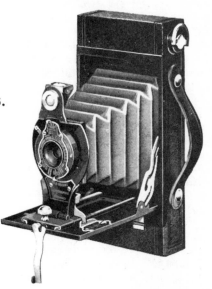

Kodak Ball Bearing Shutter
1915-1923	Meniscus Achromatic	6
1915-1923	Rapid Rectilinear f8	8

Kodex Shutter
1924-1926	Meniscus Achromatic	9
1924-1926	Rapid Rectilinear	11
1925-1926	Kodar f7.9	12

NO. 2A FOLDING AUTOGRAPHIC BROWNIE CAMERA

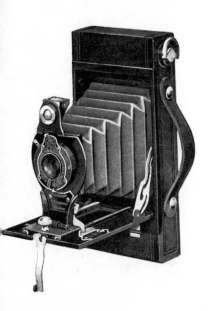

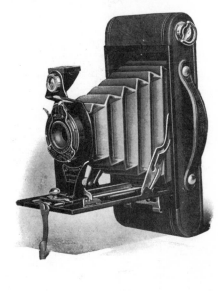

IDENTIFICATION: "No. 2A Folding Autographic Brownie" on lens
standard and strap. **CHARACTERISTICS:** Vertically styled folding

camera with metal body. Changed from square ends in 1916 to round
ends in 1917. **LENS:** (see variations below). **SHUTTER:** (see
variations below). **FILM SIZE:** A116. **IMAGE:** $2\frac{1}{2}$x$4\frac{1}{4}$ in. **BODY**
$1\frac{1}{2}$x3-3/8x7-7/8 in. **WEIGHT:** 25 oz. **DATES:** 1915-1926. **PRICE:** $8-13.
 Replaced the No. 2A Folding Pocket Brownie Camera (1910-1915).

DATES	LENS	SHUTTER	PRICE
1915-1923	Meniscus Achromatic	Kodak Ball Bearing	8
1915-1923	Rapid Rectiliner f8	Kodak Ball Bearing	10
1924-1926	Meniscus Achromatic	Kodex	10
1924-1926	Rapid Rectilinear	Kodex	12
1925-1926	Kodar f7.9	Kodex	13

NO. 2C FOLDING AUTOGRAPHIC BROWNIE CAMERA

IDENTIFICATION: "No. 2C Folding Autographic Brownie" on lens
standard and strap. **CHARACTERISTICS:** Vertically styled folding
camera with metal body. Changed from square ends to round ends in
1917. **LENS:** (see variations below). **SHUTTER:** (see variations below).
FILM SIZE: A130. **IMAGE:** 2-7/8x4-7/8 in. **BODY:** 1-3/4x3-3/4x8-3/4
in. **WEIGHT:** 25 oz. **DATES:** 1916-1926. **PRICE:** $9-16.

DATES	LENS	SHUTTER	PRICE
1916-1924	Meniscus Achromatic	Kodak Ball Bearing	9
1916-1924	Rapid Rectilinear	Kodak Ball Bearing	11
1925-1925	Rapid Rectilinear	Kodex	13
1925-1925	Rapid Rectilinear	Adjustable Speed	15
1925-1925	Meniscus Achromatic	Adjustable Speed	13
1925-1926	Kodar f7.9	Kodex	16
1926-1926	Meniscus Achromatic	Kodex	13

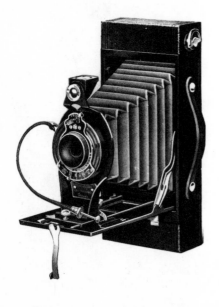 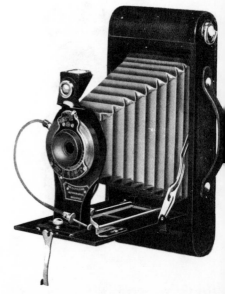

No. 2C Folding Autographic Brownie camera No. 3A Folding Autographic Brownie camera

NO. 3A FOLDING AUTOGRAPHIC BROWNIE CAMERA

IDENTIFICATION: "No. 3A Folding Autographic Brownie" on lens standard. **CHARACTERISTICS:** Vertically styled folding camera with round ends. **LENS:** (see variations below). **SHUTTER:** (see variations below). **FILM SIZE:** A122. **IMAGE:** 3¼x5½ in. **BODY:** 1-3/4x4¼x9¼ in. **WEIGHT:** 38 oz. **DATES:** 1916-1926. **PRICE:** $10-18.

Replaced the No. 3A Folding Brownie Camera (1909-1915).

DATES	LENS	SHUTTER	PRICE
1916-1924	Meniscus Achromatic	Kodak Ball Bearing	10
1916-1924	Rapid Rectilinear f8	Kodak Ball Bearing	12
1925-1925	Rapid Rectilinear	Kodex	17
1925-1925	Rapid Rectilinear	Adjustable Speed	17
1925-1925	Meniscus Achromatic	Adjustable Speed	15
1925-1926	Kodar f7.9	Kodex	18
1926-1926	Meniscus Achromatic	Kodex	15

AUTOGRAPHIC KODAK SPECIAL CAMERAS
WITH COUPLED RANGEFINDER

These cameras were the first in the world to use a coupled rangefinder, long before that idea ever caught on and became popular. It never really became popular before the advent of 35mm cameras and Leica, even though proper focusing is more critical with the longer focus lenses of the larger cameras. The added expense of the rangefinder on a top line camera which already sported a more expensive lens and shutter probably put the price out of the range of the average photographer. These cameras are not found often today.

NO. 3A AUTOGRAPHIC KODAK SPECIAL CAMERA
WITH COUPLED RANGEFINDER

IDENTIFICATION: "3A Autographic Kodak Special" below lens.
CHARACTERISTICS: Rangefinder at base of lens standard. **LENS:** (see variations below). **SHUTTER:** (see variations below). **FILM SIZE:** A122. **IMAGE:** 3¼x5½ in. **BODY:** 2x4-3/4x9½ in. **WEIGHT:** 42 oz. **DATES:** 1916-1933. **PRICE:** $49-110.

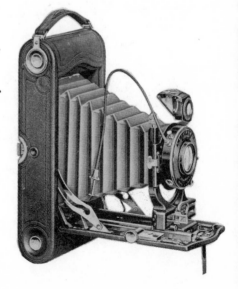

This was the first hand camera with a coupled rangefinder. A special combination back was available for ground glass focusing and use of cut film or plates. There were two military variations made: 1. Brown suede leather with black anodized metal parts. 2. Smooth brown leather with brass fittings. From 1917-1921 it had a reversible folding finder with a front-opening button under the leather. From 1922-1925 the finder was non-folding with a plastic button, not covered with

leather, to open the front.

DATES	LENS	SHUTTER	PRICE
1916-1916	Cooke Kodak Anast. f6.3	Optimo	49
1916-1924	B&L (Zeiss) Kodak Anast. f6.3	Optimo	66
1916-1924	B&L (Zeiss) Tessar Ser. IIb f6.3	Optimo	77
1916-1924	Kodak Anast. f6.3	Optimo	55
1921-1924	Kodak Anast. f6.3	Ilex	74
1921-1924	B&L Kodak Anast. f6.3	Ilex	93
1921-1924	B&L Tessar Ser. IIb f6.3	Ilex	105
1921-1925	B&L Kodak Anast. f6.3	Kodamatic	98
1921-1925	B&L Tessar Ser. IIb f6.3	Kodamatic	110
1921-1933	Kodak Anast. f6.3	Kodamatic	79

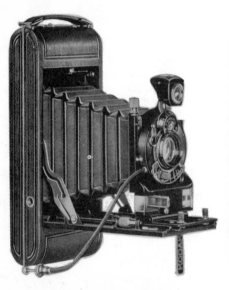

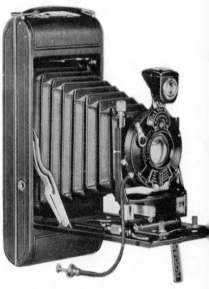

No. 1A Autographic Kodak Special camera
with rangefinder

No. 2C Autographic Kodak Special camera

NO. 1A AUTOGRAPHIC KODAK SPECIAL CAMERA
WITH COUPLED RANGEFINDER

IDENTIFICATION: "1A Autographic Kodak Special" on nameplate in middle of bed. **CHARACTERISTICS:** Rangefinder at base of lens standard. Earlier models 1917-1923 have bakelite side panels. New Model (B) 1923-1926 has removable back which overlaps sides. **LENS:** (see variations below). **SHUTTER:** (see variations below). **FILM SIZE:** A116. **IMAGE:** 2½x4¼ in. **BODY:** 1-5/8x3-3/4x8 in. **WEIGHT:** 32 oz. (Model B only 25 oz.) **DATES:** 1917-1926. **PRICE:** $45-91.

Formerly sold, without a rangefinder, as the No. 1A Autographic Kodak Special Camera.

DATES	LENS	SHUTTER	PRICE
1917-1923	Kodak Anast. f6.3	Optimo	45
1917-1923	B&L Kodak Anast. f6.3	Optimo	49
1917-1923	B&L Tessar Ser. IIb f6.3	Optimo	60
1921-1923	Kodak Anast. f6.3	Ilex	65
1921-1923	B&L Kodak Anast. f6.3	Kodamatic	83
1921-1923	B&L Kodak Anast. f6.3	Ilex	78
1921-1923	B&L Tessar Ser. IIb f6.3	Kodamatic	91
1921-1923	B&L Tessar Ser. IIb f6.3	Ilex	86
1921-1926	Kodak Anast. f6.3	Kodamatic	70

NO. 2C AUTOGRAPHIC KODAK SPECIAL CAMERA

CHARACTERISTICS: All have coupled rangefinder. There are no non-rangefinder models of the No. 2C Autographic Kodak Special Camera as with the No. 1A and No. 3A sizes. **LENS:** Kodak Anast. f6.3/6 in. **SHUTTER:** Kodamatic. **FILM SIZE:** A130. **IMAGE:** 2-7/8x4-7/8 in. **BODY:** 1-9/16x3-7/8x8-3/4 in. **WEIGHT:** 32 oz. **DATES:** 1923-1928. **PRICE:** $65. (illustrated on previous page)

STEREO KODAK MODEL 1 CAMERA

IDENTIFICATION: "Stereo Kodak Model 1" on shutter face between lenses. **CHARACTERISTICS:** Folding stereo rollfilm camera. **LENS:** Kodak Anast. f7.7/5¼ in. **SHUTTER:** (see variations below). **FILM SIZE:** 101. **IMAGE:** 3-1/8x3-3/16 in. **BODY:** 2-3/16x4-3/4x10½ in. **WEIGHT:** 47 oz. **DATES:** 1917-1925. **PRICE:** $45-53.

DATES	LENS	SHUTTER	PRICE
1917-1918	Kodak Anast. f7.7	Stereo Automatic	45
1919-1925	Kodak Anast. f7.7	Stereo Ball Bearing	53

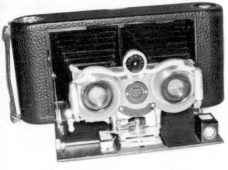

Left: Stereo Kodak Model 1 camera
Right: No. 2C Brownie camera

NO. 2C BROWNIE CAMERA

CHARACTERISTICS: Box camera. **LENS:** Meniscus Achromatic. **SHUTTER:** Rotary. **FILM SIZE:** 130. **IMAGE:** 2-7/8x4-7/8 in. **BODY:** 3-7/8x6¼x7¼ in. **WEIGHT:** 27 oz. **DATES:** 1917-1934. **PRICE:** $4.50.

POCKET KODAK CAMERAS (INCLUDING SERIES II, SPECIAL, JUNIOR, AND COLORED MODELS.)

Available in sizes No. 1, No. 1A, No. 2C, No. 3, and No. 3A. All have the autographic feature, but "Autographic" was not a part of the official name. These cameras should not be confused with the early Pocket Kodak box cameras of 1895-1900.

NO. 1 POCKET KODAK SERIES II CAMERA

IDENTIFICATION: "No. 1 Pocket Kodak Series II" nameplate on lens standard on bed. **CHARACTERISTICS:** When the front is opened, the lens standard automatically moves into position, unlike the earlier models. **LENS:** (see variations below). **SHUTTER:** (see variations below). **FILM SIZE:** 120. **IMAGE:** $2\frac{1}{4}$x$3\frac{1}{4}$ in. **BODY:** 1-5/16x3-1/16x6-7/16 in. **WEIGHT:** $16\frac{1}{2}$ oz. **DATES:** 1922-1931. **PRICE:** $14-24.

Available in focusing and fixed-focus models.

DATES	LENS	SHUTTER	PRICE
1922-1924	Meniscus Achromatic	Kodak Ball Bearing	14
1922-1925	Kodak Anast. f7.7	Kodak Ball Bearing	20
1924-1931	Kodak Anast. f7.7	Diomatic	24
1925-1931	Meniscus Achromatic	Kodex	14
1925-1931	Kodar f7.9	Kodex	17

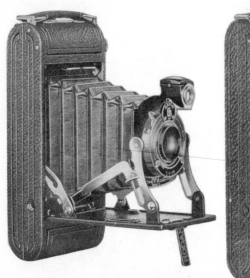 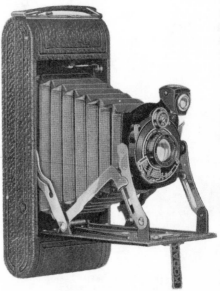

Left: No. 1 Pocket Kodak Series II camera
Right: No. 1A Pocket Kodak Series II camera

NO. 1A POCKET KODAK SERIES II CAMERA (BLACK)

IDENTIFICATION: "No. 1A Pocket Kodak Series II" nameplate on bed. **CHARACTERISTICS:** Front is self-erecting when opened. Autographic stylus on back near handle. **LENS:** (see variations below). **SHUTTER:** (see variations below). **FILM SIZE:** 116. **IMAGE:** $2\frac{1}{2}$x$4\frac{1}{4}$ in. **BODY:**

1-9/16x3-5/16x8 in. **WEIGHT:** 26 oz. **DATES:** 1923-1931. **PRICE:** $15-26. Available in fixed focus and focusing models.

DATES	LENS	SHUTTER	PRICE
1923-1924	Meniscus Achromatic	Kodak Ball Bearing	15
1923-1925	Kodak Anast. f7.7	Kodak Ball Bearing	22
1924-1931	Kodak Anast. f7.7	Diomatic	26
1925-1931	Meniscus Achromatic	Kodex	15
1925-1931	Kodar f7.9	Kodex	19

NO. 1A POCKET KODAK SERIES II CAMERA (COLORED)

IDENTIFICATION: "No. 1A Pocket Kodak Series II" nameplate on bed. **LENS:** Meniscus Achromatic. **SHUTTER:** Kodex. **FILM SIZE:** 116. **IMAGE:** 2½x4¼ in. **BODY:** 1-9/16x3-5/16x8 in. **WEIGHT:** 26 oz. **DATES:** 1928-1932. **PRICE:** $25.

Available in beige, blue, brown, gray, and green. (Beige 1928-1929 only. Green 1929-1932 only.) Originally supplied with matching carrying case.

NO. 1A KODAK SERIES III CAMERA

IDENTIFICATION: "No. 1A Kodak Series III" at base of lens standard. **CHARACTERISTICS:** Front is not self-erecting. **LENS:** (see variations below). **SHUTTER:** Diomatic. **FILM SIZE:** 116. **IMAGE:** 2½x4¼ in. **BODY:** 1-9/16x3-5/16x8 in. **WEIGHT:** 27 oz. **DATES:** 1924-1931. **PRICE:** $29-32.

DATES	LENS	SHUTTER	PRICE
1924-1926	Kodak Anast. f7.7	Diomatic	30
1926-1928	Kodak Anast. f6.3	Diomatic	29
1929-1931	Kodak Anast. f5.6	Diomatic	32

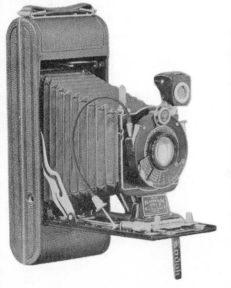
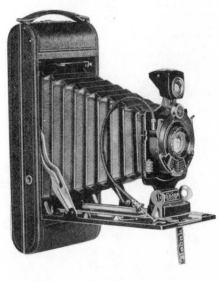

Left: No. 1A Kodak Series III camera
Right: No. 2C Kodak Series III camera

NO. 2C KODAK SERIES III CAMERA

IDENTIFICATION: "No. 2C Kodak Series III" at base of lens standard.
CHARACTERISTICS: Removable back type. LENS: (see variations below). SHUTTER: Diomatic. FILM SIZE: 130. IMAGE: 2-7/8x4-7/8 in. BODY: 1-9/16x3-7/8x8-3/4 in. WEIGHT: 32 oz. DATES: 1924-1932. PRICE: $32-35. (illustrated on previous page)

DATES	LENS	SHUTTER	PRICE
1924-1926	Kodak Anast. f7.7	Diomatic	33
1926-1932	Kodak Anast. f6.3	Diomatic	32

NO. 1 KODAK SERIES III CAMERA

IDENTIFICATION: "No. 1 Kodak Series III" on base of lens standard.
CHARACTERISTICS: Does not have self-erecting front. All have autographic feature. LENS: Kodak Anast. f6.3/4¼ in. SHUTTER: Diomatic. FILM SIZE: 120. IMAGE: 2¼x3¼ in. BODY: 1-5/8x3½x6½ in. WEIGHT: 20 oz. DATES: 1926-1931. PRICE: $26.

This camera was erroneously listed as No. 1 "Pocket" Kodak Series III Camera in several chronologies of Kodak cameras, which has led to some confusion.

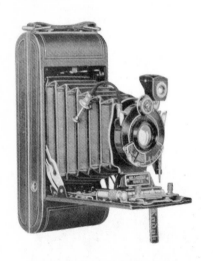

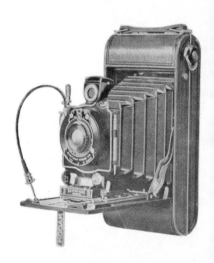

No. 1 Kodak Series III camera No. 3 Kodak Series III camera

NO. 3 KODAK SERIES III CAMERA

IDENTIFICATION: "Kodak 3 Series III" at base of lens standard.
LENS: (see variations below). SHUTTER: (see variations below).
FILM SIZE: 118. IMAGE: 3¼x4¼ in. BODY: 1-5/8x4-1/8x8 in.
WEIGHT: 35 oz. DATES: 1926-1933. PRICE: $23-33.

DATES	LENS	SHUTTER	PRICE
1926-1928	Kodak Anast. f6.3	Diomatic	30
1926-1930	Kodar f7.9	Kodex	23
1929-1933	Kodak Anast. f5.6	Diomatic	33
1931-1933	Kodak Anast. f6.3	Kodex	26

VEST POCKET KODAK MODEL B CAMERA

IDENTIFICATION: "Vest Pocket Kodak Model B" on shutter face.
CHARACTERISTICS: Front of camera removes from rollholder for film loading. All Model B variations have the Autographic feature. Folding bed with pull-out front. Black "iridescent" covering. **LENS:** (see variations below). **SHUTTER:** V.P. Rotary. **FILM SIZE:** 127. **IMAGE:** 1-5/8x2½ in. **BODY:** 1x2-3/8x4-3/4 in. **WEIGHT:** 9 oz. **DATES:** 1925-1934. **PRICE:** $5-8.

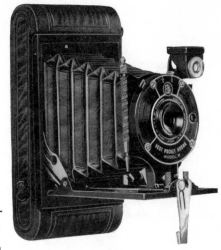

The most significant changes in the Model B from the earlier models are that the entire front of the camera removes from the rollholder section for loading, and it has a folding bed which serves as a front door. The earlier models were loaded from the side, which occasionally presented minor problems. They employed a straight pull-out front which was strut-supported and left the lens unprotected when collapsed.

DATES	LENS	SHUTTER	PRICE
1925-1934	Meniscus	V.P. Rotary	5
1928-1931	Periscopic	V.P. Rotary	8
1932-1934	Kodak Doublet	V.P. Rotary	8

VEST POCKET KODAK SERIES III CAMERA

IDENTIFICATION: "Vest Pocket Kodak Series III" on back catch.
CHARACTERISTICS: Folding bed style with pull-out front similar to Model B, but with removable back. All variations have the autographic feature. **LENS:** (see variations below). **SHUTTER:** (see variations below). **FILM SIZE:** 127. **IMAGE:** 1-5/8x2½ in. **BODY:** 1x2-3/8x4-3/4 in. **WEIGHT:** 9 oz. **DATES:** 1926-1933. **PRICE:** $10-18.

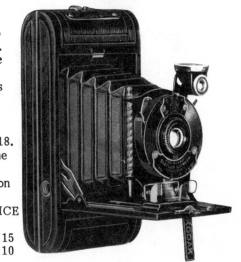

Appearing just a year after the Model B, the Series III further simplified the film loading operation by providing a removable back.

DATES	LENS and SHUTTER		PRICE
1926-30	Kodak Anast. f6.3		
	Diomatic		15
1926-33	Kodar f7.9	Kodex	10
1930-33	Kodak Anast. f5.6		
	Diomatic		18

VEST POCKET KODAK SPECIAL CAMERA (LATER TYPE)

IDENTIFICATION: "Vest Pocket Kodak Special" on back catch.
CHARACTERISTICS: Folding bed with pull-out front. Removable back like Series III. All variations have autographic feature. **LENS:** (see variations below). **SHUTTER:** Diomatic. **FILM SIZE:** 127. **IMAGE:** 1-5/8x2½ in. **BODY:** 1x2-3/8x4-3/4 in. **WEIGHT:** 9 oz. **DATES:** 1926-1935. **PRICE:** $20-28.

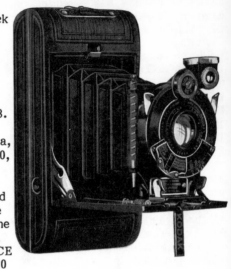

This camera is identical to the Vest Pocket Kodak Series III Camera, but with a better lens. Before 1930, the f5.6 lens was furnished only on the "Special". After 1930, the f5.6 lens was used on the "Series III" and no longer considered "Special". The name on the back catch becomes the main distinction for the f5.6 model.

DATES	LENS	PRICE
1926-30	Kodak Anast. f5.6	20
1926-35	Kodak Anast. f4.5	25

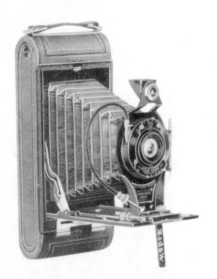

Left: No. 2C Pocket Kodak camera
Right: No. 1 Pocket Kodak camera

NO. 2C POCKET KODAK CAMERA

IDENTIFICATION: "No. 2C Pocket Kodak" on lens standard.
CHARACTERISTICS: Front of camera removes from rollholder for loading. **LENS:** (see variations below). **SHUTTER:** (see variations below). **FILM SIZE:** 130. **IMAGE:** 2-7/8x4-7/8 in. **BODY:**

1-3/4x4x8-7/8 in. **WEIGHT:** 2¼ lb. **DATES:** 1925-1932. **PRICE:** $13-23.

DATES	LENS	SHUTTER	PRICE
1925-1932	Meniscus Achromatic	Kodex	13
1926-1932	Kodar f7.9	Kodex	16
1927-1927	Kodak Anast. f7.7	Kodex	18
1927-1932	Kodak Anast. f6.3	Kodak Ball Bearing	21

NO. 1 POCKET KODAK CAMERA (BLACK)

IDENTIFICATION: "No. 1 Pocket Kodak" on lens standard. **CHARACTERISTICS:** Stylus for Autographic back is attached to the lensboard. **LENS:** (see variations below). **SHUTTER:** Kodex. **FILM SIZE:** 120. **IMAGE:** 2¼x3¼ in. **BODY:** 1-5/16x3-1/8x6-3/4 in. **WEIGHT:** 24 oz. **DATES:** 1926-1931. **PRICE:** $9-19. (illustrated on previous page)

DATES	LENS	SHUTTER	PRICE
1926-1931	Meniscus Achromatic	Kodex	9
1926-1931	Kodar f7.9	Kodex	12
1927-1927	Kodak Anast. f7.7	Kodex	15
1927-1931	Kodak Anast. f6.3	Kodex	17

NO. 1 POCKET KODAK CAMERA (COLORED)

IDENTIFICATION: "No. 1 Pocket Kodak" on lens standard. **CHARACTERISTICS:** Available in blue, brown, gray, and green. **LENS:** Kodar f7.9. **SHUTTER:** Kodex. **FILM SIZE:** 120. **IMAGE:** 2¼x3¼ in. **BODY:** 1-5/16x3-1/8x6-3/4 in. **WEIGHT:** 24 oz. **DATES:** 1929-1932. **PRICE:** $18.

NO. 1A POCKET KODAK CAMERA (BLACK)

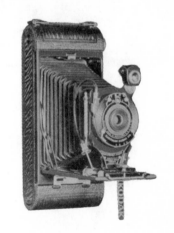

IDENTIFICATION: "No. 1A Pocket Kodak" on lens standard. **CHARACTERISTICS:** Folding-bed camera, not self-erecting. Autographic stylus attached to lensboard. **LENS:** (see variations below). **SHUTTER:** Kodex. **FILM SIZE:** 116. **IMAGE:** 2½x4¼ in. **BODY:** 1½x3½x8 in. **WEIGHT:** 31 oz. **DATES:** 1926-1931. **PRICE:** $10-18.

Body covering changed to "iridescent" imitation leather in 1929.

DATES	LENS	PRICE
1926-1931	Kodar f7.9	13
1926-1931	Meniscus Achromatic	10
1927-1927	Kodak Anast. f7.7	16
1927-1931	Kodak Anast. f6.3	18

NO. 1A POCKET KODAK CAMERA (COLORED)

IDENTIFICATION: "No. 1A Pocket Kodak" on lens standard. **CHARACTERISTICS:** Available in blue, brown, gray, and green. Otherwise, like the black model. **LENS:** Kodar f7.9/5-1/8 in. **SHUTTER:** Kodex. **FILM SIZE:** 116. **IMAGE:** 2½x4¼ in. **BODY:** 1½x3½x8 in. **WEIGHT:** 31 oz. **DATES:** 1929-1932. **PRICE:** $20.

NO. 3A POCKET KODAK CAMERA

IDENTIFICATION: "No. 3A Pocket Kodak" on lens standard. **CHARACTERISTICS:** Folding bed camera, not self-erecting. Camera front removes from rollholder for loading. **LENS:** (see variations below). **SHUTTER:** (see variations below). **FILM SIZE:** 122. **IMAGE:** $3\frac{1}{4}$x$5\frac{1}{2}$ in. **BODY:** 1-3/4x4$\frac{1}{2}$x9$\frac{1}{2}$ in. **WEIGHT:** 2$\frac{1}{2}$ lb. **DATES:** 1927-1934. **PRICE:** $15-25.

DATES	LENS	SHUTTER	PRICE
1927-1927	Kodak Anast. f7.7	Kodex	20
1927-1934	Meniscus Achromatic	Kodex	15
1927-1934	Kodar f7.9	Kodex	18
1927-1934	Kodak Anast. f6.3	Kodak Ball Bearing	23

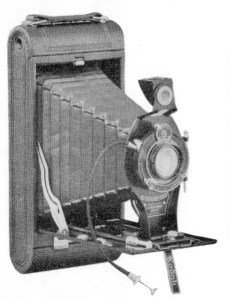 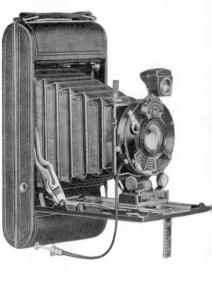

Left: No. 3A Pocket Kodak camera
Right: No. 3 Pocket Kodak Special camera

NO. 3 POCKET KODAK SPECIAL CAMERA

IDENTIFICATION: "Pocket Kodak 3 Special" at base of lens standard. **LENS:** (see variations below). **SHUTTER:** Kodamatic. **FILM SIZE:** 118. **IMAGE:** $3\frac{1}{4}$x$4\frac{1}{4}$ in. **BODY:** 1-11/16x4-1/8x8 in. **WEIGHT:** 2 lb. **DATES:** 1926-1933. **PRICE:** $43-63.

DATES	LENS	SHUTTER	PRICE
1926-1927	Kodak Anast. f6.3	Kodamatic	53
1926-1928	Kodak Anast. f5.6	Kodamatic	53
1926-1933	Kodak Anast. f4.5	Kodamatic	63

NO. 1 POCKET KODAK SPECIAL CAMERA

IDENTIFICATION: "No. 1 Pocket Kodak Special" at base of lens standard. **LENS:** (see variations below). **SHUTTER:** Kodamatic. **FILM SIZE:** 120. **IMAGE:** $2\frac{1}{4}$x$3\frac{1}{4}$ in. **BODY:** 1$\frac{1}{4}$x3-1/8x6$\frac{1}{2}$ in. **WEIGHT:** 21 oz. **DATES:** 1926-1934. **PRICE:** $35-60.

DATES	LENS	SHUTTER	PRICE
1926-1927	Kodak Anast. f6.3	Kodamatic	45
1926-1929	Kodak Anast. f5.6	Kodamatic	45
1926-1934	Kodak Anast. f4.5	Kodamatic	55

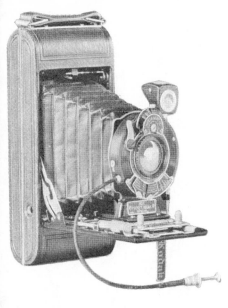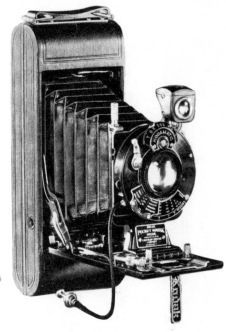

Pocket Kodak Special cameras.
Left: No. 1. Right: No. 1A

NO. 1A POCKET KODAK SPECIAL CAMERA

IDENTIFICATION: "No. 1A Pocket Kodak Special" at base of lens standard. **LENS:** (see variations below). **SHUTTER:** Kodamatic. **FILM SIZE:** 116. **IMAGE:** $2\frac{1}{2}$x$4\frac{1}{4}$ in. **BODY:** 1-11/16x3-3/8x$8\frac{1}{4}$ in. **WEIGHT:** 27 oz. **DATES:** 1926-1934. **PRICE:** $40-65.

DATES	LENS	SHUTTER	PRICE
1926-1927	Kodak Anast. f6.3	Kodamatic	50
1926-1929	Kodak Anast. f5.6	Kodamatic	50
1926-1934	Kodak Anast. f4.5	Kodamatic	60

NO. 2C POCKET KODAK SPECIAL CAMERA

LENS: (see variations below). **SHUTTER:** Kodamatic. **FILM SIZE:** 130. **IMAGE:** 2-7/8x4-7/8 in. **BODY:** 1-3/4x4x8-7/8 in. **WEIGHT:** 2 lb. **DATES:** 1928-1933. **PRICE:** $60-70.

DATES	LENS	SHUTTER	PRICE
1928-1929	Kodak Anast. f5.6	Kodamatic	60
1929-1933	Kodak Anast. f4.5	Kodamatic	70

NO. 1 POCKET KODAK JUNIOR CAMERA
IDENTIFICATION: "No. 1 Pocket Kodak Junior" nameplate on bed.
CHARACTERISTICS: Available in black, blue, brown, and green.
LENS: Meniscus Achromatic. **SHUTTER:** Kodo. **FILM SIZE:** 120.
IMAGE: 2¼x3¼ in. **BODY:** 1¼x3¼x6½ in. **WEIGHT:** 21 oz. **DATES:**
1929-1932. **PRICE:** $9.

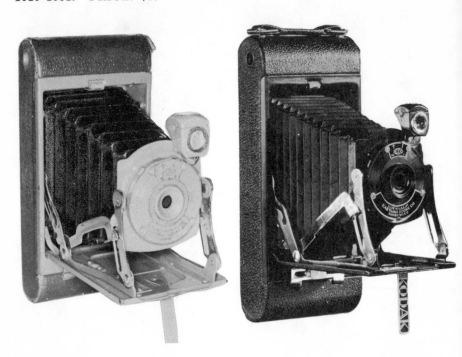

No. 1 Pocket Kodak Junior camera No. 1A Pocket Kodak Junior camera

NO. 1A POCKET KODAK JUNIOR CAMERA
IDENTIFICATION: "No. 1A Pocket Kodak Junior" nameplate on bed.
CHARACTERISTICS: Available in black, blue, brown, and green.
LENS: Meniscus Achromatic. **SHUTTER:** Kodo. **FILM SIZE:** 116.
IMAGE: 2½x4¼ in. **BODY:** 1½x3½x8 in. **WEIGHT:** 28 oz. **DATES:**
1929-1932. **PRICE:** $10.

A LITTLE CLASS FOR THE COMMON MAN
Kodak cameras, like Tin Lizzies, were available in black. It was almost that simple from 1888 until 1928, but the roaring twenties demanded more. Beginning in 1928, Kodak began offering a variety of cameras in lively colors and special motifs. We have already listed the colored models of the Pocket Kodak cameras along with their black counterparts, but the most interesting models are the special creations which follow. The functional design of the camera is basically

unchanged from earlier models, but it has had a packaging change which made it more attractive. And so for a few years, while the stock market crashed and the bread lines grew and all of life seemed dark and dreary, Eastman Kodak's new cameras added a bright spot for the common man.

VANITY KODAK CAMERA

IDENTIFICATION: "Vest Pocket Kodak Series III" on the back catch. **CHARACTERISTICS:** V.P. Kodak Series III Camera in blue, brown, gray, green, and red with a matching case. **LENS:** Kodak Anast. f6.3/3¼ in. **SHUTTER:** Diomatic. **FILM SIZE:** 127. **IMAGE:** 1-5/8x2½ in. **BODY:** 1x2-3/8x4-3/4 in. **WEIGHT:** 9 oz. **DATES:** 1928-1933. **PRICE:** $30.

Vanity Kodak cameras are all Vest Pocket Kodak Series III cameras. (Any camera marked "Vanity Kodak Model B" on the shutter face is actually the camera from the Vanity Kodak Ensemble.) The Vanity Kodak Camera came in a satin-lined case with matching colored covering.

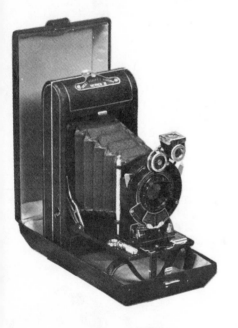

Vanity Kodak camera outfit

Vanity Kodak camera from Ensemble

VANITY KODAK ENSEMBLE

IDENTIFICATION: "Vanity Kodak Model B" on the shutter face. **CHARACTERISTICS:** Vest Pocket Kodak Model B Camera with lipstick, compact, mirror, and change pocket. Available in beige, gray, and green. **LENS:** Meniscus. **SHUTTER:** V.P. Rotary. **FILM SIZE:** 127. **IMAGE:** 1-5/8x2½ in. **BODY:** 1x2-3/8x4-3/4 in. **WEIGHT:** 9 oz. **DATES:** 1928-1929. **PRICE:** $20.

KODAK PETITE CAMERA

IDENTIFICATION: "Kodak Petite" on the shutter face. **CHARACTERIS-TICS:** V.P. Kodak Model B Camera in blue, gray, green, lavender, and old rose. **LENS:** Meniscus. **SHUTTER:** V.P. Rotary. **FILM SIZE:** 127. **IMAGE:** 1-5/8x2½ in. **BODY:** 1x2-3/8x4-3/4 in. **WEIGHT:** 9 oz. **DATES:** 1929-1933. **PRICE:** $8.

Came in several art-deco designs with a matching fabric-covered case.

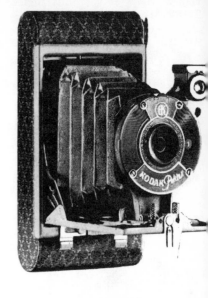

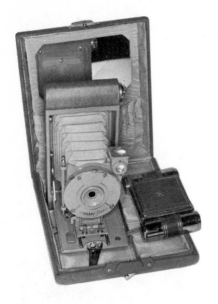

KODAK ENSEMBLE

IDENTIFICATION: "Kodak Petite" on the shutter face. **CHARACTER-ISTICS:** Kodak Petite Camera with lipstick, compact, and mirror in a suede case. Available in beige, green, and old rose. **LENS:** Meniscus. **SHUTTER:** V.P. Rotary. **FILM SIZE:** 127. **IMAGE:** 1-5/8x2½ in. **BODY:** 1x2-3/8x4-3/4 in. **WEIGHT:** 9 oz. **DATES:** 1929-1933. **PRICE:** $15.

KODAK COQUETTE CAMERA

IDENTIFICATION: "Kodak Petite" on the shutter face. **CHARACTER-ISTICS:** Kodak Petite Camera in blue with matching lipstick holder and compact. **LENS:** Meniscus. **SHUTTER:** V.P. Rotary. **FILM SIZE:** 127. **IMAGE:** 1-5/8x2½ in. **BODY:** 1x2-3/8x4-3/4 in. **WEIGHT:** 9 oz. **DATES:** 1930-1931. **PRICE:** $13.

BOY SCOUT KODAK CAMERA

IDENTIFICATION: "Boy Scout Kodak" on the shutter face. **CHARAC-TERISTICS:** Vest Pocket Kodak Model B Camera in special olive-drab

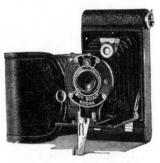

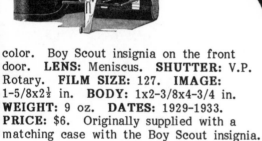

color. Boy Scout insignia on the front door. **LENS:** Meniscus. **SHUTTER:** V.P. Rotary. **FILM SIZE:** 127. **IMAGE:** 1-5/8x2½ in. **BODY:** 1x2-3/8x4-3/4 in. **WEIGHT:** 9 oz. **DATES:** 1929-1933. **PRICE:** $6. Originally supplied with a matching case with the Boy Scout insignia.

GIRL SCOUT KODAK CAMERA

IDENTIFICATION: "Girl Scout Kodak" on the shutter face. **CHARACTERISTICS:** Vest Pocket Kodak Model B Camera in green finish. Girl Scout emblem on front door. **LENS:** Meniscus. **SHUTTER:** V.P. Rotary. **FILM SIZE:** 127. **IMAGE:** 1-5/8x2½ in. **BODY:** 1x2-3/8x4-3/4 in. **WEIGHT:** 9 oz. **DATES:** 1929-1934. **PRICE:** $6. Originally supplied with a matching case with the Girl Scout insignia.

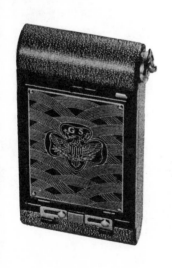

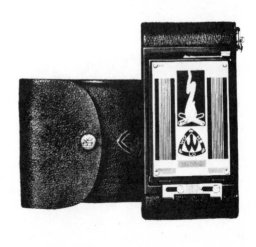

Left: Girl Scout Kodak camera
Right: Camp Fire Girls' Kodak camera

CAMP FIRE GIRLS' KODAK CAMERA

IDENTIFICATION: "Camp Fire Girls Kodak" on the shutter face.
CHARACTERISTICS: Vest Pocket Kodak Model B Camera in brown
finish. Camp Fire Girls emblem on front door. **LENS:** Meniscus.
SHUTTER: V.P. Rotary. **FILM SIZE:** 127. **IMAGE:** 1-5/8x2½ in.
BODY: 1x2-3/8x4-3/4 in. **WEIGHT:** 9 oz. **DATES:** 1931-1934.
PRICE: $6. Originally supplied with a matching case with the Camp
Fire Girls' insignia. (illustrated on previous page)

FIFTIETH ANNIVERSARY KODAK CAMERA

IDENTIFICATION: "Fiftieth Anniversary of Kodak" in foil seal on side.
CHARACTERISTICS: No. 2 Hawkeye Camera Model C in tan. Gold
lacquered metal parts and gold foil seal. Made to commemorate the
50th anniversary of the Eastman Kodak Co. **LENS:** Meniscus.
SHUTTER: Rotary. **FILM SIZE:** 120. **IMAGE:** 2¼x3¼ in. **BODY:**
3x4¼x5-5/8 in. **WEIGHT:** 12 oz. **DATES:** 1930-1930. **QUANTITY:**
550,000 (500,000 U.S.A. and 50,000 Canada).

From May 1 to May 31, 1930, the Eastman Kodak Co. gave away
550,000 cameras to any child in the U.S.A. or Canada whose twelfth
birthday fell in 1930. The child, accompanied by a parent or guardian,
simply went to any authorized Kodak dealer to receive the free camera
and a free roll of film. Two stated purposes of this mass giveaway
were: 1. In appreciation of the parents and grandparents of these
children who had helped amateur
photography and Kodak to grow. 2.
To further promote the popularity of
amateur photography, which will
increase the use of Kodak products.
The campaign was a smash success,
and if you don't believe it, just ask
anyone born in 1918. Many still
remember that special gift as the
high point of the depression years.

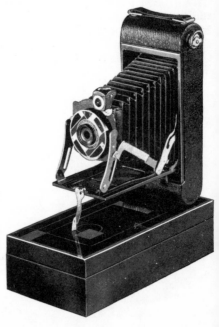

Above: Fiftieth Anniversary
 of Kodak camera.
Right: No. 1A Gift Kodak camera.

NO. 1A GIFT KODAK CAMERA

CHARACTERISTICS: Similar to No. 1A Pocket Kodak Jr. Camera in brown. **LENS:** Meniscus Achromatic. **SHUTTER:** Kodo. **FILM SIZE:** 116. **IMAGE:** 2½x4¼ in. **BODY:** 1½x3½x8 in. **WEIGHT:** 28 oz. **DATES:** 1930-1931. **PRICE:** $15.

A special rendition of the No. 1A Pocket Kodak Junior Camera which was introduced for the 1930 Christmas season. The camera is covered with brown genuine leather, and decorated with an enameled metal inlay on the front door, as well as a matching metal faceplate on the shutter. The case is a cedar box, the top plate of which repeats the art-deco design of the camera. (illustrated on previous page)

NO. 2 BEAU BROWNIE CAMERA

IDENTIFICATION: "Beau Brownie" on front. **CHARACTERISTICS:** Box camera with two-tone enameled faceplate in art-deco design. Available in black, blue, green, rose and tan. Matching carrying case also available. **LENS:** Doublet. **SHUTTER:** Rotary. **FILM SIZE:** 120. **IMAGE:** 2¼x3¼ in. **BODY:** 3x4x5½ in. **WEIGHT:** 16½ oz. **DATES:** 1930-1933. **PRICE:** $4. Green and rose available from 1930-1931 only.

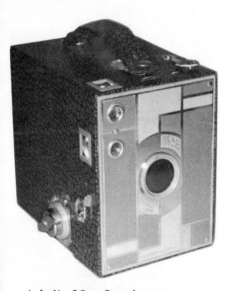 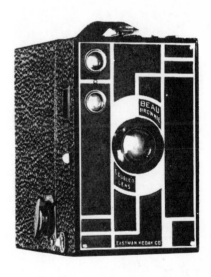

Left: No. 2 Beau Brownie camera
Right: No. 2A Beau Brownie camera

NO. 2A BEAU BROWNIE CAMERA

IDENTIFICATION: "Beau Brownie" on front. **CHARACTERISTICS:** Box camera with two-tone enameled faceplate in art-deco design. Available in black, blue, green, rose and tan. Matching cases also available. **LENS:** Doublet. **SHUTTER:** Rotary. **FILM SIZE:** 116. **IMAGE:** 2½x4¼ in. **BODY:** 3¼x5x6 in. **WEIGHT:** 21½ oz. **DATES:** 1930-1933. **PRICE:** $5. Green and rose available from 1930-1931 only.

BOY SCOUT BROWNIE CAMERA (FOR 120 FILM)

IDENTIFICATION: "Boy Scout Brownie" on strap. **CHARACTERIS-TICS:** Box camera with special faceplate with Boy Scout emblem. Uses 120 film (not 620). **LENS:** Meniscus. **SHUTTER:** Rotary. **FILM SIZE:** 120. **IMAGE:** 2¼x3¼ in. **BODY:** 3x4x5½ in. **WEIGHT:** 1 lb. **DATES:** 1932-1932. **PRICE:** $2.

This model, using 120 film, was made for only a short time in 1932. In 1932, Kodak introduced 620 film, and this camera was changed to take the new film and renamed "Six-20 Boy Scout Brownie".

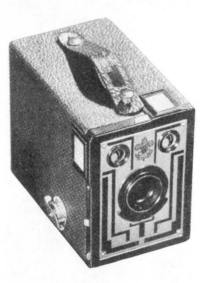 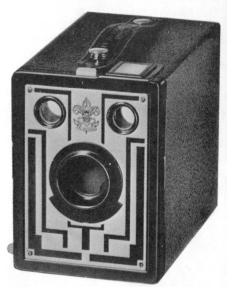

SIX-20 BOY SCOUT BROWNIE CAMERA

IDENTIFICATION: "Six-20 Boy Scout Brownie" on strap. **CHARACTERISTICS:** Box camera with Boy Scout emblem on front plate. **LENS:** Meniscus. **SHUTTER:** Rotary. **FILM SIZE:** 620. **IMAGE:** 2¼x3¼ in. **BODY:** 3x4x5 in. **WEIGHT:** 17 oz. **DATES:** 1933-1934. **PRICE:** $2.25.

CENTURY OF PROGRESS WORLD'S FAIR SOUVENIR CAMERA

IDENTIFICATION: "1833-1933 Century of Progress World's Fair Souvenir" on front plate. **CHARACTERISTICS:** Like No. 2 Brownie Special Camera (an export model), but with special faceplate. **LENS:** Doublet. **SHUTTER:** Rotary. **FILM SIZE:** 120. **IMAGE:** 2¼x3¼ in. **BODY:** 3x4x5½ in. **DATES:** 1933. Only about 2000 examples of this special commemorative camera were made because of the depressed economy in 1933.

TWO NEW FILMS WHICH DIDN'T CHANGE THE WORLD

Six-20 film was first introduced in 1932 for the Kodak Six-20 Camera. Until this time, Kodak films had been numbered sequentially by date of introduction, beginning with the No. 101 in 1895 and continuing through the No. 130 in 1916. From 1916-1932, no new film sizes were introduced by Kodak. Suddenly in 1932, Kodak introduced two new sizes, 620 and 616. These numbers did not fit the sequential film numbering system which had been used for the last 30 new sizes. This may have been due to the fact that these new sizes were primarily a change in the spool and not the size of the film. 616 and 620 spools were like 116 and 120 spools but with a smaller axle and narrower flange. The 116 and 120 spools had originated in 1899 and 1901 when the axles were made of wood and required the larger axle size for strength. Now that the spools were made of steel, the increased material and manufacturing costs for 116 and 120 spools were unneccessary.

Kodak's new 616 and 620 films were designed to replace the earlier sizes. To that end, Kodak stopped producing cameras for 116 and 120 film and introduced new cameras for the new film sizes. They even went so far as to change the Boy Scout Brownie Camera from 120 to 620 film even though this camera had only been around for a few months in the 120 film size. Kodak Ltd. in England and Kodak A.G. in Germany also made the switch, but the whole world was not ready to join in the switch. Had the change been made only for the larger 116/616 size, perhaps it would have succeeded, but the 120 film size, introduced by Kodak's own Brownie Camera in 1901, had become so widely used throughout the world that it refused to be replaced. Rolleiflex, Rolleicord, Super Ikonta, Dolly Supersport, Reflex Korelle, Pilot Reflex, Primarflex, Welta Perle, and many other cameras of foreign manufacture continued to use the old standby, 120.

It is purely speculative thinking, but what would have happened if other major manufacturers had responded to the new 620 film with important new camera designs to use it? Perhaps there would have been less incentive for Kodak to design quality cameras for 620 film. Certainly there would have been the Kodak Six-20, Vigilant Six-20 and Duaflex cameras, but would we have had the pleasure of such quality instruments as the Super Kodak Six-20, Medalist, and Chevron cameras? Did Kodak build these quality cameras for 620 film because nobody else would? With the benefit of hindsight, 620 film seems to have been unnecessary, because the battle was won by 120 film. The 116/616 battle was less significant because the size fell out of popularity.

KODAK SIX-16 CAMERA

IDENTIFICATION: "Six-16 Kodak" at base of lens standard. **CHARACTERISTICS:** Enameled art-deco body sides. Doublet and f6.3 models have self-erecting front with chrome bed supports. f4.5 model is not self-erecting. **LENS:** (see variations below). **SHUTTER:** (see variations below). **FILM SIZE:** 616 (introduced in 1932 with this camera). **IMAGE:** $2\frac{1}{2}$x$4\frac{1}{4}$ in. **BODY:** 1-5/8x3-3/8x7 in. **WEIGHT:** 26 oz. **DATES:** 1932-1934. **PRICE:** $11-30.

First camera made for the new 616 film. Available in black or brown.

DATES	LENS	SHUTTER	PRICE
1932-1932	Meniscus Achromatic (fixed focus)	Kodal	11
1932-1933	Kodak Doublet (fixed focus)	Kodon	13
1932-1933	Kodak Anast. f4.5	Diodak	30
1932-1934	Kodak Anast. f6.3	Diodak	17

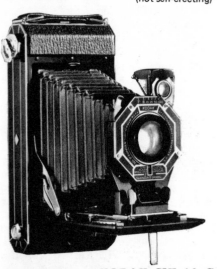

Kodak Six-16 camera
(not self-erecting)

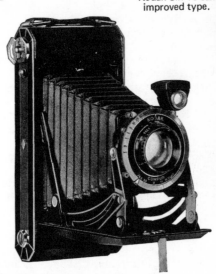

Kodak Six-16 came
improved type.

KODAK SIX-16 CAMERA (IMPROVED)

IDENTIFICATION: "Six-16 Kodak" on bed below lens. **CHARACTER-ISTICS:** Similar to earlier model, but with improved design for bed supports, recognizable by black enameling. All models including f4.5 are now self-erecting. **LENS:** (see variations below). **SHUTTER:** (see variations below). **FILM SIZE:** 616. **IMAGE:** $2\frac{1}{2}$x$4\frac{1}{4}$ in. **BODY:** 1-5/8x3-3/8x7 in. **WEIGHT:** 26 oz. **DATES:** 1934-1936. **PRICE:** $16-40.

DATES	LENS	SHUTTER	PRICE
1934-1935	Kodak Anast. f6.3	Diodak	20
1934-1936	Kodak Anast. f4.5	Compur	40
1934-1936	Kodak Doublet (focusing)	Kodon	16
1935-1936	Kodak Anast. f6.3	Dakar	20

KODAK SIX-20 CAMERA

CHARACTERISTICS: Enameled body sides in art-deco style. Self-erecting front with chrome bed supports. (f4.5 model not self-erecting.) **LENS:** (see variations below). **SHUTTER:** (see variations below). **FILM SIZE:** 620 (introduced in 1932 with this camera). **IMAGE:** $2\frac{1}{4}$x$3\frac{1}{4}$ in. **BODY:** $1\frac{1}{4}$x3x5-3/4 in. **WEIGHT:** 19 oz. **DATES:** 1932-1934. **PRICE:** $10-28.

The first camera made for the new 620 film. Available in black or brown.

DATES	LENS	SHUTTER	PRICE
1932-1932	Meniscus Achromatic	Kodal	10
1932-1934	Kodak Anast. f4.5	Diodak	28
1932-1934	Kodak Anast. f6.3	Kodon	15
1932-1934	Kodak Doublet (fixed focus)	Kodon	12
1933-1934	Kodak Doublet w/2 position focus	Kodon	14

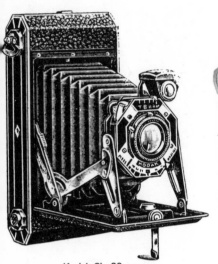

Kodak Six-20 camera

KODAK SIX-20 CAMERA
(IMPROVED)

CHARACTERISTICS: Similar to previous model, but with improved design for bed-support struts, most easily recognized by black enameling.
LENS: (see variations below).

Kodak Six-20 camera, improved model.

SHUTTER: Kodon. **FILM SIZE:** 620.
IMAGE: $2\frac{1}{4}$x$3\frac{1}{4}$ in. **BODY:** $1\frac{1}{4}$x3x5-3/4 in. **WEIGHT:** 19 oz. **DATES:** 1934-1937. **PRICE:** $14-38.

DATES	LENS	SHUTTER	PRICE
1934-1937	Kodak Doublet w/3 position focus	Kodon	14
1934-1937	Kodak Anast. f6.3	Kodon	18
1934-1937	Kodak Anast. f4.5	Compur	38

KODAK RANCA CAMERA

CHARACTERISTICS: Similar to Pupille Camera, but with dial-set Pronto shutter. **LENS:** Nagel Anast. f4.5. **SHUTTER:** Pronto. **FILM SIZE:** 127. **IMAGE:** 1-3/16x1-9/16 in. (3x4 cm) **BODY:** 2-1/8x$2\frac{1}{2}$x3-3/4 in. **WEIGHT:** 14 oz. **DATES:** 1932-1934. **PRICE:** $17.

Manufactured by Kodak A.G. (formerly Dr. Nagel-Werk) in Stuttgart, Germany.

KODAK PUPILLE CAMERA

CHARACTERISTICS: Quality compact camera for half-frame pictures on 127 film. Compur shutter. Helical focusing mount. **LENS:** Schneider Xenon f2.0. **SHUTTER:** Compur. **FILM SIZE:** 127. **IMAGE:** 1-3/16x1-9/16 in. (3x4 cm). **BODY:** 2x2-5/8x3-3/4 in. **WEIGHT:** 14 oz. **DATES:** 1932-1935. **PRICE:** $75-90.

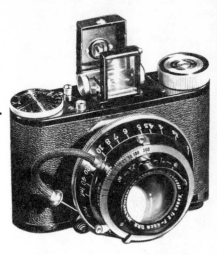

Manufactured by Kodak A.G. (formerly Dr. Nagel-Werk) in Stuttgart, Germany. The Pupille Camera was also sold in Europe as the Nagel Pupille where it was available with Xenar, Tessar, and Leitz Elmar lenses. The Nagel and Kodak models are both identified on the front of the shutter face.

KODAK VOLLENDA CAMERA

CHARACTERISTICS: Compact folding-bed camera with self-erecting strut-supported lensboard. **LENS:** (see variations below). **SHUTTER:** (see variations below). **FILM SIZE:** 127. **IMAGE:** 1-3/16x1-9/16 in. (3x4 cm) **BODY:** 1¼x3-1/8x4-3/8 in. **WEIGHT:** 12 oz. **DATES:** 1932-1937. **PRICE:** $20-44.

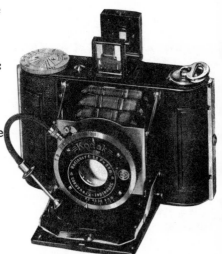

Made by Kodak A.G. (formerly Dr. Nagel-Werk) in Stuttgart, Germany. Other Vollenda models were marketed in Europe but not in the United States. These include:

Kodak Vollenda 620 Camera 6x9 cm
 (vertical body style) 1934-1939
Kodak Vollenda 620 Camera 6x6 cm
 (horizontal body style) 1940-1941
Kodak Vollenda Junior 620 Camera
 6x9 cm (vertical style) 1933-1937
Kodak Vollenda Junior 616 Camera
 6.5x11 cm (vertical style) 1934-1937

DATES	LENS	SHUTTER	PRICE
1932-1935	Schneider Radionar Anast. f3.5	Compur	28
1933-1937	Schneider Radionar Anast. f4.5	Pronto	20
1935-1937	Schneider Radionar Anast. f3.5	Compur Rapid	45

KODAK RECOMAR 18 CAMERA

IDENTIFICATION: "Kodak" embossed on front and back leather. "18" embossed on carry strap. **CHARACTERISTICS:** European-style folding plate camera. **LENS:** Kodak Anast. f4.5/105 mm. **SHUTTER:** Compur. **FILM TYPE:** filmpacks or plates. **IMAGE:** 2¼x3¼ in. **BODY:** 1-3/4x3-1/8x4-3/4 in. **WEIGHT:** 24 oz. **DATES:** 1932-1940. **PRICE:** $40-54.

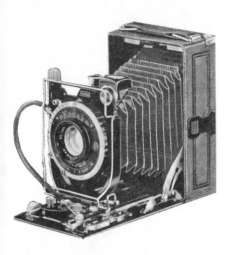 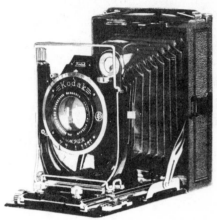

KODAK RECOMAR 33 CAMERA

IDENTIFICATION: "33" embossed on carry strap. "Kodak" embossed in leather on front and back. **LENS:** Kodak Anast. f4.5/135 mm. **SHUTTER:** Compur. **FILM TYPE:** filmpacks or plates. **IMAGE:** 3¼x4¼ in. **BODY:** 2x4¼x6 in. **WEIGHT:** 40 oz. **DATES:** 1932-1940. **PRICE:** $48-63.

SIX-16 BROWNIE CAMERA

IDENTIFICATION: Identified on strap but not on art-deco front. **CHARACTERISTICS:** Basic box camera with art-deco faceplate. Waist-level brilliant finders. Two-position focus with auxiliary lens. **LENS:** Diway. **SHUTTER:** Rotary. **FILM SIZE:** 616. **IMAGE:** 2½x4¼ in. **BODY:** 3½x5¼x5½ in. **WEIGHT:** 23 oz. **DATES:** 1933-1941. **PRICE:** $3.50. (illustrated on following page)

Replaced the No. 2A Brownie Camera (116 film) after 616 film was introduced. Replaced by Target Brownie Six-16 Camera in April 1941.

SIX-20 BROWNIE CAMERA

IDENTIFICATION: "Six-20 Brownie" on strap. **CHARACTERISTICS:** Box camera with metal art-deco front. Lever on front removes auxillary lens for close focusing. Brilliant finders. **LENS:** Diway. **SHUTTER:** Rotary. **FILM SIZE:** 620. **IMAGE:** 2¼x3¼ in. **BODY:** 3x4x5 in. **WEIGHT:** 16 oz. **DATES:** 1933-1941. **PRICE:** $2.50.

Replaced the No. 2 Brownie Camera (120 film) after the introduction of 620 film. (illustrated on following page)

Six-16 Brownie camera

Six-20 Brownie camera

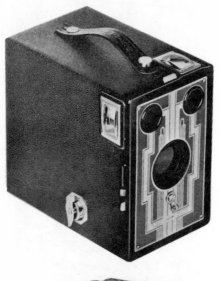

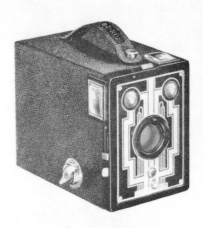

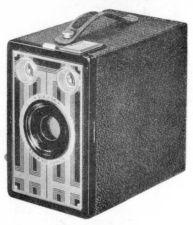

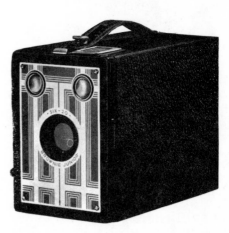

Six-16 Brownie Junior camera

Six-20 Brownie Junior camera

SIX-16 BROWNIE JUNIOR CAMERA

IDENTIFICATION: "Six-16 Brownie Junior" on faceplate and strap. **CHARACTERISTICS:** Basic box camera with art-deco faceplate. Like Six-16 Brownie Camera but reflex finders have ground glass. No auxiliary lens. **LENS:** Meniscus. **SHUTTER:** Rotary. **FILM SIZE:** 616. **IMAGE:** $2\frac{1}{2}$x$4\frac{1}{4}$ in. **BODY:** $3\frac{1}{2}$x$5\frac{1}{4}$x$5\frac{1}{2}$ in. **WEIGHT:** 22 oz. **DATES:** 1934-1942. **PRICE:** $2.75.

Some models have brass-colored faceplate with art-deco design. Some models have solid black faceplate with embossed design.

SIX-20 BROWNIE JUNIOR CAMERA

IDENTIFICATION: "Six-20 Brownie Junior" on faceplate around lens. **CHARACTERISTICS:** Fixed focus box camera. Ground glass reflex finders. **LENS:** Meniscus. **SHUTTER:** Rotary. **FILM SIZE:** 620. **IMAGE:** 2¼x3¼ in. **BODY:** 3x4x5 in. **WEIGHT:** 17 oz. **DATES:** 1934-1942. **PRICE:** $2.25. (illustrated on previous page)

JIFFY KODAK SIX-16 CAMERA

IDENTIFICATION: "Jiffy Kodak Six-16" below handle. **CHARACTER- ISTICS:** Strut camera with art-deco front. **LENS:** Twindar. **SHUTTER:** Built-in. **FILM SIZE:** 616. **IMAGE:** 2½x4¼ in. **BODY:** 1½x3½x7½ in. **WEIGHT:** 28 oz. **DATES:** 1933-1937. **PRICE:** $8.

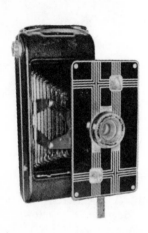 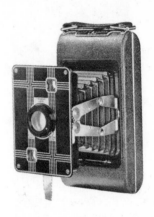

JIFFY KODAK SIX-20 CAMERA

IDENTIFICATION: "Jiffy Kodak Six-20" below handle. **CHARACTERISTICS:** Pop-out front with knee-struts. Art-deco faceplate. **LENS:** Twindar. **SHUTTER:** Built-in. **FILM SIZE:** 620. **IMAGE:** 2¼x3¼ in. **BODY:** 1-3/8x3¼x6¼ in. **WEIGHT:** 19 oz. **DATES:** 1933-1937. **PRICE:** $7.

JIFFY KODAK V.P. CAMERA

IDENTIFICATION: "Jiffy Kodak V.P." on the latch. **CHARACTERISTICS:** Black plastic body and front plate. Folding style with scissor-struts. Similar to the Bantam f6.3. **LENS:** Doublet (fixed focus). **SHUTTER:** Jiffy V.P. **FILM SIZE:** 127. **IMAGE:** 1-5/8x2½ in. **BODY:** 1-3/8x2-13/16x5½ in. **WEIGHT:** 10 oz. **DATES:** 1935-1942. **PRICE:** $5.

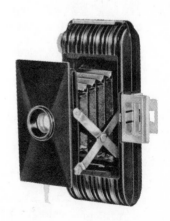

JIFFY KODAK SIX-16 SERIES II CAMERA

IDENTIFICATION: "Jiffy Kodak Six-16 Series II" below handle. **CHARACTERISTICS:** Similar to earlier model, but with black pin-grain imitation leather front. **LENS:** Twindar. **SHUTTER:** Built-in. **FILM SIZE:** 616. **IMAGE:** 2½x4¼ in. **BODY:** 1-7/8x3-3/4x7-13/16 in. **WEIGHT:** 26½ oz. **DATES:** 1937-1942. **PRICE:** $10.

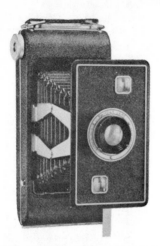
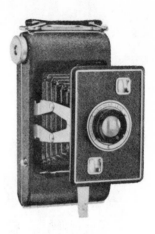

Jiffy Kodak Six-16 Series II camera Jiffy Kodak Six-20 Series II camera

JIFFY KODAK SIX-20 SERIES II CAMERA

IDENTIFICATION: "Jiffy Kodak Six-20 Series II" below handle. **CHARACTERISTICS:** Similar to early model, but black pin-grain imitation leather front. **LENS:** Twindar. **SHUTTER:** Built-in. **FILM SIZE:** 620. **IMAGE:** 2¼x3¼ in. **BODY:** 1-11/16x3½x6-9/16 in. **WEIGHT:** 18½ oz. **DATES:** 1937-1948. **PRICE:** $9.

KODAK ENTERS THE FIELD OF 35MM PHOTOGRAPHY

Kodak's entry into the field of 35mm photography with the Retina Camera in 1934 necessitated a new film. The popular Leica and Contax cameras were already using 35mm film in a 24x36 mm format, but the film had to be spooled by the user into special re-loadable cassettes. Reloadable cassettes were a very logical approach when 35mm cameras were introduced, since short ends of 35mm cine film were readily available and inexpensive. Many manufacturers had used 35mm film, each with its own cassette design. Kodak could have done the same by introducing a totally new design for a reloadable cassette, but by 1934, the picture frame size and exposures per roll had been standardized by Leica and Contax cameras. Kodak produced a new design which was compatible with Leica and Contax cameras, but with the added advantage of being disposable. The simplification and further standardization provided by this new film cassette were significant steps forward in 35mm photography.

RETINA CAMERAS

Eastman Kodak entered the 35mm camera market during the slow recovery from the depression, and the Retina cameras were especially designed to attract customers who couldn't afford the Leica and Contax cameras. Eastman had purchased the Nagel Camerawerk in 1932 to provide good quality cameras at the more reasonable prices allowed by reduced labor costs in Germany. Fortunately, Eastman Kodak had kept Dr. August Nagel at the helm of the Stuttgart facility, now called Kodak A.G. The responsibility of designing a low cost quality camera for Kodak's 35mm debut was given to Dr. Nagel, who had a proven track record long before he sold his factory to Eastman Kodak.

Nagel designed the first folding 35mm camera after the traditional bed and bellows style, but he gave extra support to the lens standard with a pair of scissor-struts. This precision arrangement for positioning the lens allowed for maximum sharpness in a camera which also folded to encase itself and slipped easily into a pocket. Best of all, this handy little camera could be purchased for just over $50 while a Leica commanded close to $200.

A long succession of Retina cameras followed with minor changes. The most accurate and widely accepted method of classifying the Retina cameras is by the Stuttgart factory type number. Since the Retina line covers such a long time span, we are providing a short chronological summary on page 171 for the convenience of the reader.

While many models were not originally marketed in the U.S.A. and technically fall outside the scope of this work, it would be impossible to ignore them. This book, however, illustrates only those Retina Cameras which were marketed in the USA and Canada, although we have made notations on the other models which were not imported.

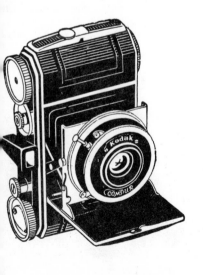 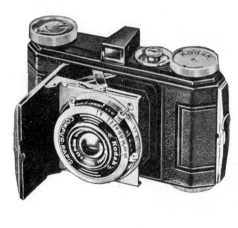

Left: Kodak Retina camera (type 117)
Right: Kodak Retina camera (type 118)

KODAK RETINA CAMERA (TYPE 117)
CHARACTERISTICS: Film advance release wheel next to winding knob. Top film sprocket with short shaft. Rewind release on advance

91

knob. Large diameter advance and rewind knobs. Black finish with nickel trim. **LENS:** Schneider Xenar f3.5. **SHUTTER:** Compur -1/300. **FILM SIZE:** 135. **IMAGE:** 24x36 mm. **BODY:** 1¼x3x4-3/4 in. **WEIGHT:** 1 lb. **DATES:** 1934-1935. **PRICE:** $53. Made by Kodak AG.

KODAK RETINA CAMERA (TYPE 118)

CHARACTERISTICS: Film advance release lever at rear of top housing. Full length film sprocket shaft with top sprocket only. Rewind release on advance knob. **LENS:** Schneider Xenar f3.5. **SHUTTER:** Compur Rapid -1/500. **FILM SIZE:** 135. **IMAGE:** 24x36 mm. **BODY:** 1¼x3x4-3/4 in. **WEIGHT:** 1 lb. **DATES:** 1935-1937. **PRICE:** $58. Made by Kodak A.G. (illustrated on preceding page)

KODAK RETINA II CAMERA (TYPE 122)

IDENTIFICATION: "Retina" in script on top of the camera. **CHARACTERISTICS:** Lever film advance. Coupled rangefinder with separate eyepiece. Two round rangefinder windows. **LENS:** Kodak Anast. Ektar f3.5, Schneider Xenon f2.8 or f2.0. **SHUTTER:** Compur Rapid. **FILM SIZE:** 135. **IMAGE:** 24x36 mm. **BODY:** 1½x3-1/8x4-7/8 in. **WEIGHT:** 18 oz. **DATES:** 1936-1937. Made by Kodak A.G. Not imported into the USA.

KODAK RETINA CAMERA (I) (TYPE 119)

CHARACTERISTICS: Recessed exposure counter between advance knob and viewfinder. Rewind release lever to right of film advance release button. Black lacquered metal parts. Lacks accessory shoe. Reduced diameter advance and rewind knobs. Five milled rows on rewind knob. **LENS:** Kodak Ektar f3.5 or Schneider Xenar f3.5. **SHUTTER:** Compur or Compur Rapid. **FILM SIZE:** 135. **IMAGE:** 24x36 mm. **BODY:** 1½x3x4-3/4 in. **WEIGHT:** 1 lb. **DATES:** 1936-1938. Made by Kodak A.G. Not marketed in the USA. This model was not called "I" until 1937.

KODAK RETINA CAMERA (I) (TYPE 126)

CHARACTERISTICS: Compur-Rapid shutter. Five milled rows on rewind knob. Accessory shoe (or 2 mounting screws) between finder and rewind knob. **LENS:** (see variations below). **SHUTTER:** Compur Rapid. **FILM SIZE:** 135. **IMAGE:** 24x36 mm. **BODY:** 1½x3x4-3/4 in. **WEIGHT:** 1 lb. **DATES:** 1936-1938. **PRICE:** $58.

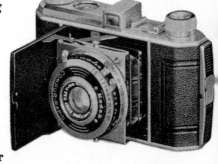

Made by Kodak A.G. Available with black or chrome trim. This model was not called "I" until 1937. Only the model with the Kodak Ektar f3.5 lens was sold in the USA. In Europe a Schneider Xenar f3.5, Zeiss Tessar f3.5, Rodenstock Ysar, and Angenieux Alcor were available.

KODAK DUO SIX-20 CAMERA

IDENTIFICATION: "Kodak Duo Six-20" on bed. **CHARACTERISTICS:** Horizontally styled self-erecting camera for half-frame 620. Black enameled top plate and finder. Folding rewind key. **LENS:** Kodak Anast. f3.5. **SHUTTER:** (see variations below). **FILM SIZE:** 620. **IMAGE:** 1-5/8x2¼ in. **BODY:** 1-3/8x3½x5 in. (4.5x6 cm) **WEIGHT:** 17 oz. **DATES:** 1934-1937. **PRICE:** $53-58.

Made by Kodak A.G. (Dr. Nagel-Werk) in Stuttgart.

DATES	LENS	SHUTTER	PRICE
1934-1935	Kodak Anast. f3.5	Compur	53
1935-1937	Kodak Anast. f3.5	Compur Rapid	58
	Kodak Anast. f4.5	Pronto	EUR
	Zeiss Tessar f3.5	Pronto	EUR

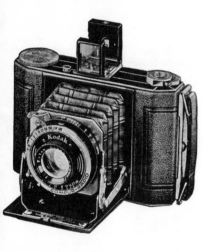 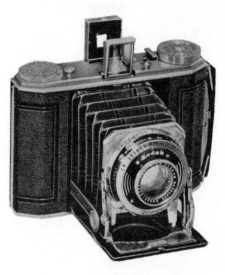

Left: Kodak Duo Six-20 camera
Right: Kodak Duo Six-20 Series II camera

KODAK DUO SIX-20 SERIES II CAMERA

CHARACTERISTICS: Like Duo Six-20 Camera, but with improved strut design. Release bar for closing on front edge of bed. Chrome top plate and finder. Advance knob without folding key. **LENS:** Kodak Anast. f3.5. **SHUTTER:** Compur Rapid. **FILM SIZE:** 620. **IMAGE:** 1-5/8x2¼ in. **BODY:** 1½x3-3/4x5-1/8 in. **WEIGHT:** 22 oz. **DATES:** 1937-1939. **PRICE:** $52-58.

KODAK DUO SIX-20 SERIES II CAMERA W/RANGEFINDER

IDENTIFICATION: "Duo Six-20 Series II" embossed on back. **CHARACTERISTICS:** Coupled rangefinder combined with viewfinder in single eyepiece. Automatic film stop and exposure counter. Body release with double exposure prevention. **LENS:** Kodak Anast. f3.5. **SHUTTER:** Compur Rapid. **FILM SIZE:** 620. **IMAGE:** 1-5/8x2¼ in. **BODY:** 1½x4x5 in. **WEIGHT:** 24 oz. **DATES:** 1939-1940. **PRICE:** $85. (illustrated on following page)

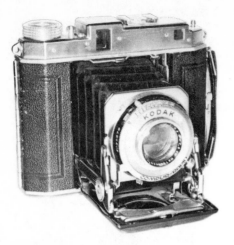
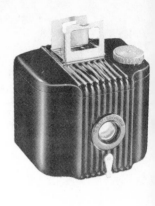

Left: Kodak Duo Six-20 Series II camera w/RF
Right: Baby Brownie camera

BABY BROWNIE CAMERA
IDENTIFICATION: 'Baby Brownie' on lens rim. **CHARACTERISTICS:** Small bakelite box camera with shutter lever below lens. Folding frame finder. **LENS:** Meniscus. **SHUTTER:** Rotary. **FILM SIZE:** 127. **IMAGE:** 1-5/8x2½ in. **BODY:** 2½x2-3/4x3-1/8 in. **WEIGHT:** 6.5 oz. **DATES:** 1934-1941. **PRICE:** $1.

This was the first Kodak camera to be made of molded plastic. Export model has small button above lens for time exposures.

KODAK REGENT CAMERA
CHARACTERISTICS: Rangefinder incorporated into streamlined leather covered body. **LENS:** Schneider Xenar f3.8 or f4.5, Zeiss Tessar f4.5/105 mm. **SHUTTER:** Compur-S 1/250 or Compur Rapid 1/400. **FILM SIZE:** 620. **IMAGE:** 2¼x3¼ in. or 1-3/4x2¼ in. **BODY:** 1¼x4x7½ in. **WEIGHT:** 20 oz. **DATES:** 1935-1939. Made by Kodak A.G. Not imported into the U.S.A.

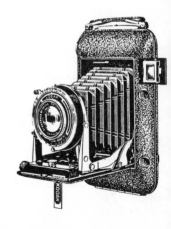

KODAK REGENT II CAMERA
IDENTIFICATION: 'Regent II' on top of chrome rangefinder housing. **CHARAC-TERISTICS:** Folding bed style similar to Vollenda 620 camera but with coupled rangefinder on right side of body. **LENS:** Schneider Xenar f3.5/105 mm. **SHUTTER:** Compur Rapid. **FILM SIZE:** 620. **IMAGE:** 2¼x3¼ in. or 1-3/4x2¼ in. **DATES:** 1939-1939. Made by Kodak A.G. Not imported into the U.S.A.

KODAK JUNIOR SIX-16 CAMERA

IDENTIFICATION: 'Kodak Junior Six-16' on front of bed. **CHARAC-TERISTICS:** Octagonal shutter face. Self-erecting. **LENS:** (see variations below). **SHUTTER:** (see variations below). **FILM SIZE:** 616. **IMAGE:** 2½x4¼ in. **DATES:** 1935-1937. **PRICE:** $12-16.

DATES	LENS	SHUTTER	PRICE
1935-1937	Kodak Doublet	Kodon	12
1935-1937	Kodak Anast. f6.3	Kodex	16

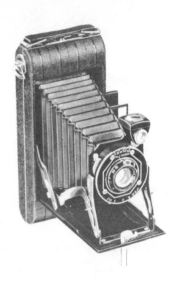 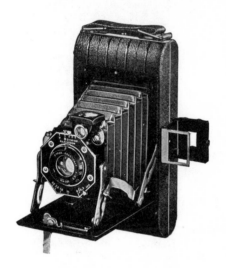

Left: Kodak Junior Six-16 camera
Right: Kodak Junior Six-20 camera

KODAK JUNIOR SIX-20 CAMERA

IDENTIFICATION: "Kodak Junior Six-20" on front of bed. **CHARAC-TERISTICS:** Octagonal shutter face. Self-erecting. **LENS:** (see variations below). **SHUTTER:** Kodon. **FILM SIZE:** 620. **IMAGE:** 2¼x3¼ in. **BODY:** 1¼x3x6 in. **WEIGHT:** 18 oz. **DATES:** 1935-1937. **PRICE:** $10-14.

DATES	LENS	SHUTTER	PRICE
1935-1937	Kodak Doublet	Kodon	10
1935-1937	Kodak Anast. f6.3	Kodon	14

KODAK JUNIOR SIX-16 SERIES II CAMERA

IDENTIFICATION: 'Kodak Junior Six-16 Series II' on front edge of bed. **CHARACTERISTICS:** Self-erecting with quick release bar at front of bed. **LENS:** (see variations below). **SHUTTER:** (see variations below). **FILM SIZE:** 616. **IMAGE:** 2½x4¼ in. **BODY:** 1½x3¼x7½ in. **WEIGHT:** 27 oz. **DATES:** 1937-1940. **PRICE:** $11-16. (illus. on next page)

DATES	LENS	SHUTTER	PRICE
1937-1938	Kodak Anast. f6.3	Kodex	16
1937-1940	Single (fixed focus)	Kodal	11
1937-1940	Bimat w/3 position focus	Kodon	14

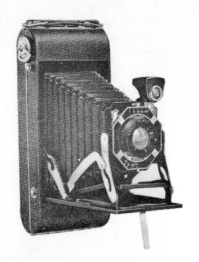
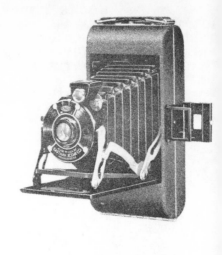

Kodak Junior Six-16 Series II camera　　Kodak Junior Six-20 Series II camera

KODAK JUNIOR SIX-20 SERIES II CAMERA

IDENTIFICATION: 'Kodak Junior Six-20 Series II' on front edge of bed.
CHARACTERISTICS: Self-erecting with quick release bar at front of bed. **LENS:** (see variations below). **SHUTTER:** (see variations below). **FILM SIZE:** 620. **IMAGE:** $2\frac{1}{4}$x$3\frac{1}{4}$ in. **DATES:** 1937-1940. **PRICE:** $9-14.

DATES	LENS	SHUTTER	PRICE
1937-1938	Kodak Anast. f6.3/100 mm	Kodon	14
1937-1940	Single (fixed focus)	Kodo	9
1937-1940	Bimat w/3 position focus	Kodon	12

KODAK JUNIOR SIX-16 SERIES III CAMERA

CHARACTERISTICS: Self-erecting with new streamlined bed supports.
LENS: (see variations below). **SHUTTER:** (see variations below).
FILM SIZE: 616. **IMAGE:** $2\frac{1}{2}$x$4\frac{1}{4}$ in. **DATES:** 1938-1939. **PRICE:** $16-30. (illustrated on next page)

DATES	LENS	SHUTTER	PRICE
1938-1939	Kodak Anast. f8.8	Kodex	16
1938-1939	Kodak Anast. f6.3	Kodex	18
1938-1939	Kodak Anast. f4.5	Diomatic	30

KODAK JUNIOR SIX-20 SERIES III CAMERA

CHARACTERISTICS: Self-erecting with new streamlined bed supports.
LENS: (see variations below). **SHUTTER:** (see variations below).
FILM SIZE: 620. **IMAGE:** $2\frac{1}{4}$x$3\frac{1}{4}$ in. **DATES:** 1938-1939. **PRICE:** $14-25. (illustrated on next page)

DATES	LENS	SHUTTER	PRICE
1938-1939	Kodak Anast. f8.8	Kodex	14
1938-1939	Kodak Anast. f6.3	Kodex	16
1938-1939	Kodak Anast. f4.5	Diomatic	25

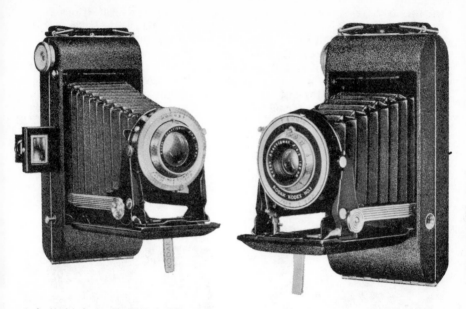

Left: Kodak Junior Six-16 Series III camera
Right: Kodak Junior Six-20 Series III camera

BANTAM FILM– A SUBSTITUTE FOR 35MM

Only a year after introducing the standard disposable 35mm cartridge, Kodak introduced a new rollfilm. It was numbered 828 because it took 8 exposures 28mm wide on a 35mm wide film strip. The new film made better use of the film area by using a single perforation on one edge to mark each frame. The resulting 28x40mm area is nearly 30% larger than the 24x36mm format of the 35mm film. Logically it should have been accepted as a good alternative, but 35mm was already too firmly extrenched to be easily replaced. Despite its lack of acceptance in its original form, the Bantam size continues on today in the improved 126 cassette which takes 28mm wide photos with a single perforation per frame.

KODAK BANTAM CAMERA (WITH RIGID FINDER)

CHARACTERISTICS: Bakelite strut-type vest pocket camera. Tubular-type viewfinder. **LENS:** (see variations below). **SHUTTER:** Built-in. **FILM SIZE:** 828 (introduced in 1935 with this camera). **IMAGE:** 28x40 mm. **BODY:** 1x2¼x4-3/8 in. **WEIGHT:** 8 oz. **DATES:** 1935-1938. **PRICE:** $6-10. (illustrated on following page)

DATES	LENS	SHUTTER	PRICE
1935-1937	Kodak Anast. f6.3	Built-in	10
1935-1938	Doublet f12.5	Built-in	6

KODAK BANTAM SPECIAL CAMERA

IDENTIFICATION: "Kodak Bantam Special" cast inside front. **CHARACTERISTICS:** Black enameled cast aluminum body with

horizontal metal stripes. Helical focus with coupled rangefinder. **LENS:** (see variations below). **SHUTTER:** (see variations below). **FILM SIZE:** 828. **IMAGE:** 28x40 mm. **BODY:** 1-3/4x3¼x4-7/8 in. **WEIGHT:** 17 oz. **DATES:** 1936-1948. **PRICE:** $88-117.

The Bantam Special Camera was a masterpiece of art-deco styling with quality construction and an excellent shutter and lens combination. World War II forced a change in the shutter from the German Compur to Kodak's Supermatic, but in either variation it was the best camera for 828 film that money could buy.

DATES	LENS	SHUTTER	PRICE
1936-1940	Kodak Anast. Ektar f2	Compur Rapid	110
1941-1948	Kodak Anast. Ektar f2	Supermatic	117

Kodak Bantam camera (with rigid finder) Kodak Bantam Special camera

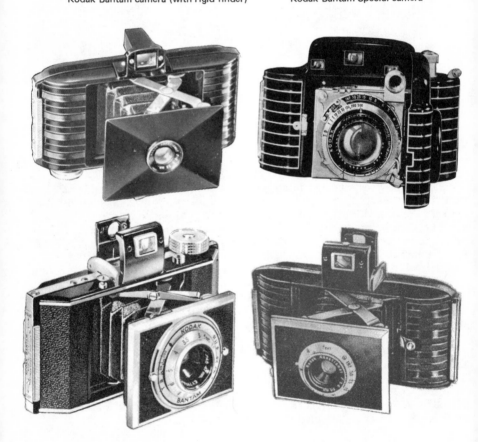

Kodak Bantam f4.5 camera Kodak Bantam f5.6 camera

KODAK BANTAM F4.5 CAMERA
IDENTIFICATION: "Kodak" above the lens. "Bantam" below the lens. **CHARACTERISTICS:** Diecast aluminum body with imitation leather

covering. **LENS:** Kodak Anast. Special f4.5. **SHUTTER:** Built-in. **FILM SIZE:** 828. **IMAGE:** 28x40 mm. **BODY:** 1½x2-3/4x4½ in. **WEIGHT:** 12 oz. **DATES:** 1938-1948. **PRICE:** $28.

KODAK BANTAM F5.6 CAMERA
IDENTIFICATION: "Kodak Bantam" on the latch. **CHARACTERIS-TICS:** Body style like f6.3 model, but flat metal faceplate and focusing lens. **LENS:** Kodak Anast. f5.6. **SHUTTER:** Built-in. **FILM SIZE:** 828. **IMAGE:** 28x40 mm. **BODY:** 1x2¼x4-3/8 in. **WEIGHT:** 9½ oz. **DATES:** 1938-1941. **PRICE:** $17. (illustrated on previous page)

KODAK BANTAM F6.3 CAMERA
(WITH FOLDING OPTICAL FINDER)
IDENTIFICATION: "Kodak Bantam" on the latch. **CHARACTERIS-TICS:** Styled like original model but has folding eye-level finder. **LENS:** Kodak Anast. f6.3. **SHUTTER:** Built-in. **FILM SIZE:** 828. **IMAGE:** 28x40 mm. **BODY:** 1x2¼x4-3/8 in. **WEIGHT:** 8 oz. **DATES:** 1938-1947. **PRICE:** $10.

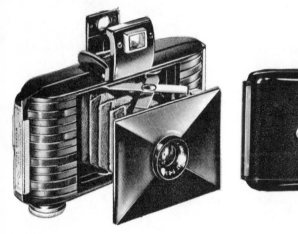
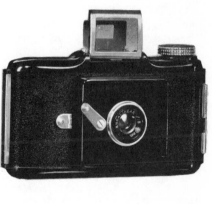

Kodak Bantam f6.3 camera Kodak Bantam f8 camera

KODAK BANTAM F8 CAMERA
IDENTIFICATION: "Kodak Bantam" on back catch. **CHARACTER-ISTICS:** Bakelite body with square telescoping front. **LENS:** Kodalinear f8. **SHUTTER:** Built-in. **FILM SIZE:** 828. **IMAGE:** 28x40 mm. **BODY:** 1x2-3/8x4-3/8 in. **WEIGHT:** 7 oz. **DATES:** 1938-1942. **PRICE:** $5.

BULLET CAMERA
IDENTIFICATION: "Bullet Camera" on lens rim. **CHARACTERISTICS:** Bakelite body with helical telescoping front. **LENS:** Meniscus. **SHUTTER:** Rotary. **FILM SIZE:** 127. **IMAGE:** 1-5/8x2½ in. **BODY:** 1-7/8x2-3/4x4-7/8 in. **WEIGHT:** 7 oz. **DATES:** 1936-1942. **PRICE:** $2.85. (illustrated on following page)

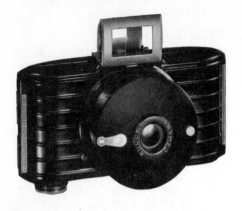

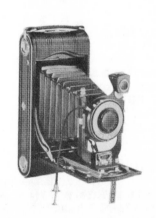

NO. 3A KODAK SERIES II CAMERA

IDENTIFICATION: "3A Kodak Series II" on lens standard. **LENS:** (see variations below). **SHUTTER:** (see variations below). **FILM SIZE:** 122. **IMAGE:** $3\frac{1}{4}$x$5\frac{1}{2}$ in. **BODY:** 2x4-7/8x10 in. **WEIGHT:** 3 lb. 2 oz. **DATES:** 1936-1941. **PRICE:** $40-75.

Replaced by the No. 3A Kodak Series III camera in July 1941.

DATES	LENS	SHUTTER	PRICE
1936-1941	Kodak Anast. f6.3	Diodak	40
1937-1940	Kodak Anast. f4.5	Compur	75

NO. 3A KODAK SERIES III CAMERA

IDENTIFICATION: "3A Kodak Series III" on lens standard.
CHARACTERISTICS: Like the 3A Kodak Series II Camera, but with a Kodamatic shutter.
LENS: Kodak Anast. f6.3.
SHUTTER: Kodamatic.
FILM SIZE: 122.
IMAGE: $3\frac{1}{4}$x$5\frac{1}{2}$ in.
BODY: 2x4-7/8x10 in.
WEIGHT: 3 lb. 2 oz.
DATES: 1941-1943. **PRICE:** $56.

This camera replaced the No. 3A Kodak Series II (1936-1941).

KODAK SENIOR SIX-16 CAMERA

IDENTIFICATION: "Kodak Senior Six-16" on release bar at front of bed. **LENS:** (see variations below). **SHUTTER:** (see variations below). **FILM SIZE:** 616. **IMAGE:** 2½x4¼ in. **DATES:** 1937-1939. **PRICE:** $18-34.

DATES	LENS	SHUTTER	PRICE
1937-1939	Bimat	Kodex	18
1937-1939	Kodak Anast. f4.5	Kodamatic	34
1937-1939	Kodak Anast. f6.3	Kodex	22
1938-1939	Kodak Anast. f6.3	Diomatic	25
1938-1939	Kodak Anast. f7.7	Kodex	20

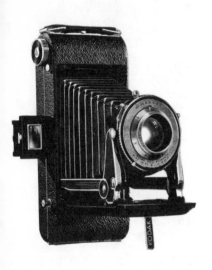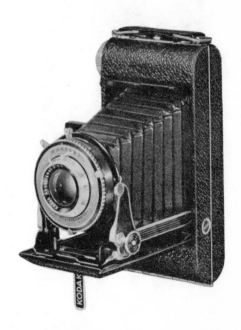

Left: Kodak Senior Six-16 camera
Right: Kodak Senior Six-20 camera

KODAK SENIOR SIX-20 CAMERA

IDENTIFICATION: "Kodak Senior Six-20" on release bar at front of bed. **LENS:** (see variations below). **SHUTTER:** (see variations below). **FILM SIZE:** 620. **IMAGE:** 2¼x3¼ in. **BODY:** 1½x3¼x6 in. **WEIGHT:** 22 oz. **DATES:** 1937-1939. **PRICE:** $16-30.

DATES	LENS	SHUTTER	PRICE
1937-1939	Bimat	Kodex	16
1937-1939	Kodak Anast. f4.5	Kodamatic	30
1937-1939	Kodak Anast. f6.3	Kodex	20
1938-1939	Kodak Anast. f6.3	Diomatic	21
1938-1939	Kodak Anast. f7.7	Kodex	17

KODAK SPECIAL SIX-16 CAMERA

CHARACTERISTICS: Similar to Kodak Junior Six-16 Series III Camera but with better lens and shutter. **LENS:** (see variations below). **SHUTTER:** (see variations below). **FILM SIZE:** 616. **IMAGE:** 2½x4¼

in. **DATES:** 1937-1939. **PRICE:** $37-49.

DATES	LENS	SHUTTER	PRICE
1937-1938	Kodak Anast. f4.5	Kodamatic	37
1937-1939	Kodak Anast. Special f4.5	Kodamatic	41
1937-1939	Kodak Anast. Special f4.5	Compur Rapid	49
1939-1939	Kodak Anast. Special f4.5	Supermatic	43

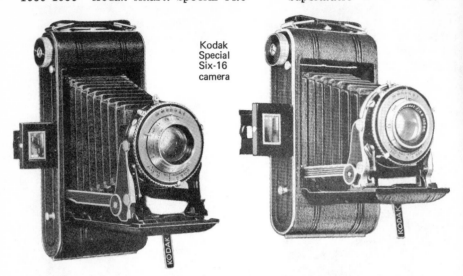

Kodak Special Six-16 camera

Kodak Special Six-20 camera

KODAK SPECIAL SIX-20 CAMERA

CHARACTERISTICS: Similar to Kodak Junior Six-20 Series III Camera but with better lens and shutter. **LENS:** (see variations below). **SHUTTER:** (see variations below). **FILM SIZE:** 620. **IMAGE:** $2\frac{1}{4}$x$3\frac{1}{4}$ in. **DATES:** 1937-1939. **PRICE:** $33-45.

DATES	LENS	SHUTTER	PRICE
1937-1938	Kodak Anast. f4.5	Kodamatic	33
1937-1939	Kodak Anast. Special f4.5	Kodamatic	38
1937-1939	Kodak Anast. Special f4.5	Compur Rapid	45
1939-1939	Kodak Anast. Special f4.5	Supermatic	40

KODAK RETINA I CAMERA (TYPE 141)

CHARACTERISTICS: Body shutter release inside edge of exposure counter disc. Seven milled rows on rewind knob. **LENS:** Kodak Anast. Ektar or Schneider Xenar f3.5. **SHUTTER:** Compur or Compur Rapid. **FILM SIZE:** 135. **IMAGE:** 24x36 mm. **BODY:** $1\frac{1}{2}$x3x4-3/4 in. **WEIGHT:** 17 oz. **DATES:** 1937-1939. **PRICE:** $49.

Made by Kodak A.G. Only the version with the Ektar lens and Compur Rapid shutter was sold in the USA. Available only with chrome trim. (illustrated on following page)

KODAK RETINA II CAMERA (TYPE 142)

IDENTIFICATION: "Retina II", with the "II" encircled, on top of camera. **CHARACTERISTICS:** Knob film advance. Coupled rangefinder

with separate eyepiece. Two round rangefinder windows. **LENS:** (see variations below). **SHUTTER:** Compur Rapid. **FILM SIZE:** 135. **IMAGE:** 24x36 mm. **BODY:** 1-5/8x3¼x4-3/4 in. **WEIGHT:** 21 oz. **DATES:** 1937-1939. **PRICE:** $115-140.

Made by Kodak A.G. The version with the Kodak Anast. Ektar lens was not sold in the USA.

DATES	LENS	SHUTTER	PRICE
1937-1939	Schneider Xenon f2.8	Compur Rapid	115
1937-1939	Schneider Xenon f2.0	Compur Rapid	140
1937-1939	Kodak Anast. Ektar f3.5	Compur Rapid	EUR

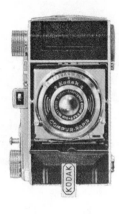

Kodak Retina I camera (type 141)

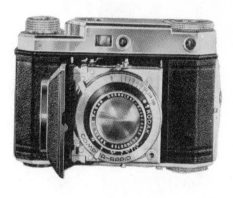

Kodak Retina II camera (type 142)

KODAK SUPREMA CAMERA
CHARACTERISTICS: Self-erecting rollfilm camera. **LENS:** Schneider Xenar f3.5/80 mm. **SHUTTER:** Compur Rapid 1-1/400. **FILM SIZE:** 620. **IMAGE:** 2¼x2¼ in. **DATES:** 1938-1939. **QUANTITY:** about 2000.
Made by Kodak A.G. Not imported into the U.S.A.

SIX-20 BULL'S-EYE BROWNIE CAMERA
IDENTIFICATION: "Six-20 Bull's-Eye Brownie" around lens rim. **CHARACTERISTICS:** Black bakelite trapezoidal box camera. Similar in style to the Six-20 Brownie Special camera. Not synchronized. **LENS:** Meniscus. **SHUTTER:** single action. **FILM SIZE:** 620. **IMAGE:** 2¼x3¼ in. **BODY:** 3-5/8x4-1/16x4-5/16 in. **WEIGHT:** 16 oz. **DATES:** 1938-1941. **PRICE:** $3.

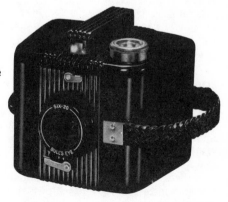

SIX-16 BROWNIE SPECIAL CAMERA

IDENTIFICATION: "Six-16 Brownie Special" around lens. **CHARAC-TERISTICS:** Trapezoidal metal box camera without flash sync. **LENS:** Meniscus. **SHUTTER:** Rotary. **FILM SIZE:** 616. **IMAGE:** 2½x4¼ in. **DATES:** 1938-1942. **PRICE:** $4.50.

While the Six-20 size of this camera was later synchronized and was quite popular until 1954, the Six-16 size never received that improvement and was discontinued in 1942.

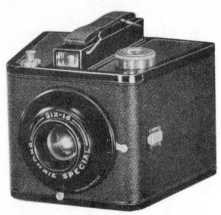

Six-16 Brownie Special camera Six-20 Brownie Special camera

SIX-20 BROWNIE SPECIAL CAMERA

IDENTIFICATION: "Six-20 Brownie Special" around lens. **CHARACTERISTICS:** Trapezoid-shaped metal box camera without flash sync. **LENS:** Meniscus. **SHUTTER:** Rotary. **FILM SIZE:** 620. **IMAGE:** 2¼x3¼ in. **BODY:** 3½x3-3/4x4¼ in. **WEIGHT:** 18 oz. **DATES:** 1938-1942. **PRICE:** $4.

SUPER KODAK SIX-20 CAMERA

IDENTIFICATION: "Super Kodak Six-20" on a plate on front of bed. **CHARACTERISTICS:** "Clamshell" front with meter cell and rangefinder at top. **LENS:** Kodak Anast. Special f3.5. **SHUTTER:** Built-in 8 speed. **FILM SIZE:** 620. **IMAGE:** 2¼x3¼ in. **BODY:** 2-3/8x3-13/16x8-3/16 in. **WEIGHT:** 44 oz. **DATES:** 1938-1944. **PRICE:** $225.

This exceptional camera has the honor of introducing to the world the benefit of automatic exposure control. The user chooses the desired shutter speed and a large selenium cell automatically adjusts the diaphragm for the correct exposure. This feature alone would make the Super Kodak Six-20 Camera a landmark achievement in photography, and therefore a desired collectable. But, the camera also shows classic styling, is of durable and quality construction with a die cast aluminum body, and offers numerous features which make it stand head and shoulders above the crowd of cameras of the day. The film winding crank winds the film, tensions the shutter, and automatically opens and closes the cover over the exposure number window. The viewfinder and

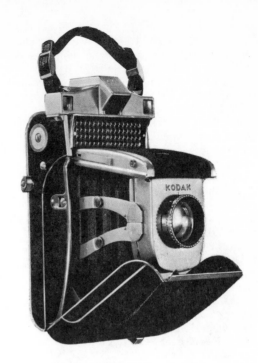

coupled wide-base rangefinder are combined in a single eyepiece, certainly more convenient than the separate eyepiece style in use on the prestigious Leica 35mm cameras available in 1938. The fast f3.5 lens makes it competitive with most 35mm cameras for low-light use. The high price of this quality camera, the ever-increasing popularity of 35mm cameras, and market pressures during the war years combined to make the Super Kodak Six-20 a financial diaster, and it was dropped from the Kodak line-up with less than 725 cameras sold to the public.

KODAK 35 CAMERA

IDENTIFICATION: "Kodak 35" on folding optical finder. **CHARACTERISTICS:** 35mm camera with bakelite body. **LENS:** (see variations below). **SHUTTER:** (see variations below). **FILM SIZE:** 135. **IMAGE:** 24x36 mm. **BODY:** 2-3/4x2-3/4x5½ in. **WEIGHT:** 18 oz. **DATES:** 1938-1948. **PRICE:** $14-58.

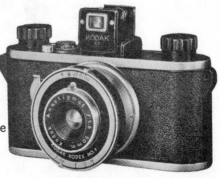

F3.5 and f4.5 models have double exposure prevention, chrome knobs and finder. F5.6 model has black knobs and finder. (Also made in a military model with an olive drab body and black trim. "PH-324" is

printed on the back.)

The Kodak 35 Camera was introduced about 2 years after the low-priced Argus A. But in the same year, Argus introduced the Model C with a coupled rangefinder. Kodak thus faced stiff competition from Argus who had lower priced basic cameras, and a rangefinder model for the appealing price of $25.00.

DATES	LENS	SHUTTER	PRICE
1938-1945	Kodak Anast. f5.6	Kodex	19
1938-1948	Kodak Anast. f4.5	Diomatic	30
1938-1948	Kodak Anast. Special f3.5	Kodamatic	40
1946-1947	Kodak Anast. f4.5	Flash Diomatic	35
1947-1948	Kodak Anaston f4.5	Flash Diomatic	50

KODAK 35 CAMERA W/RANGEFINDER

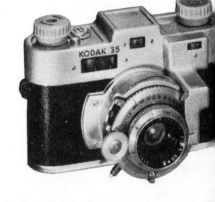

IDENTIFICATION: "Kodak 35" on front of top housing. **CHARACTERISTICS:** Guard over external coupling for rangefinder gives appearance of an "add-on". Knurled focusing wheel beside lens. **LENS:** (see variations below). **SHUTTER:** (see variations below). **FILM SIZE:** 135. **IMAGE:** 24x36 mm. **BODY:** 3-1/16x3-7/16x5-7/16 in. **WEIGHT:** 24 oz. **DATES:** 1940-1951. **PRICE:** $48-87.

This Kodak model was designed to compete with the extremely popular Argus C-3, but without much success. Although solid and capable of good results, it had an appearance that not even a mother could love. Ugly, slightly unhandy to use, and carrying a higher price tag than the Argus C-3, it just couldn't compete on equal terms. It was replaced by the Signet 35 Camera in 1951.

DATES	LENS	SHUTTER	PRICE
1940-1948	Kodak Anast. Special f3.5	Kodamatic	48
1946-1948	Kodak Anast. Special f3.5	Flash Kodamatic	75
1947-1951	Kodak Anastar f3.5	Flash Kodamatic	75

KODAK RETINA I CAMERA (TYPE 143)

CHARACTERISTICS: Like Type 141, but black trim. No accessory shoe. **LENS:** Schneider Xenar f3.5. **SHUTTER:** Compur. **FILM SIZE:** 135. **IMAGE:** 24x36 mm. **BODY:** 1½x3x4-3/4 in. **WEIGHT:** 17 oz. **DATES:** 1939-1939. Made by Kodak A.G. Not imported into the USA.

KODAK RETINA I CAMERA (TYPE 148)

CHARACTERISTICS: Taller top housing. Body release next to exposure counter. Cable release socket next to shutter release. Double exposure prevention. **LENS:** (see variations below). **SHUTTER:**

(see variations below). **FILM SIZE:** 135. **IMAGE:** 24x36 mm. **BODY:** 1½x3x4-3/4 in. **WEIGHT:** 17 oz. **DATES:** 1939-1939. **PRICE:** $49. Made by Kodak A.G. Only the version with the Kodak Anast. Ektar lens and Compur Rapid shutter was sold in the USA.

DATES	LENS	SHUTTER	PRICE
1939-1939	Kodak Anast. Ektar f3.5	Compur Rapid	49
1939-1939	Kodak Anast. Ektar f3.5	Compur	EUR
1939-1939	Schneider Xenar f3.5	Compur	EUR
1939-1939	Schneider Xenar f3.5	Compur Rapid	EUR

KODAK RETINA I CAMERA (TYPE 149)
CHARACTERISTICS: Like Type 148, but black lacquered edges of body. No accessory shoe. **LENS:** Schneider Xenar f3.5. **SHUTTER:** Compur. **FILM SIZE:** 135. **IMAGE:** 24x36 mm. **BODY:** 1½x3x4-3/4 in. **WEIGHT:** 17 oz. **DATES:** 1939-1939.
Made by Kodak A.G. Not imported into the USA.

KODAK RETINA IIA CAMERA (TYPE 150)
IDENTIFICATION: "Retina IIa" on top of camera. **CHARACTERISTICS:** Coupled rangefinder with single eyepiece. Small extensible rewind knob. Strap lugs at body ends. **LENS:** Kodak Ektar f3.5, Schneider Xenon f2.8 or f2.0. **SHUTTER:** Compur Rapid. **FILM SIZE:** 135. **IMAGE:** 24x36 mm. **BODY:** 1-5/8x3¼x4-3/4 in. **WEIGHT:** 21 oz. **DATES:** 1939-1939.
Made by Kodak A.G. Not imported into the USA.

KODAK RETINETTE CAMERA (TYPE 147)
IDENTIFICATION: "Retinette" embossed on back. **CHARACTERISTICS:** Horizontal body style. Body curved out to flat bed. Bed hinged at bottom of camera. **LENS:** Kodak Anast. f6.3. **SHUTTER:** Kodak 3-speed. **FILM SIZE:** 135. **IMAGE:** 24x36 mm. **DATES:** 1939-1939. Made by Kodak A.G. Not imported into the USA.

KODAK RETINETTE II CAMERA (TYPE 160)
CHARACTERISTICS: Folding style. Bed swings to the side. Table stand on bed. Deeper bed than on Type 147. Body not curved. Black enameled half-top housing. Ribbed front standard. **LENS:** Kodak Anast, f3.5 or f4.5. **SHUTTER:** Kodak 4-speed or Compur. **FILM SIZE:** 135. **IMAGE:** 24x36 mm. **DATES:** 1939-1939.
Made by Kodak A.G. Not imported into the USA.

NEW YORK WORLD'S FAIR BABY BROWNIE CAMERA
IDENTIFICATION: "New York World's Fair" on front plate. **CHARACTERISTICS:** Like the Baby Brownie Camera except for special faceplate. **LENS:** Meniscus. **SHUTTER:** Rotary. **FILM SIZE:** 127. **IMAGE:** 1-5/8x2½ in. **BODY:** 2½x2-3/4x3-1/8 in. **WEIGHT:** 7 oz. **DATES:** 1939-1940. **PRICE:** $1.25.
This camera was not listed in the regular Kodak catalogs and was probably available only at the fair. A suede finish carrying case with strap cost an additional $.25.

NEW YORK WORLD'S FAIR BULLET CAMERA
IDENTIFICATION: "New York World's Fair" on shutter face."
CHARACTERISTICS: Black bakelite camera with helical telescoping front. Identical to the Bullet camera but with special markings.
LENS: Meniscus. **SHUTTER:** Rotary. **FILM SIZE:** 127. **IMAGE:** 1-5/8x2½ in. **BODY:** 1-7/8x2-3/4x4-7/8 in. **WEIGHT:** 7 oz. **DATES:** 1939-1940. **PRICE:** $2.25.

This camera is not listed in the regular Kodak catalogs and was probably available only at the fair.

KODAK MONITOR SIX-16 CAMERA
IDENTIFICATION: "Monitor" on folding optical finder. **LENS:** (see variations below). **SHUTTER:** (see variations below). **FILM SIZE:** 616. **IMAGE:** 2½x4¼ in. **BODY:** 1-15/16x4¼x8 in. **WEIGHT:** 37½ oz. **DATES:** 1939-1948. **PRICE:** $35-52.

DATES	LENS	SHUTTER	PRICE
1939-1948	Kodak Anast. f4.5	Kodamatic	35
1939-1948	Kodak Anast. Special f4.5	Supermatic	49

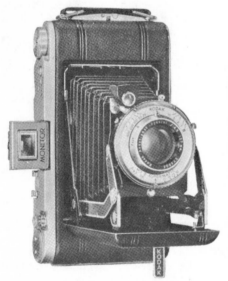

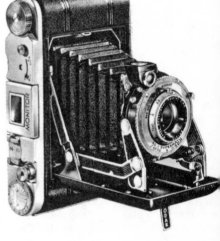

Kodak Monitor Six-16 camera Kodak Monitor Six-20 camera

KODAK MONITOR SIX-20 CAMERA
IDENTIFICATION: "Monitor" on folding optical finder. **LENS:** (see variations below). **SHUTTER:** (see variations below). **FILM SIZE:** 620. **IMAGE:** 2¼x3¼ in. **BODY:** 1-3/4x4x6-3/4 in. **WEIGHT:** 27½ in. **DATES:** 1939-1948. **PRICE:** $30-76.

DATES	LENS	SHUTTER	PRICE
1939-1948	Kodak Anast. f4.5	Kodamatic	30
1939-1948	Kodak Anast. Special f4.5	Supermatic	43
1946-1948	Kodak Anast. Special f4.5	Flash Supermatic	76
1946-1948	Kodak Anast. f4.5	Flash Kodamatic	52

KODAK VIGILANT SIX-16 CAMERA

IDENTIFICATION: "Kodak Vigilant Six-16" on front edge of bed. **CHARACTERISTICS:** Folding bed rollfilm camera with folding optical finder. Body release. **LENS:** (see variations below). **SHUTTER:** (see variations below). **FILM SIZE:** 616. **IMAGE:** $2\frac{1}{2}$x$4\frac{1}{4}$ in. **BODY:** 1-7/8x4x7-7/8 in. **WEIGHT:** 32 oz. **DATES:** 1939-1948. **PRICE:** $16-43.

DATES	LENS	SHUTTER	PRICE
1939-1940	Kodak Anast. f8.8	Kodex	16
1939-1940	Kodak Anast. f6.3	Kodex	20
1939-1948	Kodak Anast. f4.5	Kodamatic	29
1939-1948	Kodak Anast. Special f4.5	Supermatic	43
1940-1942	Kodak Anast. f8.8	Diomatic	16
1940-1948	Kodak Anast. f6.3	Diomatic	20

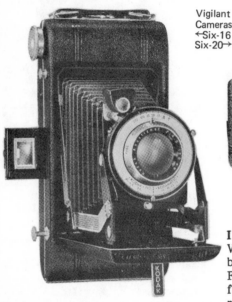

Vigilant
Cameras
←Six-16
Six-20→

KODAK VIGILANT SIX-20 CAMERA

IDENTIFICATION: "Kodak Vigilant Six-20" on front edge of bed. **CHARACTERISTICS:** Folding bed rollfilm camera with folding optical finder. Body release. **LENS:** (see variations below). **SHUTTER:** (see variations below). **FILM SIZE:** 620. **IMAGE:** $2\frac{1}{4}$x$3\frac{1}{4}$ in. **BODY:** 1-3/4x3-11/16x6-9/16 in. **WEIGHT:** $23\frac{1}{2}$ oz. **DATES:** 1939-1949. **PRICE:** $15-49.

DATES	LENS	SHUTTER	PRICE
1939-1940	Kodak Anast. f8.8	Kodex	15
1939-1940	Kodak Anast. f6.3	Kodex	17
1939-1948	Kodak Anast. f4.5	Kodamatic	25
1939-1948	Kodak Anast. Special f4.5	Supermatic	38
1940-1948	Kodak Anast. f8.8	Diomatic	15
1940-1948	Kodak Anast. f6.3	Diomatic	17
1946-1948	Kodak Anast. f8.8	Dakon	24
1946-1948	Kodak Anast. f6.3	Dakon	28
1946-1948	Kodak Anast. f4.5	Flash Kodamatic	40
1947-1949	Kodak Anaston f6.3	Flash Dakon	42

KODAK VIGILANT JUNIOR SIX-16 CAMERA
IDENTIFICATION: "Kodak Vigilant Junior Six-16" on front edge of bed.
CHARACTERISTICS: Less expensive model of Vigilant Six-16 Camera.
Lacks body release. Non-optical folding frame finder. **LENS:** (see
variations below). **SHUTTER:** (see variations below). **FILM SIZE:** 616.
IMAGE: 2½x4¼ in. **BODY:** 1-7/8x4-3/16x8 in. **WEIGHT:** 29 oz.
DATES: 1940-1948. **PRICE:** $10-13.

DATES	LENS	SHUTTER	PRICE
1940-1948	Kodet	Dak	10
1940-1948	Bimat	Dakon	13

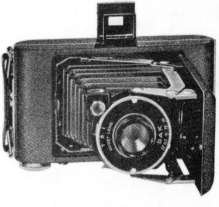

Vigilant Junior Six-20 camera

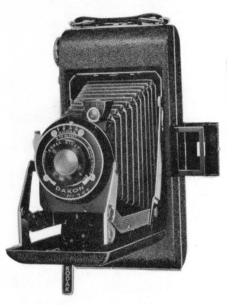

Vigilant Junior Six-16 camera

KODAK VIGILANT JUNIOR SIX-20 CAMERA
IDENTIFICATION: "Kodak Vigilant Junior Six-20" on bed's front edge. **CHARACTERISTICS:** Less expensive model of Vigilant Six-20 Camera. Lacks body release. Non-optical folding frame finder.
LENS: (see variations below). **SHUTTER:** (see variations below).
FILM SIZE: 620. **IMAGE:** 2¼x3¼ in. **BODY:** 1-3/4x3-7/8x6-5/8 in.
WEIGHT: 23 oz. **DATES:** 1940-1949. **PRICE:** $9-20.

DATES	LENS	SHUTTER	PRICE
1940-1948	Bimat	Dakon	11
1940-1949	Kodet f12.5	Dak	9

BABY BROWNIE SPECIAL CAMERA
IDENTIFICATION: "Baby Brownie Special" around lens. **CHARACTERISTICS:** Small black bakelite box camera with rigid optical finder.
White shutter button on side. **LENS:** Meniscus. **SHUTTER:** Rotary.
FILM SIZE: 127. **IMAGE:** 1-5/8x2½ in. **BODY:** 2-3/4x3x3½ in.
WEIGHT: 6 oz. **DATES:** 1939-1954. **PRICE:** $1.25. (illus. next page)

KODAK DUEX CAMERA

IDENTIFICATION: "Kodak Duex" on shutter face.
CHARACTERISTICS: Bakelite body with helical telescoping front.
LENS: Kodak Doublet. **SHUTTER:** I and B. **FILM SIZE:** 620.
IMAGE: 1-5/8x2¼ in. **BODY:** 2-3/4x3-3/4x5 in. **WEIGHT:** 13½ oz.
DATES: 1940-1942. **PRICE:** $6.

Baby Brownie Special camera Kodak Duex camera

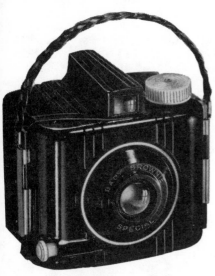

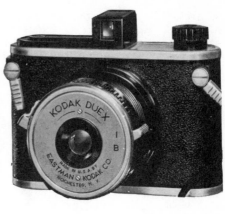

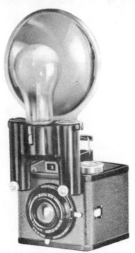

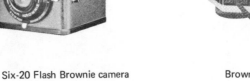

Six-20 Flash Brownie camera Brownie Reflex camera

111

SIX-20 FLASH BROWNIE CAMERA (illus. p. 111)

IDENTIFICATION: "Six-20" above lens. "Flash Brownie" below lens. **CHARACTERISTICS:** Metal trapezoidal box camera. Like Six-20 Brownie Special Camera, but with flash sync. **LENS:** Mensicus. **SHUTTER:** Rotary. **FILM SIZE:** 620. **IMAGE:** 2¼x3¼ in. **BODY:** 3¼x3-3/4x4¼ in. **WEIGHT:** 18 oz. **DATES:** 1940-1946. **PRICE:** $4.25.
Continued as "Brownie Flash Six-20 Camera" after July of 1946.

BROWNIE REFLEX CAMERA (illus. p. 111)

IDENTIFICATION: "Brownie Reflex" above finder lens on front plate. **CHARACTERISTICS:** Twin lens reflex style, bakelite box camera. No synchronization on this original model. **LENS:** Meniscus. **SHUTTER:** Rotary. **FILM SIZE:** 127. **IMAGE:** 1-5/8x1-5/8 in. **BODY:** 2¼x3½x4-3/4 in. **WEIGHT:** 15 oz. **DATES:** 1940-1941. **PRICE:** $5.25.
This camera was improved with the addition of flash synchronization and continued after August of 1941 as the "Synchro Model".

BROWNIE REFLEX CAMERA- SYNCHRO MODEL

IDENTIFICATION: "Brownie Reflex Synchro Model" above finder lens. **CHARACTERISTICS:** Like Brownie Reflex Camera but with sync connection at bottom of front. **LENS:** Meniscus. **SHUTTER:** Rotary. **FILM SIZE:** 127. **IMAGE:** 1-5/8x1-5/8 in. **BODY:** 2¼x3½x4-3/4 in. **WEIGHT:** 15 oz. **DATES:** 1941-1952. **PRICE:** $6-12.
Formerly without synchronization in 1940-1941.

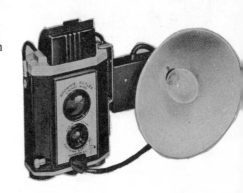

TARGET BROWNIE SIX-20 CAMERA

IDENTIFICATION: "Target Brownie Six-20" on front above lens. **CHARACTERISTICS:** Box camera with art-deco faceplate. **LENS:** Meniscus. **SHUTTER:** Rotary. **FILM SIZE:** 620. **IMAGE:** 2¼x3¼ in. **BODY:** 3x4x5 in. **WEIGHT:** 17 oz. **DATES:** 1941-1946. **PRICE:** $2.65.
Continued as the Brownie Target Six-20 Camera after July 1946.

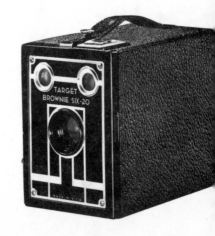

TARGET BROWNIE SIX-16 CAMERA

IDENTIFICATION: "Target Brownie Six-16" on front and strap. **CHARACTERISTICS:** Similar to Six-16 Brownie Camera, but without two-position focus. **LENS:** Meniscus. **SHUTTER:** Rotary. **FILM SIZE:** 616. **IMAGE:** 2½x4¼ in. **BODY:** 3½x5½x5½ in. **WEIGHT:** 21 oz. **DATES:** 1941-1946. **PRICE:** $3.

Replaced Six-16 Brownie Camera (1933-1941). Continued from July 1946-1951 as "Brownie Target" instead of "Target Brownie".

KODAK EKTRA CAMERA

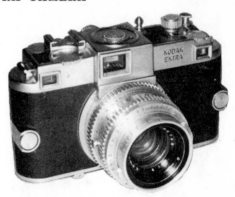

IDENTIFICATION: "Kodak Ektra" on front of top housing. (Not to be confused with the 1970's Ektra pocket cameras.) **CHARACTER-ISTICS:** 35mm rangefinder camera with interchangeable lenses and backs. **LENS:** (see variations below). **SHUTTER:** Focal Plane. **FILM SIZE:** 135. **IMAGE:** 24x36 mm. **BODY:** 3-3/8x3-7/16x5-11/16 in. **WEIGHT:** 39 oz. **DATES:** 1941-1948. **QUANTITY:** about 2000. **PRICE:** $235-542.

When Eastman Kodak Co. presented the Ektra Camera in 1941, they called it, without reservation, the world's most distinguished camera. It was then, and still is, an impressive machine. Six interchangeable Kodak Ektra lenses from 35mm to 153mm were available, and the viewfinder was adjustable for any of them, with automatic parallax correction. The wide base rangefinder was extremely accurate with all lenses. But, the unique feature was the interchangeable magazine back. Although interchangeable backs are common now, in 1941 they were a great innovation in the booming 35mm camera market. The Ektra also featured lever film advance, rapid rewind crank, and a film movement indicator, all features which added greatly to the convenience of 35mm photography.

LENS	PRICE	LENS	PRICE
Kodak Ektar f1.9/50 mm	300	Kodak Ektar f3.5/90 mm	260
Kodak Ektar f3.3/35 mm	243	Kodak Ektar f3.8/135 mm	305
Kodak Ektar f3.5/50 mm	235	Kodak Ektar f4.5/153 mm	325

KODAK MEDALIST CAMERA

IDENTIFICATION: "Kodak Medalist" on top of finder. **CHARACTER-ISTICS:** Fine focus wheel next to lens. **LENS:** Kodak Ektar f3.5/100mm. **SHUTTER:** Supermatic. **FILM SIZE:** 620. **FILM TYPE:** rollfilm or accessory back for plates, packs and sheetfilms. **IMAGE:** 2¼x3¼ in. **BODY:** 3-5/8x4-3/8x5½ in. **WEIGHT:** 3 lb. 2 oz. **DATES:** 1941-1948. **PRICE:** $165.

The Medalist Camera was designed with the professional photographer in mind, blending the advantages of the precision 35mm cameras with the versatility of a press camera. Although primarily for the use of 620 rollfilm, it also could use an accessory back for ground

glass focusing and sheetfilms, plates, or packs. With over 150 available emulsions in addition to the five 620 films, there was certainly film available for any need.

The excellent five-element Ektar f3.5 lens was especially designed for the Medalist Camera, and while the Supermatic shutter didn't quite match the top speeds of a focal plane shutter, its 1/400 second speed was adequate for nearly any need. The rigid double helix provided strong and accurate support for the lens and shutter, and its smooth focusing action was coupled to an accurate split-image rangefinder. Automatic parallax correction and double exposure prevention also add to the ease of operation.

Several variations exist: "Kodak Medalist" printed back to front or front to back; aluminum lens helix polished or black anodized.

Left: Kodak Medalist camera
Right: Kodak Medalist II camera

KODAK MEDALIST II CAMERA

IDENTIFICATION: "Kodak Medalist II" on top of finder. **CHARACTERISTICS:** Flash synch post replaces the fine focus wheel next to lens. **LENS:** Kodak Ektar f3.5. **SHUTTER:** Flash Supermatic. **FILM SIZE:** 620. **IMAGE:** 2¼x3¼ in. **BODY:** 3-5/8x4-3/8x5½ in. **WEIGHT:** 3 lb. 2 oz. **DATES:** 1946-1953. **PRICE:** $262-312.

WARTIME PRODUCTION

With the advent of World War II, it became more difficult for any company involved in the production of consumer goods. Supplies were rationed, and priority was given to military production. Eastman Kodak Co. was forced to suspend production of many cameras during the war, which accounts for the number of cameras which are listed here as "discontinued" in 1942. Many of these were suspended in 1942 with the intention of resuming production after the war. Some indeed were continued after the war, but others were abandoned. For this reason,

some cameras which were officially discontinued in 1946 had already been out of production since about 1942. (There are no consumer catalogs after 1941.)

KODAK MATCHBOX CAMERA

IDENTIFICATION: Not identified on the camera. **CHARACTERISTICS:** Simple bakelite and metal camera in shape of matchbox. No viewfinder. **LENS:** f5/1 in. fixed focus (45 degree angle of coverage). **SHUTTER:** 1/50 sec. or time exp. **FILM SIZE:** 16mm. **IMAGE:** ½x½ in. **BODY:** 7/8x2½x2-3/8 in. **WEIGHT:** 3½ oz. **DATES:** 1944-1945. **QUANTITY:** 1000.

The matchbox camera, also known as "Camera X" and "M.B." was originated when a representative from the Office of Secret Services visited Kodak late in 1943. A camera was needed for OSS agents and underground leaders for intelligence and propaganda photos. The initial order for 500 cameras was delivered early in 1944. A second order for 500 additional cameras was completed in 1944-1945.

The camera made 30 exposures on a two-foot length of film. It was originally supplied with several rolls of film, tablets of chemicals, spoon, agitating stick, chamois, and film clips. It could also be used with a special stand and close-up lens to copy documents.

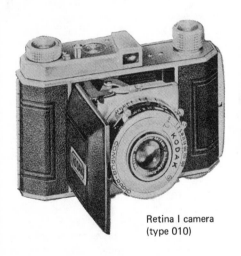

Retina I camera
(type 010)

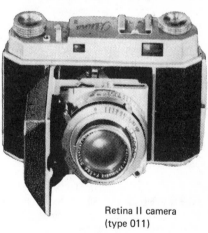

Retina II camera
(type 011)

KODAK RETINA I CAMERA (TYPE 010)

IDENTIFICATION: "Retina" embossed on back leather. **CHARACTERISTICS:** Similar to Type 148. Made from pre-war and wartime parts. USA imports have EK prefix on the serial number in the inside back. **LENS:** f3.5 coated and uncoated Retina Xenar, Kodak Anast. Ektar,

115

Rodenstock Ysar. **SHUTTER:** Compur Rapid. **FILM SIZE:** 135. **IMAGE:** 24x36 mm. **BODY:** 1½x3x4-3/4 in. **WEIGHT:** 1 lb. **DATES:** 1946-1949. **PRICE:** $73.
Made by Kodak A.G., except for the Kodak Ektar coated lens which was made in the USA. Only the version with the Retina Xenar coated lens was sold in the USA.

KODAK RETINA II CAMERA (TYPE 011)
IDENTIFICATION: "Retina II" on top. **CHARACTERISTICS:** Like the IIa Type 150. No strap lugs. Single eyepiece range/viewfinder. Viewfinder image moves when focusing. No film type indicator on top. **LENS:** Retina f2.0 coated and uncoated Xenon or Heligon, and Kodak Ektar f2.0 coated. **SHUTTER:** Compur Rapid. **FILM SIZE:** 135. **IMAGE:** 24x36 mm. **BODY:** 1-3/4x3¼x4-3/4 in. **WEIGHT:** 20 oz. **DATES:** 1946-1949. **PRICE:** $198. (illustrated on preceding page)
Made by Kodak A.G. Only the version with the Retina Xenon f2.0 coated lens was imported into the USA.

KODAK RETINA II CAMERA (TYPE 014)
IDENTIFICATION: "Retina II" engraved on top. **CHARACTERISTICS:** Single eyepiece range/viewfinder. Film type indicator under rewind knob. **LENS:** Retina Xenon or Heligon. **SHUTTER:** Compur Rapid. **FILM SIZE:** 135. **IMAGE:** 24x36 mm. **BODY:** 1-3/4x3-3/8x4-3/4 in. **WEIGHT:** 19½ oz. **DATES:** 1949-1950.
Made by Kodak A.G. Not imported into the USA.

KODAK RETINETTE CAMERA (TYPE 012)
CHARACTERISTICS: Horizontal body style. Bed swings to side. Half top-housing is chromed. Housing ends at viewfinder window. No accessory shoe. Separate cable release socket. **LENS:** Enna Ennatar f4.5 or Schneider Reomar f4.5. **SHUTTER:** Prontor-S. **FILM SIZE:** 135. **IMAGE:** 24x36 mm. **DATES:** 1949-1951.
Made by Kodak A.G. Not imported into the USA.

KODAK RETINA I CAMERA (TYPE 013)
CHARACTERISTICS: Full top housing with integral finder. Knob film advance. **LENS:** Retina Xenar f2.8 or f3.5. **SHUTTER:** Compur Rapid. **FILM SIZE:** 135. **IMAGE:** 24x36 mm. **BODY:** 1½x3x4-3/4 in. **WEIGHT:** 1 lb. **DATES:** 1949-1954.
Made by Kodak A.G. Not imported into the USA.

BROWNIE TARGET SIX-16 CAMERA (illus. p. 117)
IDENTIFICATION: "Brownie Target Six-16" on front and strap. **CHARACTERISTICS:** Basic box camera with brilliant finders. **LENS:** Meniscus. **SHUTTER:** Rotary. **FILM SIZE:** 616. **IMAGE:** 2½x4¼ in. **BODY:** 3½x5½x5½ in. **WEIGHT:** 21 oz. **DATES:** 1946-1951. **PRICE:** $5. Formerly called Target Brownie Six-16 Camera from 1941-1946.

BROWNIE TARGET SIX-20 CAMERA
IDENTIFICATION: "Brownie" above lens. "Target Six-20" below lens. "Brownie Target Six-20" on strap. **LENS:** Meniscus. **SHUTTER:** Rotary. **FILM SIZE:** 620. **IMAGE:** 2¼x3¼ in. **BODY:** 3x4x5 in.

WEIGHT: 17 oz. **DATES:** 1946–1952.
PRICE: $4. Formerly called
Target Brownie Six-20 Camera
1941–1946.

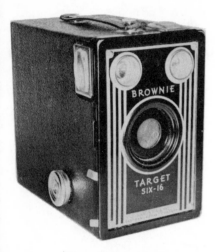

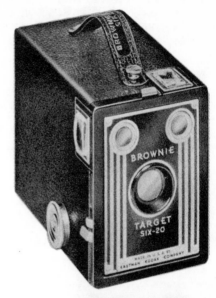

↑ Brownie Target Six-16 camera
 Brownie Target Six-20 camera ↗
↓ Kodak Reflex camera
 Kodak Reflex II camera ↘

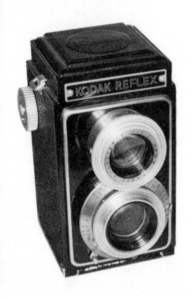

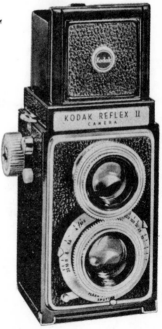

KODAK REFLEX CAMERA

IDENTIFICATION: "Kodak Reflex" on front. **CHARACTERISTICS:** Twin lens reflex with externally gear-coupled lenses. **LENS:** Kodak Anast. f3.5. **SHUTTER:** Flash Kodamatic. **FILM SIZE:** 620. **IMAGE:** 2¼x2¼ in. **BODY:** 3¼x4x5-5/8 in. **WEIGHT:** 33 oz. **DATES:** 1946-1949. **PRICE:** $100-138. (illustrated on previous page)

KODAK REFLEX II CAMERA

IDENTIFICATION: "Kodak Reflex II Camera" on front. **LENS:** Kodak Anastar f3.5. **SHUTTER:** Flash Kodamatic. **FILM SIZE:** 620. **IMAGE:** 2¼x2¼ in. **DATES:** 1948-1954. **PRICE:** $135-161. (illus. p. 117)

BROWNIE FLASH SIX-20 CAMERA

IDENTIFICATION: "Brownie" above lens. "Flash Six-20" below lens. **CHARACTERISTICS:** Identical to Six-20 Flash Brownie Camera except for changed word order in name. **LENS:** Meniscus. **SHUTTER:** Rotary. **FILM SIZE:** 620. **IMAGE:** 2¼x3¼ in. **BODY:** 3¼x3-3/4x4¼ in. **WEIGHT:** 18 oz. **DATES:** 1946-1954. **PRICE:** $7-13.

Formerly called Six-20 Flash Brownie Camera from 1940-1946.

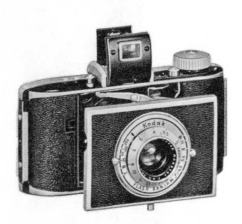

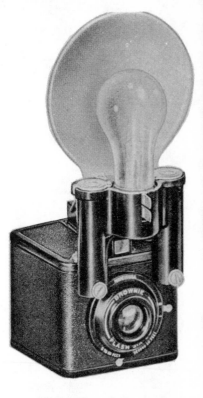

Kodak Flash Bantam camera Brownie Flash Six-20 camera

KODAK FLASH BANTAM CAMERA

IDENTIFICATION: "Kodak" above lens. "Flash Bantam" below. **CHARACTERISTICS:** Styled like regular f4.5 model but with sync post on lensboard and notch in body. No strap lugs. **LENS:** Kodak Anast. Special f4.5 1947-48, Kodak Anastar f4.5 1948-53. **SHUTTER:** Built-in with flash sync. 1/25-1/200. **FILM SIZE:** 828. **IMAGE:** 28x40 mm. **BODY:** 1½x2½x4-5/8 in. **WEIGHT:** 13 oz. **DATES:** 1947-1953. **PRICE:** $50 with Anastar. $58 with Anast.

KODAK DUAFLEX CAMERA

IDENTIFICATION: "Kodak Duaflex Camera" at bottom of front. **CHARACTERISTICS:** Large brilliant finder without hood. **LENS:** (see variations below). **SHUTTER:** I and B. **FILM SIZE:** 620. **IMAGE:** 2¼x2¼ in. **BODY:** 2-7/8x3x4½ in. **WEIGHT:** 13 oz. **DATES:** 1947-1950. **PRICE:** $12-17.

The deluxe model with the f8 focusing lens also featured double exposure prevention. This feature can be identified by the diagonal metal housing connecting the winding knob and the shutter button.

DATES	LENS	PRICE
1947-1950	Kodet f15 (fixed focus)	12
1949-1950	Kodar f8 (focusing)	17

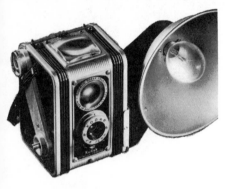 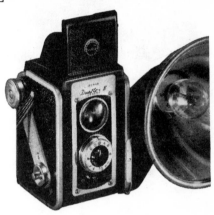

Kodak Duaflex camera Kodak Duaflex II camera

KODAK DUAFLEX II CAMERA

IDENTIFICATION: "Kodak Duaflex II Camera" on front plate. **CHARACTERISTICS:** Re-styled version of Duaflex camera with finder hood added. Flash attached like original model. **LENS:** fixed focus Kodet f15, focusing Kodar f8. **SHUTTER:** I and B. **FILM SIZE:** 620. **IMAGE:** 2¼x2¼ in. **BODY:** 2-7/8x3x4½ in. **WEIGHT:** 1 lb. **DATES:** 1950-1954. **PRICE:** $14 with f15. $22 with f8.

The deluxe model with f8 lens has double exposure prevention.

KODAK DUAFLEX III CAMERA

IDENTIFICATION: "Kodak Duaflex III Camera" on front plate. **CHARACTERISTICS:** Styled like II, but uses different flashholder. **LENS:** fixed focus Kodet f15, focusing Kodar f8. **SHUTTER:** I and B. **FILM SIZE:** 620. **IMAGE:** 2¼x2¼ in. **BODY:** 2-7/8x3x4½ in. **WEIGHT:** 1 lb. **DATES:** 1954-1956. **PRICE:** $16 with f15. $24 with f8. All models now have double exposure prevention. (illus. next page)

KODAK DUAFLEX IV CAMERA

IDENTIFICATION: "Kodak Duaflex IV" on front plate. **CHARACTERISTICS:** Brown and tan color. Zone focusing scale on Kodar model. **LENS:** fixed focus Kodet f15, focusing Kodar f8. **SHUTTER:** I and B. **FILM SIZE:** 620. **IMAGE:** 2¼x2¼ in. **BODY:** 2-7/8x3x4½ in. **WEIGHT:** 17 oz. **DATES:** 1955-1960. **PRICE:** $16 with f15. $24 with f8. All models have double exposure prevention.

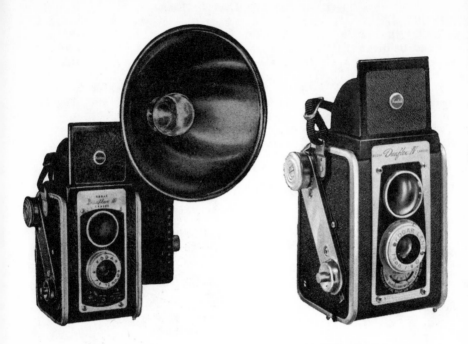

Kodak Duaflex III camera Kodak Duaflex IV camera

KODAK TOURIST CAMERA

IDENTIFICATION: "Kodak Tourist Camera" on front edge of bed.
CHARACTERISTICS: Gray plastic top housing with viewfinder extending above top. Double hinged removable back. **LENS:** (see variations below). **SHUTTER:** (see variations below). **FILM SIZE:** 620. **IMAGE:** $2\frac{1}{4}$x$3\frac{1}{4}$ in. **BODY:** 1-7/8x4x6-3/4 in. **WEIGHT:** 1 lb. **DATES:** 1948-1951. **PRICE:** $29-95.

The f12.5 and f8.8 models have a slightly larger front window on the viewfinder, but no accessory shoe. The "Deluxe" models, f6.3 and f4.5, have an accessory shoe for a rangefinder, and utilize the "Tourist Adapter Kit" to allow four image sizes on 620 or 828 film.

DATES	LENS	SHUTTER	PRICE
1948-1951	Kodak Anaston f4.5	Flash Kodamatic	62
1948-1951	Kodak Anaston f6.3	Flash Diomatic	47
1948-1951	Kodak Anaston f8.8	Flash Diomatic	37
1948-1951	Kodet f12.5	Flash Kodon	29
1949-1951	Kodak Anastar f4.5	Synchro-Rapid 800	95

KODAK TOURIST II CAMERA

IDENTIFICATION: "Kodak Tourist II Camera" on top housing.
CHARACTERISTICS: Top housing is taller than earlier model so viewfinder doesn't project. **LENS:** (see variations below). **SHUTTER:** (see variations below). **FILM SIZE:** 620. **IMAGE:** 2¼x3¼ in. **BODY:** 1-7/8x4x6-3/4 in. **WEIGHT:** 1 lb. **DATES:** 1951-1958. **PRICE:** $26-100.

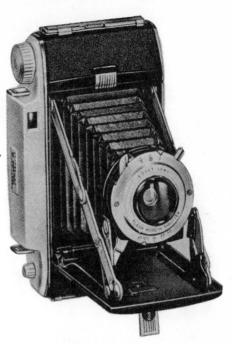

The Deluxe models, with the Anaston or Anastar f4.5 lens, have an accessory shoe and enlarged viewfinder window.

DATES	LENS	SHUTTER	PRICE
1951-1952	Kodak Anaston f6.3	Flash Diomatic	48
1951-1953	Kodak Anaston f4.5	Flash Kodamatic	75
1951-1953	Kodak Anastar f4.5	Synchro-Rapid 800	100
1951-1958	Kodak Anaston f6.3	Kodak Flash 200	46
1951-1958	Kodet f12.5	Flash Kodon	26

KODAK PONY 828 CAMERA

IDENTIFICATION: "Kodak Pony 828 Camera" on front. **CHARACTERISTICS:** Telescoping front. **LENS:** Kodak Anaston f4.5. **SHUTTER:** Kodak Flash 200. **FILM SIZE:** 828. **IMAGE:** 28x40 mm. **BODY:** 2¼x3-1/8x5 in. **WEIGHT:** 13 oz. **DATES:** 1949-1959. **PRICE:** $30.

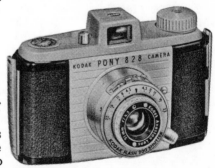

This is the first in the series of Pony cameras. It is easily distinguished from the later 35mm models by the lack of a rewind knob on the top right side of the camera next to the shutter release. It was sold also as a part of a technical close-up outfit. It is also the last Kodak camera to be sold for 828 film,

the Bantam RF Camera having been discontinued in 1957. Surely the sales comparisons between the Pony 828 and 135 cameras must have convinced even the most diehard supporters of 828 film that they were a minority.

KODAK PONY 135 CAMERA

IDENTIFICATION: "Kodak Pony 135 Camera" on front plate. **CHARACTERISTICS:** Black bakelite body. Telescoping front. **LENS:** Kodak Anaston f4.5/51mm. **SHUTTER:** Kodak Flash 200. **FILM SIZE:** 135. **IMAGE:** 24x36 mm. **BODY:** 2¼x3-1/8x5-1/8 in. **WEIGHT:** 13 oz. **DATES:** 1950-1954. **PRICE:** $35.

Introduced just a year after the 828 model, and essentially identical except for film size, this camera soon proved that 828 was no match for 35mm in terms of sales.

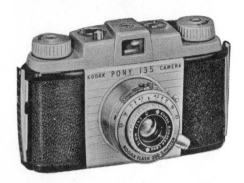 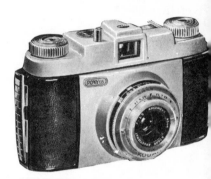

Pony 135 cameras. Left: USA model. Right: model made in France.

KODAK PONY 135 MODEL B CAMERA

IDENTIFICATION: "Kodak Pony 135 Camera Model B" on front plate. **CHARACTERISTICS:** Black bakelite body. Telescoping front. **LENS:** Kodak Anaston f4.5/44mm. **SHUTTER:** Kodak Flash 200. **FILM SIZE:** 135. **IMAGE:** 24x36 mm. **BODY:** 2¼x3-1/8x5-1/8 in. **WEIGHT:** 13 oz. **DATES:** 1953-1955. **PRICE:** $37.

KODAK PONY 135 MODEL C CAMERA

IDENTIFICATION: "Kodak Pony 135 Camera Model C" on front plate. **CHARACTERISTICS:** Brown bakelite body. Rigid, non-telescoping front. **LENS:** Kodak Anaston f3.5/44mm. **SHUTTER:** Kodak Flash 300. **FILM SIZE:** 135. **IMAGE:** 24x36 mm. **BODY:** 2¼x3-1/8x5-1/8 in. **WEIGHT:** 13 oz. **DATES:** 1955-1958. **PRICE:** $34.

KODAK PONY 135 CAMERA (MADE IN FRANCE)

IDENTIFICATION: "Pony 135" nameplate above and to side of lens. **LENS:** Angenieux f3.5/45 mm. **SHUTTER:** 4 speeds- 1/25-1/150 and B. **FILM SIZE:** 135. **IMAGE:** 24x36 mm. **BODY:** 2¼x3-1/8x5-1/8 in. **WEIGHT:** 13 oz. **DATES:** 1956.

BROWNIE HAWKEYE CAMERA

IDENTIFICATION: "Brownie Hawkeye Camera" nameplate on front. **CHARACTERISTICS:** Black bakelite body with gray buttons. No sync

posts on side. **LENS:** Meniscus.
SHUTTER: Rotary. **FILM SIZE:** 620.
IMAGE: 2¼x2¼ in. **BODY:** 3¼x3½x4¼ in.
WEIGHT: 16 oz. **DATES:** 1949-1951.
PRICE: $5.50.

BROWNIE HAWKEYE CAMERA
FLASH MODEL

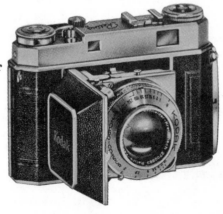

IDENTIFICATION: "Brownie Hawkeye
Camera Flash Model" on front. **CHARAC-
TERISTICS:** Like Brownie Hawkeye
Camera but synchronized. **LENS:** Meniscus
f15. **SHUTTER:** Rotary with flash sync.
FILM SIZE: 620. **IMAGE:** 2¼x2¼ in.
BODY: 3¼x3½x4¼ in. **WEIGHT:** 16 oz.
DATES: 1950-1961. **PRICE:** $7.
The same camera was made and sold
in France as Kodak Brownie Flash Camera.
The U.S.A. made model is extremely
common, which causes it to not be highly
regarded by collectors despite its good styling and durability. The
earlier non-synchronized model or the "Brownie Flash Camera" from
France are less common.

KODAK RETINA Ia CAMERA (TYPE 015)

IDENTIFICATION: "Retina Ia" on top. **CHARACTERISTICS:** Full top
housing with integral finder. Rapid film advance lever on top. **LENS**
and **SHUTTER:** Retina Xenar f3.5 in Compur Rapid. Retina Xenar
f2.8, Rodenstock Heligon f3.5, Kodak Ektar f3.5 in Synchro-Compur.
FILM SIZE: 135. **IMAGE:** 24x36 mm. **BODY:** 1½x3x4-3/4 in.
WEIGHT: 1 lb. **DATES:** 1951-1954.
Made by Kodak A.G. Not imported into the USA.

KODAK RETINA IIa CAMERA (TYPE 016)

IDENTIFICATION: "Retina IIa" on
top. **CHARACTERISTICS:** Rapid
rewind lever with built-in exposure
counter. Strap lugs on front
corners. Single eyepiece range/
viewfinder. **LENS:** Retina Xenon or
Heligon f2.0. **SHUTTER:** Synchro-
Compur or Compur Rapid (with
Xenon only). **FILM SIZE:** 135.
IMAGE: 24x36 mm. **BODY:**
1-5/8x3¼x4-7/8 in. **WEIGHT:** 1 lb.
DATES: 1951-1954. **PRICE:**
$128-169.

Made by Kodak A.G. Only the
version with the Retina Xenon lens
and Synchro-Compur shutter was
sold in the USA.

KODAK RETINETTE CAMERA (TYPE 017)

CHARACTERISTICS: Horizontal body style. Bed swings to side. Full length top housing. Bed is deeper then Type 052. Accessory shoe. Release button threaded for cable release. **LENS:** Schneider Reomar or Xenar f4.5. **SHUTTER:** Prontor SV. **FILM SIZE:** 135. **IMAGE:** 24x36 mm. **BODY:** 1½x3x4-5/8 in. **WEIGHT:** 14½ oz. **DATES:** 1952-1954. **PRICE:** $60.

Made by Kodak A.G. Only the version with the Reomar lens was sold in the USA.

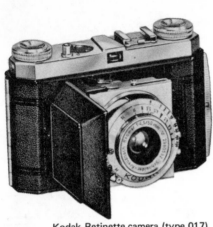

Kodak Retinette camera (type 017)

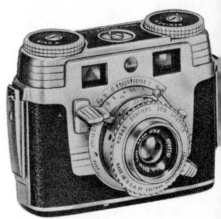

Kodak Signet 35 camera.

KODAK SIGNET 35 CAMERA

IDENTIFICATION: "Kodak Signet 35 Camera" on top. **CHARACTERISTICS:** 35mm rangefinder camera. **LENS:** Kodak Ektar f3.5. **SHUTTER:** Kodak Synchro 300. **FILM SIZE:** 135. **IMAGE:** 24x36 mm. **BODY:** 2½x3¼x4½ in. **WEIGHT:** 19 oz. **DATES:** 1951-1958. **PRICE** $75-95 (The original price of $95 was reduced to $75 by 1955.).

The Signet 35 Camera replaced the Kodak 35 rangefinder camera. It was small, sturdy, and much more attractive. The lens was excellent, but the shutter had a reputation for unreliability. A special model was made for the Army Signal Corps with a black satin finish and no serial number on the body.

BROWNIE SIX-20 CAMERA MODEL D

LENS: Meniscus. **SHUTTER:** Rotary with flash sync. **FILM SIZE:** 620. **IMAGE:** 2¼x3¼ in. **DATES:** 1953-1954. **PRICE:** $10.

KODAK CHEVRON CAMERA

IDENTIFICATION: "Kodak Chevron Camera" nameplate on top. **CHARACTERISTICS:** Professional rangefinder camera for 620 film. Built-in finder mask for 28x40 mm. images on 828 film. **LENS:** Kodak Ektar f3.5. **SHUTTER:** Synchro-Rapid 800. **FILM SIZE:** 620 (or 828 with adapter). **IMAGE:** 2¼x2¼ in. **BODY:** 3-3/4x4½x6¼ in. **WEIGHT** 2 lb. 9 oz. **DATES:** 1953-1956. **PRICE:** $198-215.

The Chevron Camera replaced the Medalist II Camera in 1953 as the top of the line for 620 film. In some ways it is similar, with its heavy cast aluminum body, helical focusing, and coupled rangefinder. However, there are major differences. The Chevron takes 12 square pictures per roll of 620 film instead of 8 larger ones. The Synchro Rapid shutter now boasts a top speed of 1/800 sec. It will not accept a ground glass back and plates, but it could be adapted for 828 film.

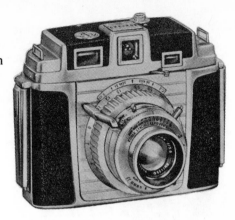

KODAK BANTAM RF CAMERA

IDENTIFICATION: "Kodak Bantam RF Camera" on front. **LENS:** Kodak Ektanon f3.9. **SHUTTER:** Kodak Flash 300. **FILM SIZE:** 828. **IMAGE:** 28x40 mm **BODY:** 2-5/8x3x5¼ in. **WEIGHT:** 14½ oz. **DATES:** 1953-1957. **PRICE:** $60.

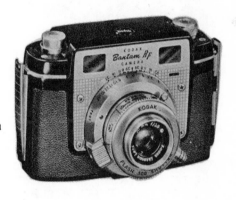

Originally, this camera was sold only in the Town & Country outfit with a case, and flash. Beginning in mid-1954 the camera was available separately. With 828 film still unable to attract a large following, this camera was finally sold out in 1950 for $30 with the flash.

BROWNIE 127 CAMERA

IDENTIFICATION: "Kodak Brownie 127 Camera" on aluminum faceplate. **CHARACTERISTICS:** Bakelite eye-level box camera with rounded ends. **LENS:** Meniscus. **SHUTTER:** Rotary. **FILM SIZE:** 127. **IMAGE:** 1-5/8x2½ in. **BODY:** 2-7/8x3x5¼ in. **WEIGHT:** 8 oz. **DATES:** 1953-1959. **PRICE:** $4.75.

Made in London by Kodak Ltd. until 1959, but imported to the United States only in 1953 and 1954. Identical to the Brownie Starlet Camera except for the faceplate.

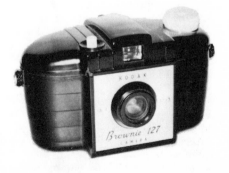

BROWNIE HOLIDAY CAMERA

IDENTIFICATION: "Brownie Holiday Camera" on front plate
CHARACTERISTICS: Brown bakelite eye-level box camera with tan controls. Not synchronized for flash. Similar to Brownie Bullet Camera. **LENS:** Kodet f15 1953-1955, Dakon 1955-1957. **SHUTTER:** Rotary. **FILM SIZE:** 127. **IMAGE:** 1-5/8x2½ in. **BODY:** 2-3/4x3x4 in. **WEIGHT:** 10 oz. **DATES:** 1953-1957. **PRICE:** $3.

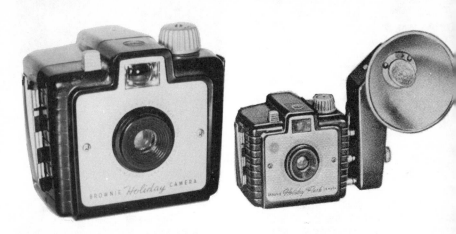

BROWNIE HOLIDAY FLASH CAMERA

IDENTIFICATION: "Brownie Holiday Flash Camera" on front plate.
CHARACTERISTICS: Like Brownie Holiday Camera, but with synch posts on side. **LENS:** Kodet f15 1954-1955, Dakon 1955-1962. **SHUTTER:** Rotary with flash synch. **FILM SIZE:** 127. **IMAGE:** 1-5/8x2½ in. **BODY:** 2-3/4x3x4 in. **WEIGHT:** 11 oz. **DATES:** 1954-1962. **PRICE:** $5.

KODAK RETINA IIc CAMERA (TYPE 020)

IDENTIFICATION: "Retina II c" (small c) on top plate. **CHARACTERISTICS:** Viewfinder windows not equal in size. Bright frame for normal lens only. Film advance lever on bottom of body. No built-in exposure meter. MX sync. **LENS:** Retina Xenon-C or Heligon-C f2.8. **SHUTTER:** Synchro-Compur. **FILM SIZE:** 135. **IMAGE:** 24x36 mm. **BODY:** 1-7/8x3-3/4x5 in. **WEIGHT:** 1 lb. **DATES:** 1954-1957. **PRICE:** $135.

Made by Kodak A.G. Only the version with the Xenon-C lens was sold in the USA. The lenses have an interchangeable front element which changes the 50mm normal lens to a 35mm wide angle or 80mm telephoto lens.

KODAK RETINA IIIc CAMERA (TYPE 021)

IDENTIFICATION: "Retina III c" (small c) on top.
CHARACTERISTICS: Like the IIc, but with coupled selenium meter. Bright frame for normal lens only. **LENS:** Retina Xenon-C or Heligon-C f2.8. **SHUTTER:** Synchro-Compur. **FILM SIZE:** 135. **IMAGE:** 24x36 mm. **BODY:** 1-7/8x3-3/4x5 in. **WEIGHT:** 24 oz. **DATES:** 1954-1957. **PRICE:** $165-185.

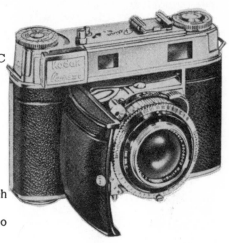

Made by Kodak A.G. Only the version with the Xenon-C lens was sold in the USA. The lenses have interchangeable front elements which change the 50mm normal lens to a 35mm wide angle or 80mm telephoto lens.

KODAK RETINA Ib CAMERA (TYPE 018)

IDENTIFICATION: "Retina I b" on top. **CHARACTERISTICS:** Rapid film advance lever at bottom. Body corners rounded. Rectangular strap lugs at body ends. Metal shroud covers bellows. **LENS:** Retina Xenar f2.8. **SHUTTER:** Synchro-Compur. **FILM SIZE:** 135. **IMAGE:** 24x36 mm. **BODY:** 1½x3x4-3/4 in. **WEIGHT:** 1 lb. **DATES:** 1954-1958.
Made by Kodak A.G. Not imported into the USA.

KODAK RETINETTE CAMERA (TYPE 022)

IDENTIFICATION: "Retinette" in script in an oval on the front plate. **CHARACTERISTICS:** Non-folding style. Rectangular front plate without the "V" design. Single finder window. **LENS:** Schneider Reomar f3.5. **SHUTTER:** Compur Rapid. **FILM SIZE:** 135. **IMAGE:** 24x36 mm. **DATES:** 1954-1958.
Made by Kodak A.G. Not imported into the USA.

KODAK STEREO CAMERA

IDENTIFICATION: "Kodak Stereo Camera" on front.
CHARACTERISTICS: Brown body with brown imitation leather covering. **LENS:** Kodak Anaston f3.5. **SHUTTER:** Kodak Flash 200. **FILM SIZE:** 135. **IMAGE:** 23x24 mm. **BODY:** 2-3/8x2-3/4x7 in. **WEIGHT:** 24 oz. **DATES:** 1954-1959. **PRICE:** $85.

BROWNIE BULL'S-EYE CAMERA (BLACK MODEL)

IDENTIFICATION: "Brownie Bull's-eye Camera" on front plate.
CHARACTERISTICS: Vertically styled black bakelite box camera for 620 film. Gray controls and aluminum-colored faceplate. **LENS:** Kodak Twindar. **SHUTTER:** Rotary. **FILM SIZE:** 620. **IMAGE:** 2¼x3¼ in. **BODY:** 3-3/4x4¼x5 in. **WEIGHT:** 24 oz.
DATES: 1954-1958. **PRICE:** $13.

BROWNIE BULL'S-EYE CAMERA (GOLD MODEL)

IDENTIFICATION: "Brownie Bull's-eye Camera" on front plate.
CHARACTERISTICS: Golden-beige metallic enameled bakelite body with brass colored front plate. Otherwise, like the black model. **LENS:** Kodak Twindar. **SHUTTER:** Rotary. **FILM SIZE:** 620. **IMAGE:** 2¼x3¼ in. **BODY:** 3-3/4x4¼x5 in. **WEIGHT:** 24 oz. **DATES:** 1957-1960. **PRICE:** $15.

KODAK RETINA REFLEX CAMERA (TYPE 025)

IDENTIFICATION: "Kodak Retina Reflex" on front of prism.
CHARACTERISTICS: Single lens reflex. Interchangeable front elements. **LENS:** Retina Xenon-C or Heligon-C f2.0.
SHUTTER: Synchro-Compur MXV.
FILM SIZE: 135.
IMAGE: 24x36 mm.
BODY: 2½x3-7/8x5-1/8 in.
WEIGHT: 30 oz.
DATES: 1956-1958. **PRICE:** $215.

Made by Kodak A.G. Only the version with the Xenon-C lens was sold in the USA.

KODAK SIGNET 40 CAMERA

IDENTIFICATION: "Kodak Signet 40 Camera" on the front.
CHARACTERISTICS: Round on one end to fit hand. Square on the other end to fit a flashholder. Thumb-lever film advance. **LENS:** Kodak Ektanon f3.5. **SHUTTER:** Kodak Synchro 400. **FILM SIZE:** 135. **IMAGE:** 24x36 mm. **WEIGHT:** 1 lb. **DATES:** 1956-1959. **PRICE:** $65.

Left: Kodak Signet 40 camera
Right: Kodak Signet 30 camera

KODAK SIGNET 30 CAMERA

IDENTIFICATION: "Kodak Signet 30 Camera" on front window. **CHARACTERISTICS:** Single stroke film advance lever on bottom. **LENS:** Kodak Ektanar f2.8. **SHUTTER:** Kodak Synchro 250. **FILM SIZE:** 135. **IMAGE:** 24x36 mm. **DATES:** 1957-1959. **PRICE:** $55.

KODAK SIGNET 50 CAMERA

IDENTIFICATION: "Kodak Signet 50 Camera" on top. **CHARACTERISTICS:** Styled like Signet 30, but with built-in exposure meter. **LENS:** Kodak Ektanar f2.8. **SHUTTER:** Kodak Synchro 250. **FILM SIZE:** 135. **IMAGE:** 24x36 mm. **DATES:** 1957-1960. **PRICE:** $82.

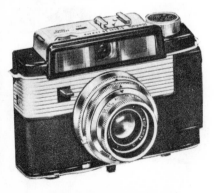
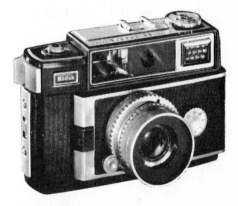

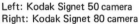
Left: Kodak Signet 50 camera
Right: Kodak Signet 80 camera

KODAK SIGNET 80 CAMERA

IDENTIFICATION: "Kodak Signet 80 Camera" on top. **CHARACTERISTICS:** Interchangeable lenses. **LENS:** Kodak Ektanar f2.8. **SHUTTER:** Behind-the-lens. **FILM SIZE:** 135. **IMAGE:** 24x36 mm. **DATES:**

1958-1962. PRICE: $130.

This camera was the finest of the Signet series, incorporating the most wanted features of the day including: exposure meter, coupled rangefinder and interchangeable lenses. Signet f4/90mm telephoto and Signet f3.5/35mm wide-angle lenses were also available. Unfortunately, its high price made if non-competitive with imported models, and it was closed out at just $60.00.

BROWNIE STARLET CAMERA (KODAK LTD. TYPE)

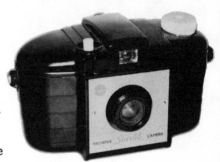

IDENTIFICATION: "Brownie Starlet Camera" on brass-colored faceplate.
CHARACTERISTICS: Bakelite eye-level box camera with rounded ends. Like Brownie 127 Camera except for faceplate. **LENS:** Meniscus. **SHUTTER:** Rotary.
FILM SIZE: 127. **IMAGE:** 1-5/8x2½ in. **BODY:** 2-7/8x3x5¼ in.
WEIGHT: 8 oz. **DATES:** 1956-1956.
PRICE: $4.

Made by Kodak Ltd. in London. Not to be confused with the Brownie Starlet Camera made in the U.S.A.

BROWNIE STARLET CAMERA (U.S.A. TYPE)

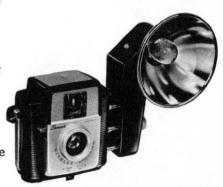

IDENTIFICATION: "Brownie Starlet Camera" on front.
CHARACTERISTICS: Black plastic eye-level camera. Synchronized.
LENS: Dakon. **SHUTTER:** Rotary.
FILM SIZE: 127.
IMAGE: 1-5/8x1-5/8 in.
BODY: 2¼x3¼x3½ in. **WEIGHT:** 5½ oz.
DATES: 1957-1962. **PRICE:** $6.

The same basic camera was continued as the Brownie Bullet II Camera from 1961-1968. Not to be confused with the Brownie Starlet Camera made by Kodak Ltd. in London.

KODAK RETINA IB CAMERA (TYPE 019)

IDENTIFICATION: "Retina I B" on top. **CHARACTERISTICS:** Uncoupled selenium meter. Extra front window for bright frame illumination. **LENS:** Retina Xenar f2.8. **SHUTTER:** Synchro-Compur. **FILM SIZE:** 135. **IMAGE:** 24x36 mm. **BODY:** 1-7/8x3½x4-7/8 in. **WEIGHT:** 22 oz. **DATES:** 1957-1960.

Made by Kodak·A.G. Not imported into the USA.

KODAK PONY II CAMERA

IDENTIFICATION: "Kodak Pony II Camera" on front plate. **CHARACTERISTICS:** Similar to earlier Pony 135 cameras, but re-styled for single speed shutter. Sync. posts on end of body. **LENS:** Kodak Anastar f3.9. **SHUTTER:** Single Speed Flash. **FILM SIZE:** 135. **IMAGE:** 24x36 mm. **BODY:** 2¼x3-1/8x5-1/8 in. **WEIGHT:** 14 oz. **DATES:** 1957-1962. **PRICE:** $27.

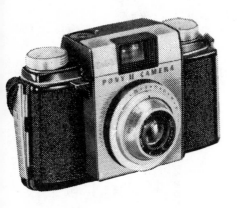
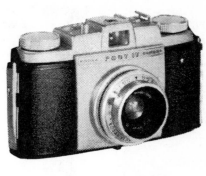

Kodak Pony II camera Kodak Pony IV camera

KODAK PONY IV CAMERA

IDENTIFICATION: "Kodak Pony IV Camera" on front plate. **CHARACTERISTICS:** Similar in style to the earlier Pony 135 cameras, but utilizing the EVS (Exposure Value System) instead of the more standard f stops. **LENS:** Kodak Anastar f3.5. **SHUTTER:** Kodak Flash 250. **FILM SIZE:** 135. **IMAGE:** 24x36 mm. **BODY:** 2¼x3-1/8x5-1/8 in. **WEIGHT:** 14 oz. **DATES:** 1957-1961. **PRICE:** $40.

BROWNIE BULLET CAMERA

IDENTIFICATION: "Brownie Bullet Camera" on front plate. **CHARACTERISTICS:** Black bakelite camera with white controls. Similar to Brownie Holiday Camera except for color and shorter strap. Not synchro- nized. **LENS:** Dakon. **SHUTTER:** Rotary. **FILM SIZE:** 127. **IMAGE:** 1-5/8x2½ in. **BODY:** 2-3/4x3x4 in. **WEIGHT:** 10 oz. **DATES:** 1957-1964.

This was a premium version of the Brownie Holiday Camera. The same camera was also available as the "Camara Brownie Chiquita".

BROWNIE CHIQUITA CAMERA

IDENTIFICATION: "Camara Brownie Chiquita" on front. **CHARAC-TERISTICS:** Identical to Brownie Bullet Camera except for Spanish language faceplate. **LENS:** Dakon. **SHUTTER:** Rotary. **FILM SIZE:** 127. **IMAGE:** 1-5/8x2½ in. **BODY:** 2-3/4x3x4 in. **WEIGHT:** 10 oz.

This was a special model of the Brownie Bullet Camera made in Rochester for export to Spanish-speaking countries.

BROWNIE STARFLEX CAMERA

IDENTIFICATION: "Brownie Starflex Camera" on front. **CHARACTER-ISTICS:** Reflex-style box camera with hooded brilliant finder. Synchronized for flash. **LENS:** Dakon. **SHUTTER:** Rotary. **FILM SIZE:** 127. **IMAGE:** 1-5/8x1-5/8 in. **BODY:** 2¼x3½x4 in. **WEIGHT:** 6½ oz. **DATES:** 1957-1964. **PRICE:** $10.

BROWNIE STARFLASH CAMERA

IDENTIFICATION: "Brownie Starflash Camera" on front. **CHARAC-TERISTICS:** Viewfinder incorporated in flash reflector. Available in black, blue, red, and white. **LENS:** Dakon. **SHUTTER:** Rotary. **FILM SIZE:** 127. **IMAGE:** 1-5/8x1-5/8 in. **BODY:** 2¼x3½x5½ in. **WEIGHT:** 7 oz. **DATES:** 1957-1965. **PRICE:** $9.

A modified design for close-up work based on the Starflash Camera was called the Startech Camera.

KODAK STARTECH CAMERA

IDENTIFICATION: "Kodak" on front plate. "Startech Camera" below lens. **CHARACTERISTICS:** Body style nearly identical to the Brownie Starflash. **LENS:** f27/50mm or f64. **SHUTTER:** 1/40. **FILM SIZE:** 127. **IMAGE:** 1-5/8x1-5/8 in. **BODY:** 2¼x3½x5½ in. **WEIGHT:** 7 oz. **DATES:** ca. 1959. **PRICE:** $35.

The Kodak Startech Camera is a special-purpose camera for medical and dental close-up photography. It was designed to be very easy to use for this specific application. The basic body is like a Brownie Starflash Camera, but with a dull finished reflector for better flash diffusion at close range. A special flash guard clips to two pegs on the camera body. This guard also incorporates a prism to correct for parallax. Two close-up lenses are supplied as part of the kit, and the two diaphragm stops are color-coordinated with the close-up lenses for proper exposure. Due to the extremely small lens openings, there is a great depth of field. So, what began as a simple snapshot camera has been changed to a specialized camera capable of quality results with snapshot ease.

KODAK RETINA IIC CAMERA (TYPE 029)

IDENTIFICATION: "Retina II C" (capital C) on top plate. **CHARACTERISTICS:** Large finder windows of equal size. Bright frames for 3 lenses. **LENS:** Retina Xenon-C or Heligon-C f2.8 with interchangeable front elements. **SHUTTER:** Synchro-Compur. **FILM SIZE:** 135. **IMAGE:** 24x36 mm. **BODY:** 1-7/8x3-3/4x5 in. **WEIGHT:** 1 lb. **DATES:** 1958-1958.
Made by Kodak A.G. Not imported into the USA.

KODAK RETINETTE F CAMERA (TYPE 022/7)

CHARACTERISTICS: Non-folding style. Same body style as Type 022. **FILM SIZE:** 135. **IMAGE:** 24x36 mm. **DATES:** 1958-1958.
Made by Kodak A.G. for export to France without a lens or shutter. Not sold in the USA.

KODAK RETINETTE II CAMERA (TYPE 026)

IDENTIFICATION: "Retinette II" on front of top housing. **CHARACTERISTICS:** Non-folding style. A continuation of the Type 022 style. Rectangular front plate with "V" design. Two finder windows. Shutter cross-coupled with diaphragm. **LENS:** Schneider Reomar f2.8. **SHUTTER:** Compur Rapid. **FILM SIZE:** 135. **IMAGE:** 24x36 mm. **DATES:** 1958-1958.
Made by Kodak A.G. Not imported into the USA.

KODAK RETINETTE IIB CAMERA (TYPE 031)

IDENTIFICATION: "Retinette II B" next to meter on front of top housing. **CHARACTERISTICS:** Non-folding camera. Rectangular face-plate with "V" design. No hot shoe. Built-in meter. **LENS:** Schneider Reomar f2.8/45mm. **SHUTTER:** Compur Rapid. **FILM SIZE:** 135. **IMAGE:** 24x36 mm. **BODY:** 2½x3¼x5 in. **WEIGHT:** 20 oz. **DATES:** 1958-1959. (illustrated on following page)
Made by Kodak A.G. Not imported into the U.S.A.

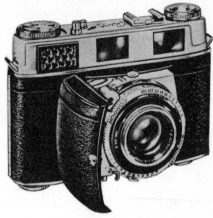

KODAK RETINA IIIC CAMERA (TYPE 028)

IDENTIFICATION: "Retina III C" (capital C) on top plate. **CHARAC-TERISTICS:** Coupled selenium meter. Equal sized finder windows. Bright frames for 3 lenses. **LENS:** Retina Xenon-C or Heligon-C f2.8 with interchangeable front elements. **SHUTTER:** Synchro-Compur. **FILM SIZE:** 135. **IMAGE:** 24x36 mm. **BODY:** 1-7/8x3-3/4x5 in. **WEIGHT:** 24 oz. **DATES:** 1958-1960. **PRICE:** $175. Made by Kodak A.G. Only the version with the Xenon-C lens was sold in the USA.

KODAK RETINA IIIS CAMERA (TYPE 027)

IDENTIFICATION: "Retina IIIS" on top plate. **CHARACTERISTICS:** Rigid body. Interchangeable lenses. **LENS:** (see variations below). **SHUTTER:** Synchro-Compur. **FILM SIZE:** 135. **IMAGE:** 24x36 mm. **BODY:** 2x3¼x5 in. **WEIGHT:** 24 oz. **DATES:** 1958-1960. **PRICE:** $158-193. Made by Kodak A.G. Only the versions with the Xenar or Xenon were sold in the USA. This was the first of the Retina cameras with a non-folding rigid body.

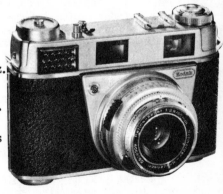

LENS	PRICE
Retina Xenon f1.9	193
Retina Xenar f2.8	158
Retina Heligon f1.9	EUR
Retina Ysarex f2.8	EUR

KODAK RETINETTE I CAMERA (TYPE 030)

IDENTIFICATION: "Retinette" in oval on front plate. **CHARACTER-ISTICS:** Non-folding style. A coninuation of the Type 022 style.

Rectangular front plate with "V" design. Two windows. **LENS:** Schneider Reomar f3.5. **SHUTTER:** Compur Rapid. **FILM SIZE:** 135. **IMAGE:** 24x36 mm. **BODY:** 2-3/4x3½x5 in. **WEIGHT:** 18 oz. **DATES:** 1958-1960.

Made by Kodak A.G. Not imported into the USA. (Type 030/7 and Type 030/9 were the export versions for Kodak-Pathe, France and Kodak Ltd., England, respectively.)

KODAK RETINA IIS CAMERA (TYPE 024)

IDENTIFICATION: "Retina II S" on top plate. **CHARACTERISTICS:** Like the IIIS, but without interchangeable lenses. **LENS:** Retina Xenar f2.8. **SHUTTER:** Synchro-Compur. **FILM SIZE:** 135. **IMAGE:** 24x36 mm. **BODY:** 2-3/4x3½x5 in. **WEIGHT:** 18 oz. **DATES:** 1959-1960.

Made by Kodak A.G. Not imported into the USA.

KODAK RETINA REFLEX S CAMERA (TYPE 034)

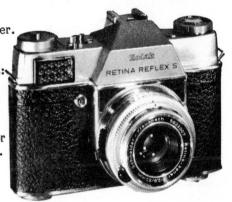

IDENTIFICATION: "Kodak Retina Reflex S" on front of prism. **CHARACTERISTICS:** Coupled meter. Interchangeable lens. **LENS:** (see variations below). **SHUTTER:** Synchro-Compur MXV. **FILM SIZE:** 135. **IMAGE:** 24x36 mm. **BODY:** 2-3/4x3-7/8x5-1/8 in. **WEIGHT:** 30 oz. **DATES:** 1959-1960. **PRICE:** $200-235. Made by Kodak A.G. Only the versions with the Xenar or Xenon lenses were sold in the USA.

LENS	PRICE
Retina Xenon f1.9	235
Retina Xenar f2.8	200
Retina Ysarex f2.8	EUR
Retina Heligon f1.9	EUR

KODAK RETINETTE IA CAMERA (TYPE 035)

IDENTIFICATION: "Retinette IA" in script on front of top housing. **CHARACTERISTICS:** Non-folding style. "V"-shaped front plate. No zone dots on lens rim. **LENS:** Schneider Reomar f3.5. **SHUTTER:** Pronto or Vero. **FILM SIZE:** 135. **IMAGE:** 24x36 mm. **BODY:** 2½x3½x5 in. **WEIGHT:** 1 lb. **DATES:** 1959-1960.

Made by Kodak A.G. Not imported into the USA. (Type 035/7 was the export version for Kodak-Pathe, France.)

KODAK RETINETTE IIA CAMERA (TYPE 036)

IDENTIFICATION: "Retinette IIA" on top. **CHARACTERISTICS:** Non-folding style. "V"-shaped front plate. Built-in meter. No hot shoe. **LENS:** Schneider Reomar f2.8. **SHUTTER:** Prontormat. **FILM SIZE:** 135. **IMAGE:** 24x36 mm. **DATES:** 1959-1960.

Made by Kodak A.G. Not imported into the USA.

KODAK RETINETTE IB CAMERA (TYPE 037)

CHARACTERISTICS: Non-folding style. "V"-shaped front plate. No hot shoe. Built-in meter. **LENS:** Schneider Reomar f2.8. **SHUTTER:** Pronto-LK. **FILM SIZE:** 135. **IMAGE:** 24x36 mm. **BODY:** $2\frac{1}{2}$x$3\frac{1}{2}$x5 in. **WEIGHT:** 1 lb. **DATES:** 1959-1963.
Made by Kodak A.G. Not imported into the USA.

BROWNIE STARMATIC CAMERA

IDENTIFICATION: "Brownie Starmatic Camera" around lens. **CHARACTERISTICS:** The Starmatic was the first automatic Brownie camera. A built-in meter automatically adjusts diaphragm. Black plastic body. **LENS:** Kodar f8. **SHUTTER:** Rotary. **FILM SIZE:** 127. **IMAGE:** 1-5/8x1-5/8 in. **DATES:** 1959-1961. **PRICE:** $35.

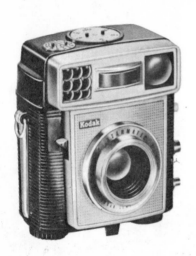 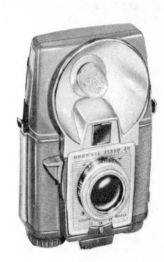

BROWNIE FLASH 20 CAMERA

IDENTIFICATION: "Brownie Flash 20" on front face. **CHARACTERIS-TICS:** Styled like Brownie Starflash Camera, but larger size for 620 film. Flash reflector incorporates viewfinder. **LENS:** f11 (zone focus). **SHUTTER:** built-in. **FILM SIZE:** 620. **IMAGE:** $2\frac{1}{4}$x$2\frac{1}{4}$ in. **BODY:** $3\frac{1}{4}$x$4\frac{1}{4}$x$6\frac{1}{4}$ in. **WEIGHT:** 13 oz. **DATES:** 1959-1962. **PRICE:** $14.

BROWNIE TWIN 20 CAMERA (illus. p. 138)

IDENTIFICATION: "Brownie Twin 20 Camera" on front. **CHARAC-TERISTICS:** Waist level and eye level finders. **LENS:** f11 (zone focus). **SHUTTER:** built-in. **FILM SIZE:** 620. **IMAGE:** $2\frac{1}{4}$x$2\frac{1}{4}$ in. **BODY:** $3\frac{1}{4}$x4x$4\frac{1}{4}$ in. **WEIGHT:** 10 oz. **DATES:** 1959-1964. **PRICE:** $11.

BROWNIE REFLEX 20 CAMERA

IDENTIFICATION: "Brownie Reflex 20 Camera" at top of front. **CHARACTERISTICS:** Reflex style camera with focusing lens and brilliant finder. Like Starflex Camera, but larger size for 620 film.

LENS: f11 (zone focus).
SHUTTER: built-in. **FILM SIZE:**
620. **IMAGE:** 2¼x2¼ in. **DATES:**
1959-1966. **PRICE:** $17.

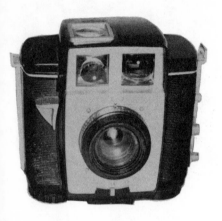

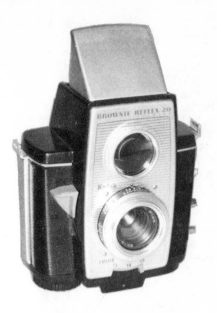

Brownie Twin 20 camera Brownie Reflex 20 camera

KODAK AUTOMATIC 35 CAMERA

IDENTIFICATION: "Kodak
Automatic 35 Camera" on top and
on shutter face. **CHARACTER-
ISTICS:** Flash synch posts on side of
body. No built-in flash. **LENS:**
Kodak Ektanar f2.8. **SHUTTER:**
Kodak Synchro 80. **FILM SIZE:**
135. **IMAGE:** 24x36 mm. **BODY:**
3x3½x5 in. **WEIGHT:** 21 oz.
DATES: 1959-1964. **PRICE:** $85.

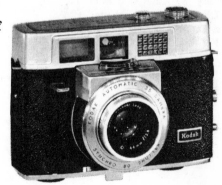

The Automatic 35 Camera, an
improved version of the Signet 35
Camera design, was the first of a
series of "aim & shoot" cameras
from Kodak. The built-in meter
automatically sets the diaphragm
when the shutter release is pressed. It even gives an illuminated
reminder in the viewfinder to wind the film.

KODAK AUTOMATIC 35B CAMERA

CHARACTERISTICS: Like the Automatic 35 Camera, but with Kodak
Automatic Flash shutter rather than Synchro 80 shutter. **LENS:** Kodak
Ektanar f2.8. **SHUTTER:** Kodak Automatic Flash. **FILM SIZE:** 135.
IMAGE: 24x36 mm. **BODY:** 3x3½x5 in. **WEIGHT:** 21 oz. **DATES:**
1961-1962. **PRICE:** $90.

Once the flash guide number was set, adjusting the focus
automatically adjusted the diaphragm for proper flash exposure.

137

KODAK AUTOMATIC 35F CAMERA

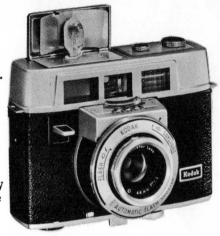

IDENTIFICATION: "Kodak Automatic 35F" on top of flash reflector. **CHARACTERISTICS:** Like the Automatic 35B Camera, but with built-in flash for AG-1 bulbs. **LENS:** Kodak Ektanar f2.8. **SHUTTER:** Kodak Automatic Flash. **FILM SIZE:** 135. **IMAGE:** 24x36 mm. **BODY:** 2-3/4x3-3/4x5 in. **WEIGHT:** 25 oz. **DATES:** 1962-1966. **PRICE:** $100.

This camera made the Automatic 35 even easier to use by eliminating the need for a separate flashholder.

KODAK AUTOMATIC 35R4 CAMERA

IDENTIFICATION: "Kodak Automatic 35 R4" on top. **CHARACTERISTICS:** Like Automatic 35B Camera, but with built-in flashcube socket.
LENS: Kodak Ektanar f2.8. **SHUTTER:** Kodak Automatic Flash. **FILM SIZE:** 135. **IMAGE:** 24x36 mm. **BODY:** 2-3/4x3-3/4x5 in. **WEIGHT:** 25 oz. **DATES:** 1965-1969. **PRICE:** $95.

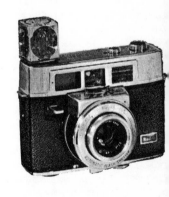

The Automatic 35R4 took over the reins from the 35F as flashcubes began to replace AG-1 bulbs in popularity.

KODAK MOTORMATIC 35 CAMERA

IDENTIFICATION: "Motormatic 35 Camera" on top. **CHARACTERIS-TICS:** Like the Automatic 35 Camera, but with spring-motor film advance. Flash sync posts on end of body. **LENS:** Kodak Ektanar f2.8. **SHUTTER:** Kodak Automatic Flash. **FILM SIZE:** 135. **IMAGE:** 24x36 mm. **BODY:** 3x4x5 in. **WEIGHT:** 27 oz. **DATES:** 1960-1962. **PRICE:** $110.

Introduced about a year after the popular Automatic 35 Camera, the Motormatic cameras added the convenience of motorized film advance and the two camera lines ran concurrently through several model changes until 1969.

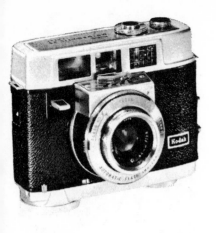
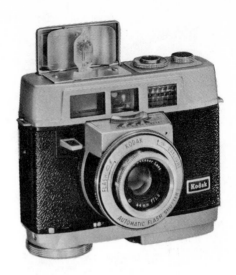

Left: Kodak Motormatic 35 camera
Right: Kodak Motormatic 35F camera

KODAK MOTORMATIC 35F CAMERA
IDENTIFICATION: "Kodak Motormatic 35F Camera" on top of flash reflector. **CHARACTERISTICS:** Like the Motormatic 35 Camera, but with built-in flash on top for AG-1 bulbs. **LENS:** Kodak Ektanar f2.8. **SHUTTER:** Kodak Automatic Flash. **FILM SIZE:** 135. **IMAGE:** 24x36 mm. **BODY:** 3x4x5 in. **WEIGHT:** 27 oz. **DATES:** 1962-1967. **PRICE:** $120.

KODAK MOTORMATIC 35R4 CAMERA
IDENTIFICATION: "Kodak Motormatic 35 R4 Camera" on top. **CHARACTERISTICS:** Like Motormatic 35 Camera, but with built-in flashcube socket on top. **LENS:** Kodak Ektanar f2.8. **SHUTTER:** Kodak Automatic Flash. **FILM SIZE:** 135. **IMAGE:** 24x36 mm. **BODY:** 3x4x5 in. **WEIGHT:** 27 oz. **DATES:** 1965-1969. **PRICE:** $110.

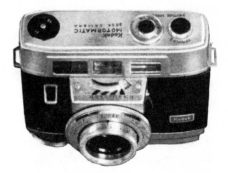

BROWNIE STARMITE CAMERA
IDENTIFICATION: "Brownie Starmite Camera" on front. **CHARACTERISTICS:** Small round flash for AG-1 bulbs. **LENS:** Dakon. **SHUTTER:** Rotary. **FILM SIZE:** 127. **IMAGE:** 1-5/8x1-5/8 in. **BODY:** 2½x3½x4-3/8 in. **WEIGHT:** 6½ oz. **DATES:** 1960-1963. **PRICE:** $11.

(illus. next page)

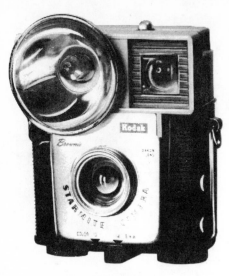

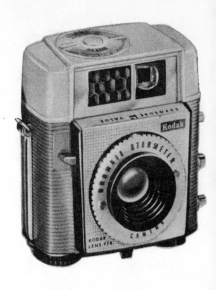

Brownie Starmite camera Brownie Starmeter camera

BROWNIE STARMETER CAMERA
IDENTIFICATION: "Brownie Starmeter Camera" around lens. **CHARACTERISTICS:** Uncoupled selenium meter. **LENS:** Kodar f8. **SHUTTER:** Rotary. **FILM SIZE:** 127. **IMAGE:** 1-5/8x1-5/8 in. **BODY:** 2½x3½x3-5/8 in. **WEIGHT:** 6½ oz. **DATES:** 1960-1965. **PRICE:** $20.

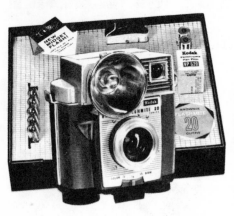

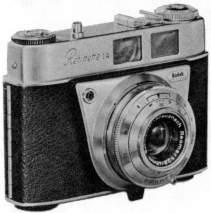

Brownie Flashmite 20 camera Retinette IA camera (type 042)

BROWNIE FLASHMITE 20 CAMERA
IDENTIFICATION: "Brownie Flashmite 20 Camera" on front. **CHARACTERISTICS:** Styled like Brownie Starmite Camera, but enlarged for 620 film. **LENS:** f11 (zone focus). **SHUTTER:** built-in. **FILM SIZE:** 620. **IMAGE:** 2¼x2¼ in. **BODY:** 3-3/8x4-3/8x4-7/8 in. **WEIGHT:** 11 oz. **DATES:** 1960-1965. **PRICE:** $15.

KODAK RETINETTE IA CAMERA (TYPE 042)

IDENTIFICATION: "Retinette IA" in script on front of top housing. **CHARACTERISTICS:** Non-folding style. "V"-shaped front plate. Click stops for zone focus, zones marked by dots on focus ring. Accessory shoe is not "hot" shoe as on later Type 044. **LENS:** Schneider Reomar f2.8. **SHUTTER:** Pronto. **FILM SIZE:** 135. **IMAGE:** 24x36 mm. **BODY:** 2½x3½x5 in. **WEIGHT:** 1 lb. **DATES:** 1960-1963. **PRICE:** $45. Made by Kodak A.G. (illustrated on previous page)

KODAK RETINA AUTOMATIC I CAMERA (TYPE 038)

IDENTIFICATION: "Retina Automatic" on top. **CHARACTERISTICS:** Rigid body. Coupled selenium meter. Shutter release on front. **LENS:** Retina Reomar f2.8. .**SHUTTER:** Prontormat-S. **FILM SIZE:** 135. **IMAGE:** 24x36 mm. **BODY:** 2-3/4x3½x5 in. **WEIGHT:** 22 oz. **DATES:** 1960-1962. Made by Kodak A.G. Not imported into the USA.

KODAK RETINA AUTOMATIC II CAMERA (TYPE 032)

IDENTIFICATION: "Retina Automatic II" on top. **CHARACTERISTICS:** Coupled automatic meter. Shutter release on front. No rangefinder. **LENS:** Retina Xenar f2.8. **SHUTTER:** Compur. **FILM SIZE:** 135. **IMAGE:** 24x36 mm. **BODY:** 2-3/4x3½x5 in. **WEIGHT:** 22 oz. **DATES:** 1960-1963. Made by Kodak A.G. Not imported into the USA.

KODAK RETINA AUTOMATIC III CAMERA (TYPE 039)

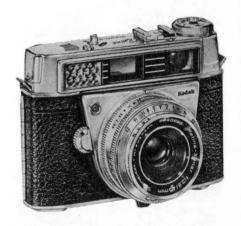

IDENTIFICATION: "Retina Automatic III" on top. **CHARACTERISTICS:** Like tha Automatic II, but with coupled rangefinder. **LENS:** Retina Xenar f2.8. **SHUTTER:** Compur. **FILM SIZE:** 135. **IMAGE:** 24x36 mm. **BODY:** 2-3/4x3½x5 in. **WEIGHT:** 22 oz. **DATES:** 1960-1964. **PRICE:** $130. Made by Kodak A.G.

KODAK RETINA REFLEX III CAMERA (TYPE 041)

IDENTIFICATION: "Kodak Retina Reflex III" on prism front. **CHARACTERISTICS:** Meter needle visible in finder. Shutter release on front. **LENS:** (variations below). **SHUTTER:** Synchro-Compur MXV. **FILM SIZE:** 135. **IMAGE:** 24x36 mm. **BODY:** 2-3/4x3-7/8x5-1/8 in. **WEIGHT:** 30 oz. **DATES:** 1960-1964. **PRICE:** $215-249. Made by Kodak A.G. Only the versions with the Xenar and Xenon were sold in the USA. (illustrated on next page)

LENS	PRICE	LENS	PRICE
Retina Xenon f1.9	249	Retina Ysarex f2.8	EUR
Retina Xenar f2.8	215	Retina Heligon f1.9	EUR

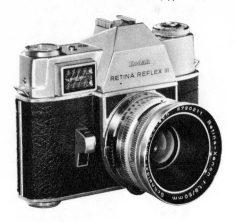 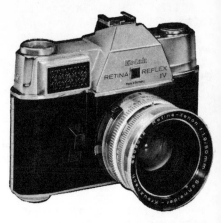

KODAK RETINA REFLEX IV CAMERA (TYPE 051)

IDENTIFICATION: "Kodak Retina Reflex IV" on front of prism.
CHARACTERISTICS: Small window on front of prism to show settings in finder. Folding crank on rewind knob. Hot shoe. **LENS:** (see variations below). **SHUTTER:** Synchro-Compur X. **FILM SIZE:** 135. **IMAGE:** 24x36 mm. **BODY:** 3½x4x5¼ in. (with f1.9 lens). **WEIGHT:** 33 oz. **DATES:** 1964-1967. **PRICE:** $242-277. Made by Kodak A.G.

LENS	PRICE
Retina Xenon f1.9/50 mm	277
Retina Xenar f2.8/50 mm	242

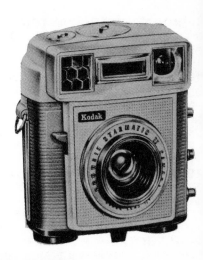

BROWNIE STARMATIC II CAMERA

IDENTIFICATION: "Brownie Starmatic II Camera" around lens. **CHARAC-TERISTICS:** Like Starmatic I Camera, but with two-tone gray plastic body. **LENS:** Kodar f8. **SHUTTER:** 2 speed. **FILM SIZE:** 127. **IMAGE:** 1-5/8x1-5/8 in. **WEIGHT:** 8 oz. **DATES:** 1961-1963. **PRICE:** $35.

BROWNIE SUPER 27 CAMERA

IDENTIFICATION: "Brownie Super 27 Camera" on hinged flash cover. **CHARACTERISTICS:** Horizontally styled camera with AG-1 flash and eye-level finder on opposite sides of the lens. **LENS:** Kodar f8. **SHUTTER:** 2 speed (1/80 normal and 1/40 flash). **FILM SIZE:** 127. **IMAGE:** 1-5/8x1-5/8 in. **BODY:** 2-3/4x2-3/4x6¼ in. **WEIGHT:** 11 oz. **DATES:** 1961-1965. **PRICE:** $19.

142

Brownie Super 27 camera Brownie Auto 27 camera

BROWNIE AUTO 27 CAMERA
IDENTIFICATION: "Brownie Auto 27" on flash door. CHARACTERIS-
TICS: Like Brownie Super 27 Camera, but with automatic metering.
Small meter window between lens and viewfinder. LENS: Kodar f8.
SHUTTER: 2 speed (1/80 normal and 1/40 flash). FILM SIZE: 127.
IMAGE: 1-5/8x1-5/8 in. BODY: 2-3/4x2-3/4x6¼ in. WEIGHT: 10 oz.
DATES: 1963-1964. PRICE: $35.

BROWNIE BULLET II CAMERA
IDENTIFICATION: "Brownie Bullet II Camera" on front. CHARAC-
TERISTICS: Black plastic eye-level camera styled like the Brownie
Starlet camera (U.S.A. type), but without flash synchronization. LENS:
Dakon. SHUTTER: Rotary. FILM SIZE: 127. IMAGE: 1-5/8x2½ in.
BODY: 2¼x3-3/8x3½ in. WEIGHT: 5 oz. DATES: 1961-1968. PRICE:
$5.
This same basic camera was sold from 1957-1962 as the Brownie
Starlet Camera.

KODAK RETINA IBS CAMERA (TYPE 040)
IDENTIFICATION: "Retina I BS" on top. LENS: Retina Xenar f2.8.
SHUTTER: Compur. FILM SIZE: 135. IMAGE: 24x36 mm. BODY:
2-3/8x3½x5 in. WEIGHT: 22 oz. DATES: 1962-1963.
Made by Kodak A.G. Not imported into the USA.

KODAK RETINA IF CAMERA (TYPE 046)
IDENTIFICATION: "RETINA IF" on top of flash reflector. CHARAC-
TERISTICS: Rigid body. Built-in AG-1 flash on top. Recessed rewind
knob. Coupled selenium meter. Prontor LK shutter distinguishes this
from the IIF. LENS: Retina Xenar f2.8. SHUTTER: Prontor 500LK.
FILM SIZE: 135. IMAGE: 24x36 mm. BODY: 2-3/8x3½x5 in.
WEIGHT: 22 oz. DATES: 1963-1964.
Made by Kodak A.G. Not imported into the USA.

KODAK RETINA IIF CAMERA (TYPE 047)

IDENTIFICATION: "RETINA IIF" on flash reflector. **CHARACTERIS-TICS:** Rigid body. Built-in AG-1 flash holder. Accesory shoe recessed in top housing. Similar to IF but with Compur Special shutter. Match-needle visible only in finder. **LENS:** Retina Xenar f2.8. **SHUTTER:** Synchro-Compur Special. **FILM SIZE:** 135. **IMAGE:** 24x36 mm. **BODY:** 2-3/8x3½x5 in. **WEIGHT:** 22 oz. **DATES:** 1963-1964. **PRICE:** $125. Made by Kodak A.G.

Retina IIF camera
(type 047)

Retinette IA camera
(type 044)

KODAK RETINETTE IA CAMERA (TYPE 044)

IDENTIFICATION: "RETINETTE IA" on front of top housing. **CHARACTERISTICS:** Non-folding style. "V"-shaped front plate. Hot shoe distinguishes this model from the Type 042. **LENS:** Schneider Reomar f2.8. **SHUTTER:** Prontor 250S 1963-1965, Prontor 300S 1965-1967. **FILM SIZE:** 135. **IMAGE:** 24x36 mm. **BODY:** 2-3/4x3½x5 in. **WEIGHT:** 17½ oz. **DATES:** 1963-1967. **PRICE:** $49.

KODAK RETINETTE IB CAMERA (TYPE 045)

IDENTIFICATION: "Retinette IB" on the top. **CHARACTERISTICS:** Non-folding style. "V"-shaped front plate. Built-in meter. Hot shoe. **LENS:** Schneider Reomar f2.8. **SHUTTER:** Prontor 500-LK. **FILM SIZE:** 135. **IMAGE:** 24x36 mm. **BODY:** 2-3/4x3½x5 in. **WEIGHT:** 18 oz. **DATES:** 1963-1966.
Made by Kodak A.G. Not imported into the USA.

BROWNIE STARMITE II CAMERA

IDENTIFICATION: "Brownie Starmite II" on front. **CHARACTER-ISTICS:** Like Starmite Camera, but with rectangular reflector recessed in body. **LENS:** Kodet f11. **SHUTTER:** Rotary. **FILM SIZE:** 127. **IMAGE:** 1-5/8x1-5/8 in. **BODY:** 2¼x3½x4 in. **WEIGHT:** 6½ oz. **DATES:** 1962-1967. **PRICE:** $12. (illustrated on next page)
The same camera manufactured and marketed in France was called "Brownie Starluxe II Camera".

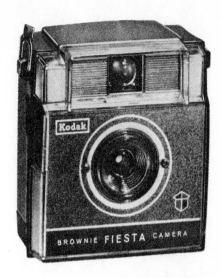

Left: Brownie Starmite II camera
Right: Brownie Fiesta Camera (gray & silver)

BROWNIE FIESTA CAMERA (GRAY AND SILVER)
IDENTIFICATION: "Brownie Fiesta Camera" at bottom of front. **CHARACTERISTICS:** Clear plastic front over metallic paper faceplate. **LENS:** Meniscus f11. **SHUTTER:** built-in. **FILM SIZE:** 127. **IMAGE:** 1-5/8x1-5/8 in. **BODY:** 2¼x3½x4 in. **WEIGHT:** 7 oz. **DATES:** 1962-1965. **PRICE:** $6.

BROWNIE FIESTA CAMERA (LIGHT AND DARK BLUE)
LENS: Meniscus f11. **SHUTTER:** built-in. **FILM SIZE:** 127. **IMAGE:** 1-5/8x1-5/8 in. **BODY:** 2¼x3½x4 in. **WEIGHT:** 7 oz. **DATES:** 1965-1966. **PRICE:** $6.

BROWNIE FIESTA R4 CAMERA
IDENTIFICATION: "Brownie Fiesta R4 Camera" on aluminum front plate. **CHARACTERISTICS:** Like Brownie Fiesta Camera, but for flashcubes. Gray plastic front with aluminum faceplate. **LENS:** Meniscus f11 fixed focus. **SHUTTER:** single speed. **FILM SIZE:** 127. **IMAGE:** 1-5/8x1-5/8 in. **BODY:** 2¼x3-3/4x3-7/8 in. **WEIGHT:** 7 oz. **DATES:** 1966-1969. **PRICE:** $9. (illustrated on next page)

KODAK WORLD'S FAIR FLASH CAMERA 1964-1965
IDENTIFICATION: "Kodak World's Fair Flash Camera 1964-1965" on awning above lens. **CHARACTERISTICS:** Like Hawkeye Flashfun Camera, but has a rigid awning over the lens. **LENS:** Achromatic. **SHUTTER:** single-speed. **FILM SIZE:** 127. **IMAGE:** 1-5/8x1-5/8 in. **BODY:** 2-3/4x3¼x5 in. **WEIGHT:** 6¼ oz. **DATES:** 1964-1965.
Sold only at the New York World's Fair. (illustrated next page)

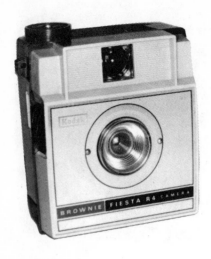
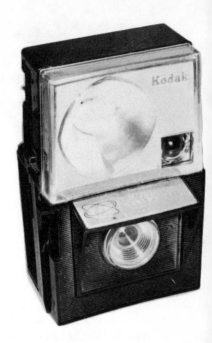

Left: Brownie Fiesta R4 camera
Right: Kodak World's Fair Flash Camera 1964-1965

THE KODAPAK CARTRIDGE CHALLENGES 35mm

For years camera designers and photographers had been teamed up in an effort to replace the 35mm cassette with something which would be quicker and easier to load and not require rewinding after exposure. Various "rapid cassette" systems had been tried as an alternative to the standard Lecia/Contax/Retina cassette. Kodak had introduced 828 rollfilm as a 35mm substitute. Yet none of these efforts had succeeded in dethroning 35mm film, nor did any of them capture a permanent spot in the photographic market. Despite its shortcomings, 35mm film had enough advantages to keep it on top.

But another challenge to that supremacy was made in 1963 with the entry of the 126 Kodapak cartridge. This was the first new film size introduced by Kodak since 828 rollfilm in 1935. It gets its number from the originally proposed image size of 26mm square. This newly designed film cartridge with a pre-threaded takeup spool launched a new era of photographic simplicity. The cartridge could simply be dropped into the back of the camera with no threading or rewinding needed. Coded notches on the cartridge could signal the film speed to the camera for automatic setting of meters and shutters. Earlier, when introducing the Pocket Kodak camera of 1895, we discussed the birth of the red window on the back of cameras in 1892. After seventy years, Kodak finally made a significant improvement upon that idea by moving the window to the cartridge, then including on the paper backing all the information you would care to know about your film: type of film, number of exposures on the roll, and current frame number. Surely

with all these features, this would be the ultimate challenge for 35mm cassettes.

But, the reigning king does not fall easily. For various good reasons, manufacturers of 35mm cameras maintain their their support of 35mm film and it continued as strong as ever. The challenger however, had enough merits that it could not be overlooked, and the full line of Instamatic cameras introduced along with the new film became an overnight success. Once again photography became more simple and earned the full support of the mass market.

INSTAMATIC CAMERAS

A number of Instamatic cameras were introduced simultaneously with the 126 Kodakpak cartridge. All of these cameras featured lever film advance with automatic frame positioning (except motorized models which substituted a wind-up knob for the advance lever). As a general guide to the numbering of Instamatic cameras, the first series (for AG-1 flashbulbs) end in "0" as 100, 150, etc. The second series (for flashcubes) began in 1965 with "4" replacing "0" as the last digit of the model number to signify the 4-sided flashcube. The third wave began in 1968 and the second digit is no longer a "0" or "5". They still use flashcubes, but metered models now have a CdS rather than selenium meter. The fourth series began in 1970 with an "X" prefix signifying that the camera uses the new "X" or "Magicube" flash.

KODAK INSTAMATIC 100 CAMERA

IDENTIFICATION: "Instamatic 100 Camera" on front. **CHARACTERISTICS:** Pop-up flashholder for AG-1 bulbs. **LENS:** f11/43 mm (fixed focus). **SHUTTER:** 2-speed (1/90 normal and 1/40 for flash). **FILM SIZE:** 126. **IMAGE:** 28x28 mm. **BODY:** 2x2-3/8x4-1/8 in. **WEIGHT:** 9 oz. **DATES:** 1963-1966. **PRICE:** $16.

This is the low-priced model of the new "Instamatic" Cameras which changed the face of photography.

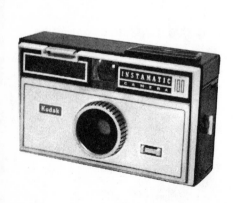 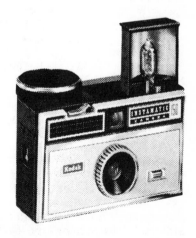

KODAK INSTAMATIC 150 CAMERA

IDENTIFICATION: "Instamatic 150 Camera" on front. **CHARACTERISTICS:** Like model 100 with the pop-up AG-1 flashholder, but also

incorporating spring-motor film advance. **LENS:** f11/43 mm (fixed focus). **SHUTTER:** 2-speed (1/90 normal and 1/40 for flash). **FILM SIZE:** 126. **IMAGE:** 28x28 mm. **DATES:** 1964-1966. **PRICE:** $30.

KODAK INSTAMATIC 300 CAMERA

IDENTIFICATION: "Instamatic 300 Camera" on front. **CHARACTER-ISTICS:** Pop-up flash. Selenium meter. **LENS:** Kodar f8/41 mm. **SHUTTER:** 2-speed (1/60 normal and 1/40 flash). **FILM SIZE:** 126. **IMAGE:** 28x28 mm. **DATES:** 1963-1966. **PRICE:** $45.

Built-in selenium meter is automatically set to the proper film speed by a notch in the film cartridge. An automatic low-light signal recommends the use of a flash.

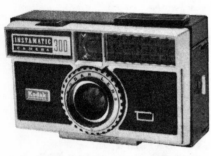
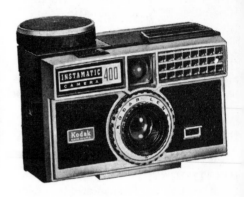

Left: Kodak Instamatic 300 camera
Right: Kodak Instamatic 400 camera

KODAK INSTAMATIC 400 CAMERA

IDENTIFICATION: "Instamatic 400 Camera" on front. **CHARACTER-ISTICS:** Similar to model 300 with meter and pop-up flash, but also has spring-motor film advance. **LENS:** Kodar f8/41 mm. **SHUTTER:** 2-speed (1/60 normal and 1/40 flash). **FILM SIZE:** 126. **IMAGE:** 28x28 mm. **DATES:** 1963-1966. **PRICE:** $53.

KODAK INSTAMATIC 500 CAMERA

IDENTIFICATION: "Kodak Instamatic 500" on front. **CHARAC-TERISTICS:** Match-needle selenium meter. Zone focusing. **LENS:** Schneider Xenar f2.8/38 mm. **SHUTTER:** Compur 1/30-1/500 and B. **FILM SIZE:** 126. **IMAGE:** 28x28 mm. **BODY:** 2x2-5/8x4-7/8 in. **WEIGHT:** 15 oz. **DATES:** 1963-1966. **PRICE:** $95.

Made by Kodak A.G. in Stuttgart (designated Type 048) and introduced in Europe as a counterpart to the American models. When it was unveiled in Germany in 1963, it was intended only for the European market, but by mid-1964 it was also being sold in the USA.

KODAK INSTAMATIC 700 CAMERA

IDENTIFICATION: "Instamatic 700 Camera" on flash reflector. **CHARACTERISTICS:** AG-1 flash socket with flip-up reflector. Automatic metering controls diaphragm and shutter. No rangefinder as on model 800, although window is present. **LENS:** Ektanar f2.8/38 mm (zone focus). **SHUTTER:** Automatic 1/30-1/250. **FILM SIZE:** 126. **IMAGE:** 28x28 mm. **DATES:** 1963-1966. **PRICE:** $110.

↙700 800 ↘

KODAK INSTAMATIC 800 CAMERA

IDENTIFICATION: "Instamatic 800 Camera" on flash reflector. **CHARACTERISTICS:** Styled like 700 with meter and flash, but also has coupled rangefinder and spring-motor film advance. **LENS:** Ektanar f2.8/38 mm. **SHUTTER:** Automatic 1/30-1/250. **FILM SIZE:** 126. **IMAGE:** 28x28 mm. **DATES:** 1964-1966. **PRICE:** $130.

The spring motor for film advance is tensioned by pulling several times on a tape at the bottom of the camera rather than using an oversized knob as on the 150 and 400 models.

KODAK INSTAMATIC 104 CAMERA

IDENTIFICATION: "Instamatic 104 Camera" on front. **CHARACTERISTICS:** Like model 100, but for flashcubes instead of AG-1 bulbs. **LENS:** f11/43 mm (fixed focus). **SHUTTER:** 2-speed (1/90 normal and 1/40 for flash). **FILM SIZE:** 126. **IMAGE:** 28x28 mm. **BODY:** 2x2½x4 in. **WEIGHT:** 9 oz. **DATES:** 1965-1968. **PRICE:** $16.

The flashcubes turn automatically when the film is advanced, so this improvement over the model 100 added further to the convenience of the already popular Instamatic cameras. Four flash shots could be fired rapidly before changing bulbs. (illustrated on next page)

KODAK INSTAMATIC 154 CAMERA

IDENTIFICATION: "Instamatic 154 Camera" on front. **CHARACTERISTICS:** Spring-motor film advance. Uses flashcubes. **LENS:** f11/43 mm (fixed focus). **SHUTTER:** 2-speed (1/90 normal and 1/40 flash). **FILM**

SIZE: 126. IMAGE: 28x28 mm. BODY: 2x2-3/4x4 in. WEIGHT: 10 oz. DATES: 1965-1969. PRICE: $29.

KODAK INSTAMATIC 304 CAMERA
IDENTIFICATION: "Instamatic 304 Camera" on front. CHARACTER-ISTICS: Lever film advance. Meter. Uses flashcubes. LENS: Kodar f8/41 mm. SHUTTER: 2-speed (1/60 normal and 1/40 flash). FILM SIZE: 126. IMAGE: 28x28 mm. BODY: 2x2½x4 in. WEIGHT: 13 oz. DATES: 1965-1969. PRICE: $45.

KODAK INSTAMATIC 404 CAMERA
IDENTIFICATION: "Instamatic 404 Camera" on front. CHARACTER-ISTICS: Spring-motor film advance. Meter. Flashcubes. LENS: Kodar f8/41 mm. SHUTTER: 2-speed (1/60 normal and 1/40 flash). FILM SIZE: 126. IMAGE: 28x28 mm. BODY: 2x2-3/4x4 in. WEIGHT: 14 oz. DATES: 1965-1969. PRICE: $56.

KODAK INSTAMATIC 704 CAMERA
IDENTIFICATION: "Instamatic 704 Camera" on front. CHARACTER-ISTICS: Like 700, but for flashcubes rather than AG-1 bulbs.

Automatic metering with selenium cell above lens. Zone focus but no rangefinder. **LENS:** Ektanar f2.8/38 mm. **SHUTTER:** Automatic 1/30-1/250. **FILM SIZE:** 126. **IMAGE:** 28x28 mm. **BODY:** 2½x3¼x4½ in. **WEIGHT:** 24 oz. **DATES:** 1965-1969. **PRICE:** $105.

KODAK INSTAMATIC 804 CAMERA
IDENTIFICATION: "Instamatic 804 Camera" on front. **CHARACTER-ISTICS:** Like 800, but for flashcubes instead of AG-1 bulbs. Spring-motor film advance. Automatic exposure control. Coupled rangefinder. **LENS:** Ektanar f2.8/38 mm. **SHUTTER:** Automatic 1/30-1/250. **FILM SIZE:** 126. **IMAGE:** 28x28 mm. **BODY:** 2½x3¼x4½ in. **WEIGHT:** 26 oz. **DATES:** 1965-1970. **PRICE:** $125.

KODAK RETINA S1 CAMERA
(TYPE 060)

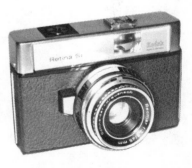

IDENTIFICATION: "Retina S1" on front of top housing. **CHARACTERISTICS:** Rigid plastic body. Built-in flashcube socket. No meter. Manual exposure with weather symbols. **LENS:** Schneider Reomar f2.8. **SHUTTER:** Kodak 4-speed w/B. **FILM SIZE:** 135. **IMAGE:** 24x36 mm. **BODY:** 2½x3½x5¼ in. **WEIGHT:** 15 oz. **DATES:** 1966-1969. **PRICE:** $60. Made by Kodak A.G.

KODAK RETINA S2 CAMERA (TYPE 061)
IDENTIFICATION: "Retina S2" on front of top housing. **CHARAC-TERISTICS:** Like S1, but with coupled selenium meter. **LENS:** Schneider Reomar f2.8. **SHUTTER:** Kodak 4-speed w/B. **FILM SIZE:** 135. **IMAGE:** 24x36 mm. **BODY:** 2½x3½x5¼ in. **WEIGHT:** 1 lb. **DATES:** 1966-1969. Made by Kodak A.G. Not imported into the USA.

KODAK INSTAMATIC S-10 CAMERA
IDENTIFICATION: "Kodak Instamatic S-10 Camera" on front.

CHARACTERISTICS: Compact styling with rectangular pop-out front. Flashcube socket on top. Film advance knob on end of body. **LENS:** Kodar f11/43 mm (fixed focus). **SHUTTER:** 2-speed (1/125 normal and 1/40 flash). **FILM SIZE:** 126. **IMAGE:** 28x28 mm. **DATES:** 1967-1970. **PRICE:** $28.

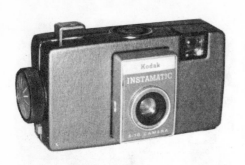 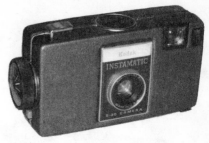

KODAK INSTAMATIC S-20 CAMERA

IDENTIFICATION: "Kodak Instamatic S-20 Camera" on front. **CHARACTERISTICS:** Like S-10, but with automatic electric eye. **LENS:** Kodar f5.6/41 mm (fixed focus). **SHUTTER:** 1/90. **FILM SIZE:** 126. **IMAGE:** 28x28 mm. **DATES:** 1967-1971. **PRICE:** $59.

KODAK INSTAMATIC 124 CAMERA

IDENTIFICATION: "Instamatic Camera 124" on front. **CHARACTER-ISTICS:** Lever advance. Flashcubes. **LENS:** f11/43 mm (fixed focus). **SHUTTER:** 2-speed (1/90 normal and 1/40 flash). **FILM SIZE:** 126. **IMAGE:** 28x28 mm. **BODY:** 2-1/8x2½x4-1/8 in. **WEIGHT:** 8 oz. **DATES:** 1968-1971. **PRICE:** $19.

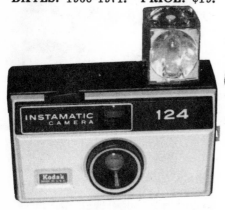 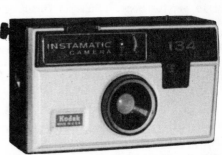

KODAK INSTAMATIC 134 CAMERA

IDENTIFICATION: "Instamatic Camera 134" on front. **CHARACTER-ISTICS:** Similar to the 124, but with meter. Flashcubes. Lever

advance. **LENS:** f11/43 mm (fixed focus). **SHUTTER:** Built-in. **FILM SIZE:** 126. **IMAGE:** 28x28 mm. **BODY:** 2-1/8x2½x4-1/8 in. **WEIGHT:** 8 oz. **DATES:** 1968-1971. **PRICE:** $28.

KODAK INSTAMATIC 174 CAMERA

IDENTIFICATION: "Instamatic Camera 174" on front. **CHARACTER-ISTICS:** Spring-motor film advance. Flashcube socket. **LENS:** f11/43 mm (fixed focus). **SHUTTER:** 2-speed (1/90 normal and 1/40 for flash). **FILM SIZE:** 126. **IMAGE:** 28x28 mm. **DATES:** 1968-1971. **PRICE:** $27.

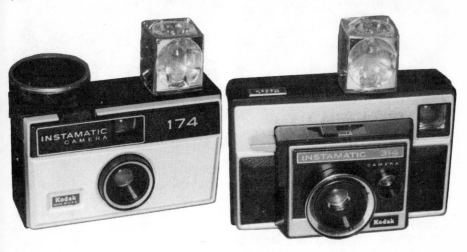

KODAK INSTAMATIC 314 CAMERA

IDENTIFICATION: "Instamatic 314 Camera" on front. **CHARACTER-ISTICS:** Lever film advance. Flashcube socket. Round CdS meter cell next to lens. **LENS:** Kodar f8/41 mm (zone focus). **SHUTTER:** 2 speed (1/90 normal and 1/45 flash). **FILM SIZE:** 126. **IMAGE:** 28x28 mm. **BODY:** 2-3/8x2-3/4x4½ in. **WEIGHT:** 10 oz. **DATES:** 1968-1971. **PRICE:** $38.

KODAK INSTAMATIC 414 CAMERA

IDENTIFICATION: "Instamatic 414 Camera" on front. **CHARACTERIS-TICS:** Like 314, but with spring-motor film advance. CdS meter. Flashcube socket. **LENS:** Kodar f8/41 mm (zone focus). **SHUTTER:** 2 speed (1/90 normal and 1/45 flash). **FILM SIZE:** 126. **IMAGE:** 28x28 mm. **BODY:** 2-3/8x3¼x4½ in. **WEIGHT:** 12 oz. **DATES:** 1968-1971. **PRICE:** $48.

KODAK INSTAMATIC 714 CAMERA

IDENTIFICATION: "Instamatic 714 Camera" above lens. **CHARACTERISTICS:** Like 704, but with CdS meter cell. Lever film advance. No rangefinder. **LENS:** Ektar f2.8/38 mm. **SHUTTER:** 1/30-1/250, B. **FILM SIZE:** 126. **IMAGE:** 28x28 mm. **DATES:** 1968-1970. **PRICE:** $120.

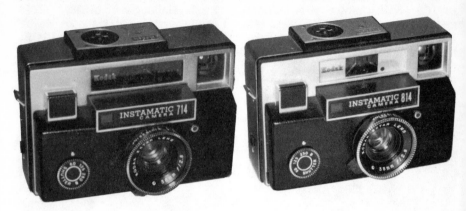

KODAK INSTAMATIC 814 CAMERA

IDENTIFICATION: "Instamatic 814 Camera" above lens. **CHARACTERISTICS:** Like 804, but with CdS rather than selenium meter cell. Like 714, but also includes rangefinder and spring-motor film advance. **LENS:** Ektra f2.8/38 mm. **SHUTTER:** 1/30-1/250, B. **FILM SIZE:** 126. **IMAGE:** 28x28 mm. **DATES:** 1968-1970. **PRICE:** $140.

KODAK INSTAMATIC REFLEX CAMERA

IDENTIFICATION: "Instamatic Reflex Camera" on front of prism. **CHARACTERISTICS:** Single lens reflex for 126 cartridges and flashcubes. Interchangeable lenses. CdS metering. **LENS:** (see variations below). **SHUTTER:** Compur Electronic 20 sec.-1/500. **FILM SIZE:** 126. **IMAGE:** 28x28 mm. **BODY:** 3x3-3/4x5¼ in. **WEIGHT:** 30 oz. **DATES:** 1968-1974. **PRICE:** $200-250.

Made by Kodak A.G. in Stuttgart. Designated Type 062. Black finish available in the U.S.A. in 1969. (It was introduced in Europe previously.) The chrome or black body could be purchased without a lens for $157 or $162 respectively.

LENS (in chrome body)	PRICE
Retina Xenar f2.8/45 mm	200
Retina Xenon f1.9/50 mm	250

KODAK INSTAMATIC 44 CAMERA

IDENTIFICATION: "Instamatic 44
Camera" on front.
CHARACTERISTICS: Styled like
Hawkeye Instamatic II Camera, but
black colored. Uses flashcubes.
LENS: f11/43 mm (fixed focus).
SHUTTER: single speed.
FILM SIZE: 126.
IMAGE: 28x28 mm.
BODY: 2¼x2-3/4x5 in.
WEIGHT: 6 oz.
DATES: 1969-1973. PRICE: $10.

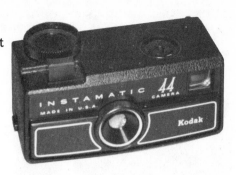

KODAK INSTAMATIC X-15 CAMERA

IDENTIFICATION: "Instamatic X-15 Camera" on front.
CHARACTERISTICS: Low-priced model for magicubes. LENS: f11/43
mm (fixed focus). SHUTTER: 2-speed (1/90 normal and 1/45 flash).
FILM SIZE: 126. IMAGE: 28x28 mm. BODY: 2-1/8x2-3/4x4½ in.
WEIGHT: 6 oz. DATES: 1970-1976. PRICE: $21.

This was the first of the Instamatic cameras to use the new
"Magicube" or "X"-cubes, which require no batteries. Early models have
a metal "Kodak" nameplate on top. Later ones have "Kodak" molded
into the plastic on top and the new Kodak trademark design on the
front.

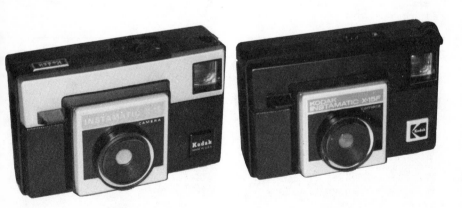

KODAK INSTAMATIC X-15F CAMERA

IDENTIFICATION: "Kodak Instamatic X-15F Camera" on front.
CHARACTERISTICS: Like X-15, but brown colored and for flipflash
rather than magicubes. LENS: f11/43 mm (fixed focus). SHUTTER:
2-speed (1/90 normal and 1/45 for flash). FILM SIZE: 126. IMAGE:
28x28 mm. BODY: 2-1/8x2-3/4x4½ in. WEIGHT: 6 oz. DATES:
1976-. PRICE: $20.

KODAK INSTAMATIC X-25 CAMERA

IDENTIFICATION: "Instamatic X-25 Camera" on front. **CHARACTER-ISTICS:** Like the X-15, but with spring-motor film advance. **LENS:** f11/43 mm (fixed focus). **SHUTTER:** 2-speed (1/90 normal and 1/45 flash). **FILM SIZE:** 126. **IMAGE:** 28x28 mm. **BODY:** 2-1/8x3¼x4½ in. **WEIGHT:** 7 oz. **DATES:** 1970-1974. **PRICE:** $31.

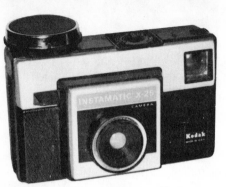 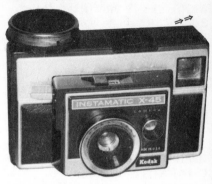

KODAK INSTAMATIC X-35 CAMERA

IDENTIFICATION: "Instamatic X-35 Camera" on front. **CHARACTER-ISTICS:** CdS metered electronic shutter. Two-position focus lever. Like the Instamatic 314 Camera, but for magicubes instead of flashcubes. **LENS:** Kodar f8/41 mm (zone focus). **SHUTTER:** 2-speed (1/90 normal and 1/45 flash). **FILM SIZE:** 126. **IMAGE:** 28x28 mm. **BODY:** 2-3/8x2-3/4x4½ in. **WEIGHT:** 10 oz. **DATES:** 1970-1976. **PRICE:** $48.

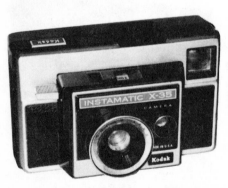 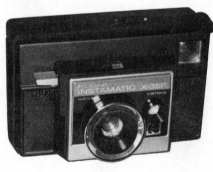

KODAK INSTAMATIC X-35F CAMERA

IDENTIFICATION: "Kodak Instamatic X-35F Camera" on front. **CHAR-ACTERISTICS:** Like X-15F, but with CdS metering and two-position focus. **LENS:** f8/41 mm (zone focus). **SHUTTER:** 2-speed (1/90 normal and 1/45 flash). **FILM SIZE:** 126. **IMAGE:** 28x28 mm. **BODY:**

2½x2-3/4x4½ in. **WEIGHT:** 10 oz. **DATES:** 1976-. **PRICE:** $54.

KODAK INSTAMATIC X-45 CAMERA

IDENTIFICATION: "INSTAMATIC X-45 CAMERA" on front. **CHARACTERISTICS:** Spring-motor film advance. CdS controlled electronic shutter. Two-position focus lever. **LENS:** Kodar f8/41 mm (zone focus). **SHUTTER:** 2-speed (1/90 normal and 1/45 flash). **FILM SIZE:** 126. **IMAGE:** 28x28 mm. **BODY:** 2½x3¼x4½ in. **WEIGHT:** 11 oz. **DATES:** 1970-1974. **PRICE:** $58. (illustrated on preceding page)

KODAK INSTAMATIC X-90 CAMERA

IDENTIFICATION: "Instamatic X-90 Camera" on front. **CHARACTERISTICS:** Spring-motor film transport. Rangefinder. Shutter speed dial on front. **LENS:** Ektar f2.8/38 mm. **SHUTTER:** Automatic 1/30-1/250 and B. **FILM SIZE:** 126. **IMAGE:** 28x28 mm. **BODY:** 2½x3¼x4-3/4 in. **WEIGHT:** 24 oz. **DATES:** 1970-1973. **PRICE:** $145.

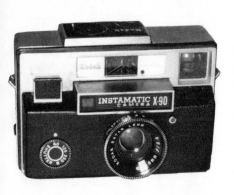 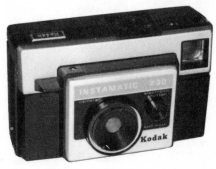

KODAK INSTAMATIC X-30 CAMERA

IDENTIFICATION: "Instamatic X-30 camera" on front. **CHARACTERISTICS:** Electronic shutter with CdS meter. **LENS:** f11/43 mm (fixed focus). **SHUTTER:** Electronic 1/125-10 sec. (1/45 flash). **FILM SIZE:** 126. **IMAGE:** 28x28 mm. **DATES:** 1971-1974. **PRICE:** $38.

POCKET INSTAMATIC CAMERAS

Pocket Instamatic Camera were the product of years of perfection of photographic equipment and processes. The film cartridge was based on the 126 Kodapak cartridge of 1963 which featured drop-in loading and a single perforation per frame for automatic film positioning. The size of the camera and its small negative were made possible by the introduction of new color films capable of providing good enlargements. The success of the camera was partially due to the ready availibility of film and processing. Earlier subminiature cameras, even those of excellent design and popular use, had always suffered from the problems of special films and processing. The combination of the new film technology, small camera size, low price, and simplicity of operation

once again spelled success for Kodak. From the first model on, all models took "X"-cubes. None were made for regular flashcubes. While the 126 cartridge system had achieved popularity mainly in the United States, the new 110 size caught the eye of foreign markets as well and many foreign manufacturers have made cameras, including sophisticated SLR systems, for the new miniature film.

KODAK POCKET INSTAMATIC 100 CAMERA

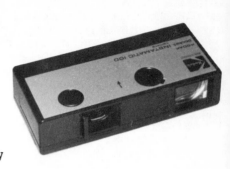

IDENTIFICATION: "Kodak Pocket Instamatic 100 Camera" on top. **CHARACTERISTICS:** Pocket camera for magicubes. Black finish on front 1972-1973, chrome finish 1973-1975. **LENS:** fixed focus f11/25mm. **SHUTTER:** 1/60 sec. **FILM SIZE:** 110. **IMAGE:** 13x17 mm. **DATES:** 1972-1975. Made by Kodak A.G. in Stuttgart.

KODAK POCKET INSTAMATIC 20 CAMERA

IDENTIFICATION: "Pocket Instamatic 20 Camera" on top. **CHARACTERISTICS:** Fixed focus. No meter. **LENS:** f9.5/25 mm. **SHUTTER:** 2-speed (1/100 normal and 1/40 flash). **FILM SIZE:** 110. **IMAGE:** 13x17 mm. **BODY:** 1x2½x5½ in. **WEIGHT:** 6 oz. **DATES:** 1972-1976. **PRICE:** $28.
This is the lowest-priced model of the Pocket Instamatic Cameras.

KODAK POCKET INSTAMATIC 30 CAMERA

IDENTIFICATION: "Pocket Instamatic 30 camera" on top. **CHARACTERISTICS:** Built-in CdS meter. **LENS:** fixed focus f9.5/25 mm. **SHUTTER:** Electronic 1/160-5 sec. **FILM SIZE:** 110. **IMAGE:** 13x17 mm. **BODY:** 1x2½x5½ in. **WEIGHT:** 6 oz. **DATES:** 1972-1976. **PRICE:** $48.

Kodak Pocket Instamatic 30 camera

Kodak Pocket Instamatic 40 camera

KODAK POCKET INSTAMATIC 40 CAMERA

IDENTIFICATION: "Pocket Instamatic 40 camera" on top. **CHARAC-TERISTICS:** Two-position focus lever. CdS meter controls electronic

shutter. **LENS:** zone focus f8/25 mm. **SHUTTER:** Electronic 1/225-5 sec. **FILM SIZE:** 110. **IMAGE:** 13x17 mm. **BODY:** 1x2½x5 in. **WEIGHT:** 6 oz. **DATES:** 1972-1975. **PRICE:** $63.

KODAK POCKET INSTAMATIC 50 CAMERA

IDENTIFICATION: "Pocket Instamatic 50 camera" on top. **CHARACTERISTICS:** Scale-focusing. Programmed electronic shutter with CdS meter. Focusing scale adjusts diaphragm automatically for flash pictures. **LENS:** Ektar f2.7/26 mm. **SHUTTER:** Electronic 1/250-5 sec. **FILM SIZE:** 110. **IMAGE:** 13x17 mm. **BODY:** 1x2¼x5-3/4 in. **WEIGHT:** 9 oz. **DATES:** 1972-1976. **PRICE:** $108.

KODAK POCKET INSTAMATIC 60 CAMERA

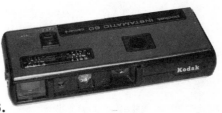

IDENTIFICATION: "Pocket Instamatic 60 camera" on top. **CHARACTERISTICS:** Like model 50, but has coupled rangefinder. **LENS:** Ektar f2.7/26 mm. **SHUTTER:** Electronic 1/250-5 sec. **FILM SIZE:** 110. **IMAGE:** 13x17 mm. **BODY:** 1x2-3/8x5-3/4 in. **WEIGHT:** 9 oz. **DATES:** 1972-1976. **PRICE:** $128.

KODAK POCKET INSTAMATIC 10 CAMERA

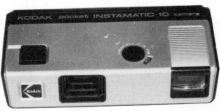

IDENTIFICATION: "Kodak Pocket Instamatic 10 camera" on top. **CHARACTERISTICS:** Low-priced model. **LENS:** f11/25 mm (fixed focus). **SHUTTER:** 2-speed (1/90 normal and 1/40 for flash). **FILM SIZE:** 110. **IMAGE:** 13x17 mm. **BODY:** 1x2-1/8x4-3/8 in. **WEIGHT:** 4 oz. **DATES:** 1973-1976. **PRICE:** $23.

KODAK TELE-INSTAMATIC 608 CAMERA

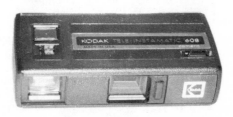

IDENTIFICATION: "Kodak TELE-INSTAMATIC 608 Camera" on top. **CHARACTERISTICS:** Fixed focus lens with tele-converter. No meter. Sliding lens cover. Uses flipflash. **LENS:** f11/25 mm normal and f11/43 mm telephoto. **SHUTTER:** 2-speed (1/125 normal and 1/45 flash). **FILM SIZE:** 110. **IMAGE:** 13x17 mm. **BODY:**

2-1/8x2-1/8x4-3/4 in. **WEIGHT:** 4 oz. **DATES:** 1975-1979. **PRICE:** $36.

KODAK TELE-INSTAMATIC 708 CAMERA

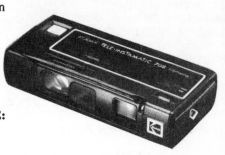

IDENTIFICATION: "Kodak TELE-INSTAMATIC 708 Camera" on top. **CHARACTERISTICS:** Programmed exposure control with silicon cell. Hinged lens cover. Uses flipflash. **LENS:** scale focus f5.6/25 mm with accessory tele-converter to make a f5.6/43 mm telephoto. **SHUTTER:** Electronic 1/30-1/300. **FILM SIZE:** 110. **IMAGE:** 13x17 mm. **BODY:** 1¼x2½x5-7/8 in. **WEIGHT:** 7 oz. **DATES:** 1976-1979. **PRICE:** $111.

KODAK TRIMLITE INSTAMATIC 18 CAMERA

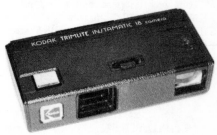

IDENTIFICATION: "Kodak Trimlite Instamatic 18 Camera" on top. **CHARACTERISTICS:** Low-priced pocket camera for flipflash. Styled like Pocket Instamatic 10 Camera. **LENS:** f11/25 mm (fixed focus). **SHUTTER:** 2-speed (1/90 normal and 1/40 flash). **FILM SIZE:** 110. **IMAGE:** 13x17 mm. **BODY:** 1x2-1/8x4½ in. **WEIGHT:** 3 oz. **DATES:** 1975-1979. **PRICE:** $24.

KODAK WINNER POCKET CAMERA

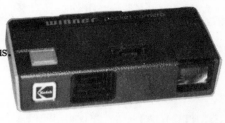

IDENTIFICATION: "Winner Pocket Camera" on top. **CHARACTERIS- TICS:** Like Trimlite Instamatic 18 Camera, but brown and tan color. Lacks bright frame and parallax marks in finder. **LENS:** fixed focus **SHUTTER:** 2 speed (1/90 normal and 1/40 flash). **FILM SIZE:** 110. **IMAGE:** 13x17 mm. **BODY:** 1x2-1/8x4½ in. **WEIGHT:** 3 oz. **DATES:** 1979-.

This is a specially named version of the Trimlite Instamatic 18 Camera made for premium use.

KODAK TRIMLITE INSTAMATIC 28 CAMERA
IDENTIFICATION: "Kodak Trimlite Instamatic 28 Camera" on top. **CHARACTERISTICS:** CdS electric eye for automatic exposure. **LENS:** fixed focus f9.5/25 mm. **SHUTTER:** Electronic 1/30-1/160. **FILM SIZE:** 110. **IMAGE:** 13x17 mm. **BODY:** 1-1/16x2-3/8x5-1/8 in. **WEIGHT:** 7 oz. **DATES:** 1975-1979. **PRICE:** $61. (illus. next page)

Kodak Trimlite Instamatic 28 camera Kodak Trimlite Instamatic 38 camera

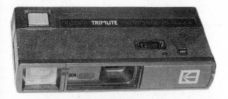 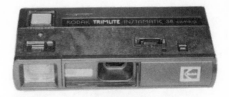

KODAK TRIMLITE INSTAMATIC 38 CAMERA

IDENTIFICATION: "Kodak Trimlite Instamatic 38 Camera" on top. **CHARACTERISTICS:** CdS meter. Two-position focus. **LENS:** zone focus f8/25 mm. **SHUTTER:** Electronic 1/225-5 sec. **FILM SIZE:** 110. **IMAGE:** 13x17 mm. **BODY:** 1-1/16x2-3/8x5-1/8 in. **WEIGHT:** 7 oz. **DATES:** 1975-1979. **PRICE:** $76.

KODAK TRIMLITE INSTAMATIC 48 CAMERA

IDENTIFICATION: "Kodak Trimlite Instamatic 48 Camera" on top. **CHARACTERISTICS:** CdS meter. Coupled rangefinder. **LENS:** Ektar f2.7/26 mm. **SHUTTER:** Electronic 1/30-1/250. **FILM SIZE:** 110. **IMAGE:** 13x17 mm. **BODY:** 1x2¼x5-3/4 in. **WEIGHT:** 9 oz. **DATES:** 1975-1979. **PRICE:** $146.

INSTANT PHOTOGRAPHY

Instant photography was an idea which had been kicking around since the Daguerreian days. The first commercially successful camera for "instant" pictures was the Dubroni wet-plate camera of 1865 with its ceramic interior for processing within the camera. Numerous systems were used through the ages, and tintypes were probably the most popular of all the instant processes. But what really made the world stop and take notice was the invention of Dr. Edwin Land, the Polaroid camera of 1948. A succession of improvements and developments eventually led Polaroid to instant color pictures and the SX-70 system with its packs of self-contained picture units.

In 1976, Kodak entered the instant-picture market which had been dominated by Polaroid. Kodak's system used a filmpack similar in appearance to Polaroid's SX-70 system, but considerably different in operation and chemistry. While the Polaroid system required a mirror in the camera to correct lateral reversal of the image, Kodak's PR-10 film is a reversal system which, like a slide, is viewed from the back and therefore does not need to be reversed for viewing. While this may not be of great significance to most instant snapshooters, the Kodak PR-10 system offered better possibilities for using the self-contained picture units in special backs on professional cameras.

KODAK EK4 INSTANT CAMERA

IDENTIFICATION: "Kodak EK4 Instant Camera" on front. CHARAC-
TERISTICS: Crank-eject pictures. LENS: f11/137 mm. SHUTTER:
Electronic 1/20-1/300. FILM SIZE: PR10. IMAGE: 67x91 mm.
BODY: 3-5/8x5¼x6½ in. DATES: 1976-1978. PRICE: $54.

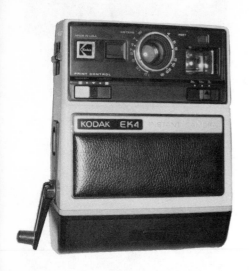 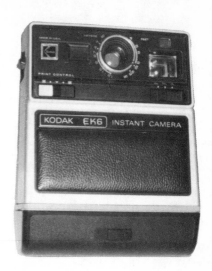

KODAK EK6 INSTANT CAMERA

IDENTIFICATION: "Kodak EK6 Instant Camera" on front. CHARAC-
TERISTICS: Motorized print ejection. LENS: f11/137 mm. SHUTTER:
Electronic 1/20-1/300. FILM SIZE: PR10. IMAGE: 67x91 mm. BODY:
3-5/8x5¼x6½ in. WEIGHT: 29 oz. DATES: 1976-1978. PRICE: $70.
This basic camera style was replaced in 1978 by the Colorburst
cameras.

KODAK EK8 INSTANT CAMERA

IDENTIFICATION: "Kodak EK8
Instant Camera" on front.
CHARACTERISTICS: Folding
camera for PR10 instant film.
Resembles "The Handle" when
opened for use. Coupled
rangefinder, silicon metering, and
motorized print ejection.
LENS: f11/137mm.
SHUTTER: electronic shutter
1/20-1/300. FILM SIZE: PR10.
IMAGE: 67x91 mm. DATES: 1977-.
Made by Kodak A.G. in
Stuttgart.

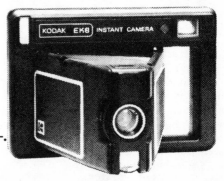

THE HANDLE - KODAK INSTANT CAMERA

IDENTIFICATION: "The Handle A Kodak Instant Camera" on front.
CHARACTERISTICS: Instant camera with handle incorporated in body. White body with blue faceplate. **LENS:** f12.7/100 mm (fixed focus). **SHUTTER:** Electronic 1/15-1/300. **FILM SIZE:** PR10.
IMAGE: 67x91 mm. **BODY:** 5-5/8x5-5/8x6-7/8 in. **WEIGHT:** 27 oz. **DATES:** 1977-1979. **PRICE:** $40.

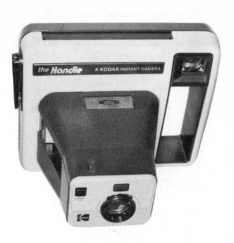

Some Eastman Kodak Co. people have called this camera the EK2, which may have been its intended designation, but what may have started as a nickname is the name which is found on the camera.

HAPPY TIMES INSTANT CAMERA

IDENTIFICATION: "Coke adds life to ... Happy Times" on front.
CHARACTERISTICS: Special brown version of "The Handle" camera with Coca-Cola trademarks. **LENS:** fixed focus f12.7/100 mm. **SHUTTER:** Electronic 1/15-1/300. **FILM SIZE:** PR10. **IMAGE:** 67x91 mm. **BODY:** 5-5/8x5-5/8x6-7/8 in. **WEIGHT:** 27 oz. **DATES:** 1978-1978.

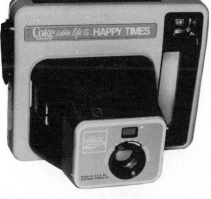

This special version of the Handle camera was produced for a Coca-Cola promotion during the summer of 1978. This model is of two-tone brown plastic with the Coca-Cola trademark and the expression "Coke adds life to... Happy times". in red and white instead of the Kodak identification plate. About 25,000 were made, and they were offered for $17.95 and proof of purchase through local Coca-Cola distributors.

KODAK PLEASER INSTANT CAMERA

IDENTIFICATION: "Pleaser Instant Camera" at top of front.
CHARACTERISTICS: Like "The Handle" Camera, but with a different name. **LENS:** 2 element fixed focus f12.7/100 mm. **SHUTTER:** electronic 1/15-1/300 sec. **FILM SIZE:** PR10. **IMAGE:** 67x91 mm. **BODY:** 5-5/8x5-5/8x6-7/8 in. **WEIGHT:** 27 oz. **DATES:** ca. 1980-81.

A special premium model of "The Handle" Camera. (illus. next page)

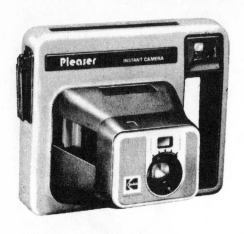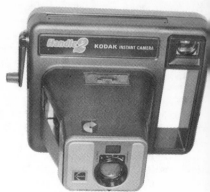

HANDLE 2 KODAK INSTANT CAMERA
IDENTIFICATION: "Handle 2 Kodak Instant Camera" on front.
CHARACTERISTICS: Similar to original "Handle" camera, but with exposure range extended to 2 seconds. All black body. **LENS:** fixed focus f12.7/100 mm. **SHUTTER:** Electronic 1/300-2 sec. **FILM SIZE:** PR10. **IMAGE:** 67x91 mm. **BODY:** 5-5/8x5-5/8x6-7/8 in. **WEIGHT:** 27 oz. **DATES:** 1979-. **PRICE:** $25.

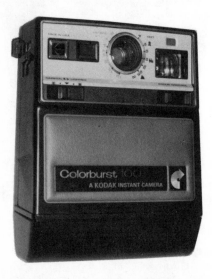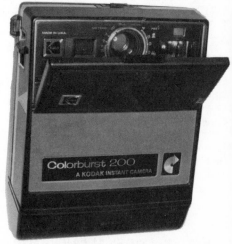

COLORBURST 100 CAMERA
IDENTIFICATION: "Colorburst 100 A Kodak Instant Camera" on front.
CHARACTERISTICS: Instant camera with motorized print ejection styled like the EK6 camera. **LENS:** f11/137 mm (close focus to 3½ ft.).

SHUTTER: Electronic 1/20-1/300. **FILM SIZE:** PR10. **IMAGE:** 67x91 mm. **BODY:** 3-5/8x5¼x6½ in. **WEIGHT:** 3 oz. **DATES:** 1978-1980. **PRICE:** $45.

COLORBURST 200 CAMERA

IDENTIFICATION: "Colorburst 200 A Kodak Instant Camera" on front. **CHARACTERISTICS:** Similar to 100, but hinged panel covers lens, finder, electric eye, and controls. **LENS:** f11/137 mm (close focus to 3½ ft.). **SHUTTER:** Electronic 1/20-1/300. **FILM SIZE:** PR10. **IMAGE:** 67x91 mm. **BODY:** 3-5/8x5¼x6½ in. **WEIGHT:** 32 oz. **DATES:** 1978-1980. **PRICE:** $55. (illustrated on preceding page)

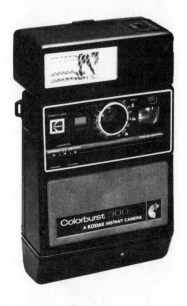

COLORBURST 300 CAMERA → **IDENTIFICATION:** "Colorburst 300 A Kodak Instant Camera" on front. **CHARACTERISTICS:** Like 100, but with built-in electronic flash. **LENS:** f11/137 mm (focusing). **SHUTTER:** Electronic 1/20-1/300. **FILM SIZE:** PR10. **IMAGE:** 67x91 mm. **BODY:** 3-5/8x5¼x8¼ in. **WEIGHT:** 2 lb. 6 oz. **DATES:** 1978-1980. **PRICE:** $75.

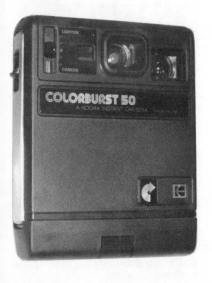

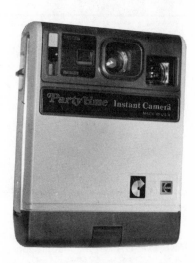

Colorburst 50 camera

Partytime Instant camera

COLORBURST 50 CAMERA (illus. previous page)

IDENTIFICATION: "Colorburst 50 A Kodak Instant Camera" on front. **CHAR^CTERISTICS:** Fixed-focus lens in rectangular recess. **LENS:** f12.? ‿n. **SHUTTER:** Electronic 1/300-2 sec. **FILM SIZE:** PR10. **IMAGE:** 67x91 mm. **BODY:** 3-5/8x5¼x6½ in. **WEIGHT:** 31 oz. **DATES:** 1979-. **PRICE:** $40. Some sale prices as low as $25.

PARTYTIME INSTANT CAMERA (illus. previous page)

IDENTIFICATION: "Partytime Instant Camera" on front. **CHAR-ACTERISTICS:** Premium version of the Colorburst 50 Camera. **LENS:** fixed focus f12.8/100 mm. **SHUTTER:** electronic 1/300- 2 sec. **FILM SIZE:** PR10. **IMAGE:** 67x91 mm. **BODY:** 3-5/8x5¼x6½ in. **WEIGHT:** 31 oz. **DATES:** ca. 1980. Offered as a premium by Tupperware.

COLORBURST 250 CAMERA

IDENTIFICATION: "Colorburst 250 A Kodak Instant Camera" on front. **CHARACTERISTICS:** Similar to model 50, but with built-in electronic flash which slides to side for use. **LENS:** fixed focus f12.8/100 mm. **SHUTTER:** Electronic 1/300-2 sec. **FILM SIZE:** PR10. **IMAGE:** 67x91 mm. **BODY:** 3¼x5x8 in. **WEIGHT:** 2 lb. 7 oz. **DATES:** 1979-. **PRICE:** $77. Sale prices as low as $50.

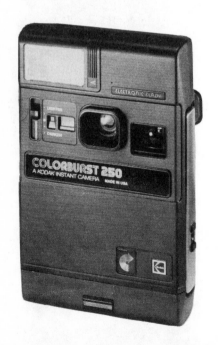 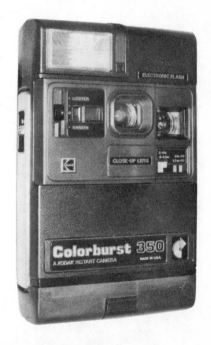

KODAK COLORBURST 350 CAMERA

IDENTIFICATION: "Colorburst 350 A Kodak Instant Camera" on front. **CHARACTERISTICS:** Automatic print ejection. Electronic flash. Like the 250 but with close-up lens. **LENS:** fixed focus f2.8/100 mm.

SHUTTER: electronic 1/300-2 sec. **FILM SIZE:** PR10. **IMAGE:** 67x91 mm. **BODY:** 3¼x5x8 in. **DATES:** 1981-. **PRICE:** $97.

KODAK EKTRA 1 CAMERA

IDENTIFICATION: "Kodak EKTRA camera 1" with large green "1" on top. **CHARACTERISTICS:** Simple pocket camera for flipflash. **LENS:** fixed focus f11/25 mm. **SHUTTER:** 3-speed 1/40-1/170 (set from film cartridge). **FILM SIZE:** 110. **IMAGE:** 13x17 mm. **BODY:** 1x2-1/8x4½ in. **WEIGHT:** 3 oz. **DATES:** 1978-. **PRICE:** $20. (illus. below)

KODAK EKTRA 2 CAMERA

IDENTIFICATION: "Kodak Ektra 2 Camera" on top. Chrome "2" on blue background. **CHARACTERISTICS:** Pocket camera for flipflash. Glass lens. Extended shutter range. **LENS:** fixed focus f5.6/22 mm. **SHUTTER:** 4-speed 1/60-1/500 (mechanical shutter automatically set by film cartridge). **FILM SIZE:** 110. **IMAGE:** 13x17 mm. **BODY:** 1-3/8x2½x6 in. **WEIGHT:** 7 oz. **DATES:** 1978-1980. **PRICE:** $32.

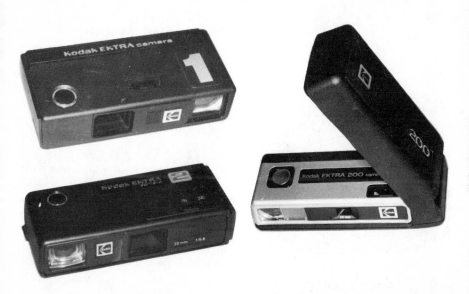

KODAK EKTRA 200 CAMERA

IDENTIFICATION: "Kodak Ektra 200 Camera" on top. **CHARACTER-ISTICS:** Pocket camera with cover/handle. Uses flipflash. **LENS:** fixed focus f11/22mm. **SHUTTER:** 2 speed (1/125 and 1/250). **FILM SIZE:** 110. **IMAGE:** 13x17 mm. **BODY:** 1¼x2¼x5¼ in. **WEIGHT:** 5 oz. **DATES:** 1980-. **PRICE:** $25.

KODAK TELE-EKTRA 1 CAMERA

IDENTIFICATION: "Kodak Teke-Ektra 1 Camera" on top. Chrome "1" on blue. **CHARACTERISTICS:** Pocket camera with hinged cover/grip. Two lenses. **LENS:** 2 Doublet fixed focus lenses: f9.5/22 mm (normal) and f11/44 mm (telephoto). **SHUTTER:** 3-speed 1/60-1/210 (mechanical shutter automatically set by film cartridge). **FILM SIZE:** 110.

IMAGE: 13x17 mm. **BODY:** 1-3/8x2½x6 in. **WEIGHT:** 7 oz. **DATES:** 1978-1981. **PRICE:** $28.

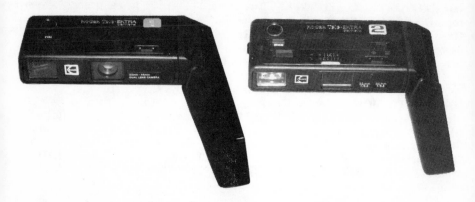

KODAK TELE-EKTRA 2 CAMERA

IDENTIFICATION: "Kodak Tele-Ektra 2 Camera" on top. Chrome "2" on green. **CHARACTERISTICS:** Like Tele-Ektra 1 Camera, but with focusing glass lens and extended range "EK" shutter speeds. **LENS:** f5.6/22 mm (normal) and f5.6/44 mm (telephoto). **SHUTTER:** 4-speed 1/60-1/500 (mechanical shutter automatically set by film cartridge). **FILM SIZE:** 110. **IMAGE:** 13x17 mm. **BODY:** 1-3/8x2½x6 in. **WEIGHT:** 7 oz. **DATES:** 1978-1980. **PRICE:** $45.

KODAK TELE-EKTRA 300 CAMERA

IDENTIFICATION: "Kodak Tele-Ektra 300 Camera" on top. **CHARACTERISTICS:** Pocket camera with detachable grip/cover. Accepts flipflash or accessory electronic flash. **LENS:** f8/22 mm (normal) and f8/44 mm (telephoto). **SHUTTER:** 2 speed (1/125, 1/250). **FILM SIZE:** 110. **IMAGE:** 13x17 mm. **BODY:** 1¼x2¼x5¼ in. **WEIGHT:** 5 oz. **DATES:** 1980-. **PRICE:** $33.

The Tele-Ektra 350 is a similar camera made for export to Europe.

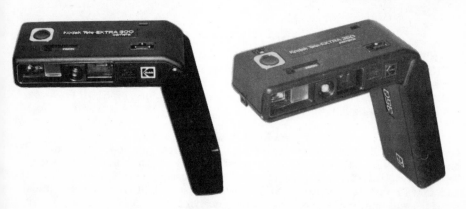

KODAK EKTRAMAX CAMERA

IDENTIFICATION: "Kodak Ektramax Camera" on top. **CHARACTERISTICS:** Pocket camera with scale-focusing lens, electronic flash, and four-position weather dial. Titanium blades in front of lens serve as shutter and diaphragm. **LENS:** Aspheric f1.9/25 mm. **SHUTTER:** 5 speed, 1/30-1/350. (controlled by film cartridge). **FILM SIZE:** 110. **IMAGE:** 13x17 mm. **BODY:** 1¼x2¼x6-3/4 in. **WEIGHT:** 7 oz. **DATES:** 1978-1981. **PRICE:** $88.

KODAK EKTRALITE 10 CAMERA

IDENTIFICATION: "Kodak Ektralite 10 Camera" on top. **CHARACTERISTICS:** Like Ektra 1 Camera, but with built-in electronic flash. **LENS:** fixed focus f8/25 mm. **SHUTTER:** 2-speed (1/125, 1/210). **FILM SIZE:** 110. **IMAGE:** 13x17 mm. **BODY:** 1-1/8x2-3/8x6-5/8 in. **WEIGHT:** 7 oz. **DATES:** 1978-. **PRICE:** $38.

KODAK STYLELITE POCKET CAMERA

IDENTIFICATION: "Stylelite Pocket Camera" on top. **CHARACTERISTICS:** Similar to Ektralite 10 Camera, but different color. For premium use. **LENS:** fixed focus. **SHUTTER:** 2 speed (1/125, 1/210). **FILM SIZE:** 110. **IMAGE:** 13x17 mm. **BODY:** 1-1/8x2-3/8x6-5/8 in. **WEIGHT:** 7 oz. **DATES:** 1979-.

KODAK EKTRALITE 30 CAMERA

IDENTIFICATION: "Kodak Ektralite 30 Camera" on top. **CHARACTERISTICS:** Swing-out electronic flash. Auto exposure. **LENS:** fixed focus f5.6/22 mm. **SHUTTER:** 2 speed (1/100, 1/500). **FILM SIZE:** 110. **IMAGE:** 13x17 mm. **DATES:** 1979-. **PRICE:** $50-70.

KODAK EKTRALITE 400 CAMERA

IDENTIFICATION: "Kodak Ektralite 400 Camera" on top. **CHARAC-TERISTICS:** Pocket camera with built-in handle/cover and electronic

flash. **SHUTTER:** 2 speed. **FILM SIZE:** 110. **IMAGE:** 13x17 mm. **DATES:** 1981-. **PRICE:** $52. Made by Kodak A.G.

KODAK EKTRALITE 500 CAMERA
IDENTIFICATION: "Kodak Ektralite 500 Camera" on top. **CHARACTERISTICS:** Pocket camera with detachable handle/cover. Built-in automatic electronic flash turns itself on when needed. **LENS:** fixed focus f8/22 mm. **SHUTTER:** 2 speed (1/125,1/250). **FILM SIZE:** 110. **IMAGE:** 13x17 mm. **BODY:** 1¼x2¼x6-7/8 in. **DATES:** 1980-. **PRICE:** $54.

KODAK TELE-EKTRALITE 20 CAMERA
IDENTIFICATION: "Kodak Tele-Ektralite 20 Camera" on top. **CHARACTERISTICS:** Electronic flash flips out from end. Tele-lens. **LENS:** 2 fixed focus lenses: f9.5/22 mm (normal) and f9.5/44 mm (telephoto). **SHUTTER:** 2 speed (1/125 and 1/210). **FILM SIZE:** 110. **IMAGE:** 13x17 mm. **DATES:** 1979-1981. **PRICE:** $40-70.
 The Tele-Stylelite Camera is a premium version of this camera.

KODAK TELE-EKTRALITE 40 CAMERA
IDENTIFICATION: "Kodak Tele-Ektralite 40 Camera" on top. **CHARACTERISTICS:** Tele-lens. Swing-out electronic flash. Auto exposure. **LENS:** 2 zone focus lenses: f5.6/22 mm (normal) and f5.6/44 mm (telephoto). **SHUTTER:** 2 speed (1/100 and 1/500). **FILM SIZE:** 110. **IMAGE:** 13x17 mm. **DATES:** 1979-. **PRICE:** $65-100.

KODAK TELE-EKTRALITE 600 CAMERA
IDENTIFICATION: "Kodak Tele-Ektralite 600 Camera" on top. **CHARACTERISTICS:** Pocket camera with detachable handle/cover and automatic electronic flash. Similar to Ektralite 500 Camera, but with telephoto lens. **LENS:** f8/22 mm (normal) and f8/44 mm (telephoto). **SHUTTER:** 2 speed (1/125, 1/250). **FILM SIZE:** 110. **IMAGE:** 13x17 mm. **BODY:** 1¼x2¼x6-7/8 in. **DATES:** 1980-. **PRICE:** $67.

RETINA CHRONOLOGICAL SUMMARY

The Type number for each camera is given in parentheses.

1934-35	Retina (117)	1958-58	Retinette II (026), F (022/7)
1935-37	Retina (118)	1958-59	Retinette IIB (031)
1936-37	Retina II (122)	1958-60	Retina IIIC (028), IIIS (027)
1936-38	Retina (I) (119), (126)		Retinette I (030)
1937-39	Retina I (141), II (142)	1959-60	Retina IIS (024)
1939-39	Retina I (143), (148), (149)		Retina Reflex S (034)
	Retina IIa (150)		Retinette IA (035), IIA (036)
	Retinette (147), II (160)	1959-63	Retinette IB (037)
1946-49	Retina I (010), II (011)	1960-62	Retina Automatic I (038)
1949-50	Retina II (014)	1960-63	Retinette IA (042)
1949-51	Retinette (012)		Retina Automatic II (032)
1949-54	Retina I (013)	1960-64	Retina Automatic III (039)
1951-54	Retina Ia (015), IIa (016)		Retina Reflex III (041)
1952-54	Retinette (017)	1962-63	Retina IBS (040)
1954-57	Retina IIc (020), IIIc (021)	1963-64	Retina IF (046), IIF (047)
1954-58	Retina Ib (018)	1963-66	Retinette IB (045)
	Retinette (022)	1963-67	Retinette IA (044)
1956-58	Retina Reflex (025)	1964-67	Retina Reflex IV (051)
1957-60	Retina IB (019)	1966-69	Retina S1 (060), S2 (061)
1958-58	Retina IIC (029)		

BIBLIOGRAPHY

Primary source materials: **Kodaks and Kodak Supplies** catalogs published annually by the Eastman Kodak Co. Additional sources include original instruction manuals and advertisements in periodicals such as: **The Camera, Camera 35, Minicam, Modern Photography,** and **Popular Photography.**

Secondary sources of information include:

Addison, John T. **Catalogue of Kodak Cameras 1964-1980.** Scarborough, Ontario: 1980

British Journal Photographic Almanac. London, England: Henry Greenwood & Co. Ltd., Annual

Coe, Brian **Cameras.** Gothenburg, Sweden: AB Nordbok, 1978

Feinberg, Alan R. **Catalog of Kodak and Brownie Cameras.** Winnetka, IL: 1972

Jenkins, Reese V. **Images and Enterprise.** Baltimore, MD: John Hopkins University Press, 1975

Lahue, Kalton C. **Collector's Guide: Kodak Retina Cameras.** Los Angeles, CA: Peterson Publishing Co., 1973

Lahue, Kalton C., and Bailey, Joseph A. **Glass, Brass, & Chrome.** Norman, OK: University of Oklahoma Press, 1972

Lothrop, Eaton S. Jr. **A Century of Cameras.** Dobbs Ferry, NY: Morgan & Morgan, 1973

For further information on cameras not in this book, may we suggest:

Addison, John T. **A Catalogue of Hawk-Eye Cameras 1888-1979.** Scarborough, Ontario: 1980

McKeown, Joan C. **Catalog of Premo Cameras.** Grantsburg, WI: Centennial Photo Service, 1981

For current price information on collectible cameras:

McKeown, James & Joan **Price Guide to Antique and Classic Still Cameras, 3rd Ed.** Grantsburg, WI: Centennial Photo Service, 1981

INDEX

A Daylight Kodak Camera,15
A Ordinary Kodak Camera,14
Anniversary Kodak Camera,80
Auto 27 Camera,143
Autographic Kodak Cameras,54,55; Junior,59-61
Autographic Kodak Special Camera,No. 1,57-59; No. 1A, 56,66; No. 2C,66,67; No. 3, 57,58; No. 3A,56,65
Automatic 35 Cameras,137,138
B Daylight Kodak Camera,16
B Ordinary Kodak Camera,14
Baby Brownie Camera,94; New York World's Fair,107; Special,110,111
Bantam Cameras,97-99; Flash, 118; RF,125; Special,97,98
Beau Brownie Cameras,81
Boy Scout Brownie Cameras,82
Boy Scout Kodak Camera,79
Brownie Camera (original),40; No. 0,53; No. 1,40; No. 2, 40,41; No. 2A,44,45; No. 2C,67; No. 3,48
Brownie 127 Camera,125
Brownie Auto 27 Camera,143
Brownie Bull's-Eye Camera,128
Brownie Bullet Camera,131; II,143
Brownie Chiquita Camera,132
Brownie Fiesta Camera,145,146
Brownie Flash 20 Camera,136
Brownie Flash Six-20 Camera,118
Brownie Flashmite 20 Camera,140
Brownie Hawkeye Cameras,122,123
Brownie Holiday Cameras,126
Brownie Reflex Cameras,111,112
Brownie Reflex 20 Camera,136,137
Brownie Six-16 Cameras,87,88; Junior,88; Special,104
Brownie Six-20 Cameras,87,88, 124; Junior,88,89; Special,104
Brownie Starflash Camera,132
Brownie Starflex Camera,132
Brownie Starlet Cameras,130
Brownie Starmatic Camera,136; II,142
Brownie Starmeter Camera,140
Brownie Starmite Camera,139,140; II,144,145
Brownie Super 27 Camera,142,143

Brownie Target Cameras,116,117 (see also Target Brownie Cameras,112,113)
Brownie Twin 20 Camera,136,137
Brownie Bull's-Eye Camera,128
Bull's-Eye Brownie Camera (Six-20),103
Bull's-Eye Cameras,24-26
Bullet Camera,99,100; New York World's Fair,108
Bullet Camera (Brownie),131; II,143
Bullet Camera (Nos. 2,4),22-24
C Daylight Kodak Camera,16
C Ordinary Kodak Camera,14,15
C Ordinary Glass Plate Kodak Camera,15
C Special Glass Plate Kodak Camera,16
Camp Fire Girls' Kodak Camera,80
Cartridge Kodak Cameras,27-29
Century of Progress World's Fair Souvenir Camera,82
Chevron Camera,124,125
Chiquita Camera (Brownie),132
Colorburst Cameras,164-166
Coquette Camera,78
Daylight Kodak Cameras,15,16
Duaflex Cameras,119,120
Duex Camera,111
Duo Six-20 Cameras,93,94
Eastman Detective Camera,7
EK2 Instant Camera (The Handle),163
EK4,EK6,EK8 Instant Cameras,164
Ektra Camera,113
Ektra 1, 2, 200 Cameras,167
Ektralite Cameras,169,170
Ektramax Camera,169
Ensembles,77,78
Eureka Cameras,36,37
Falcon Cameras,26,27
Fiesta Cameras,145,146
Fiftieth Anniversary Kodak Camera,80
Flash Bantam Camera,118
Flash 20 Camera (Brownie),136
Flash Six-20 Camera (Brownie),118
Flashmite 20 Camera,140
Flat Folding Kodak Camera,17

Flexo Kodak Camera (No. 2),37
Flush Back Kodak Camera,46
Folding Autographic Brownie
 Cameras,63-65
Folding Brownie Cameras,42,43,48
Folding Bull's-Eye Camera,26
Folding Kodak Cameras,11-13,34;
 Improved,12,13
Folding Kodet Cameras,18,19
Folding Pocket Brownie
 Cameras,43,48,49
Folding Pocket Kodak
 Camera,No. 0,33; Nos. 1,1A,30;
 No. 1A RR Type,47; No. 1A
 Special,46,47; Nos. 2,3,31; No. 3
 Deluxe,33; No. 3A,34; No.
 4,35,36
Gift Kodak Camera,80,81
Girl Scout Kodak Camera,79
Glass Plate Folding Kodak
 Camera,11
(The) Handle,163
Handle 2 Kodak Instant
 Camera,164
Happy Times Instant Camera,163
Hawkeye Cameras
 (Brownie),122,123
Holiday Cameras (Brownie),126
Instamatic Cameras,44,155
 100,150,147; 300,400,500,148
 104,154,700,800,149
 304,404,150; 704,150,151
 804,151; 124,134,152
 174,314,414,153; 714,814,154
 Reflex,154; S-10,S-20,151,152
 X-15,X-15F,155;
 X-25,X-35,X-35F,156;
 X-30,X-45,X-90,157
Jiffy Kodak Cameras,89,90
Junior Glass Plate Kodak Camera
 (see Nos. 3,4 Kodak Junior
 Cameras,10,11)
Junior Six-16 and Six-20
 Cameras,95-97
Kodak Camera (original),8; Nos.
 1-4,8-10; Nos. 3,4 Junior,10,11
Kodak Anniversary Camera,80
Kodak Automatic 35
 Cameras,137,138
Kodak Bantam Cameras,97-99;
 Flash,118; RF,125; Special,97,98
Kodak Chevron Camera,124,125

Kodak Coquette Camera,78
Kodak Duaflex Cameras,119,120
Kodak Duex Camera,111
Kodak Duo Six-20 Cameras,93,94
Kodak EK2 Instant Camera (The
 Handle),163
Kodak EK4,EK6,EK8 Instant
 Cameras,162
Kodak Ektra Camera,113
Kodak Ektra 1, 2, 200
 Cameras,167
Kodak Ektralite Cameras,169,170
Kodak Ektramax Camera,169
Kodak Ensemble,78
Kodak Flash Bantam Camera,118
Kodak Instamatic Cameras (see
 Instamatic Cameras)
Kodak Junior Cameras,Nos.
 1,1A,52,53; Nos. 3,4,10,11
Kodak Junior Six-16 and Six-20
 Cameras,95-97
Kodak Matchbox Camera,115
Kodak Medalist Cameras,113,114
Kodak Monitor Cameras,108
Kodak Motormatic 35
 Cameras,138,139
Kodak (Original) Camera,8
Kodak Petite Camera,78
Kodak Pleaser Instant
 Camera,163,164
Kodak Pocket Instamatic
 Cameras,158,159
Kodak Pony Cameras,II,IV,131;
 135,122; 828,121
Kodak Pupille Camera,86
Kodak Ranca Camera,85
Kodak Recomar Camera,87
Kodak Reflex Cameras,117,118
Kodak Regent Cameras,94
Kodak Retina Cameras (see
 Retina Cameras)
Kodak Retinette Cameras (see
 Retinette Cameras)
Kodak Senior Six-16 and Six-20
 Cameras,101
Kodak Series II Camera,No.
 3A,100
Kodak Series III
 Cameras,69,70,100
Kodak Signet Cameras,124,128,129
Kodak Six-16 Cameras,83,84
Kodak Six-20 Cameras,84,85

Kodak Special Six-16 and Six-20 Cameras,101,102
Kodak Startech Camera,132,133
Kodak Stereo Camera (35mm),127
Kodak Stylelite Pocket Camera,169
Kodak Suprema Camera,103
Kodak Tele-Ektra Cameras,167,168
Kodak Tele-Ektralite Cameras,170
Kodak Tele-Instamatic Cameras,159,160
Kodak Tele-Stylelite Pocket Camera (see Tele-Ektralite 20,170)
Kodak 35 Cameras,105,106
Kodak Tourist Cameras,120,121
Kodak Trimlite Instamatic Cameras,160,161
Kodak Vigilant Cameras,109,110
Kodak Vollenda Camera,86
Kodak Winner Pocket Camera,160
Kodak World's Fair Flash Camera 1964-1965,145,146
Kodet Cameras,18,19
Matchbox Camera,115
Medalist Cameras,113,114
Monitor Cameras,108
Motormatic 35 Cameras,138,139
New York World's Fair Cameras,107,108
No. 0 Brownie Camera,53
No. 0 Folding Pocket Kodak Camera,33
No. 1 Autographic Kodak Junior Camera,59,60
No. 1 Autographic Kodak Special Camera,57-59
No. 1 Brownie Camera,40
No. 1 Falcon Camera,26
No. 1 Folding Pocket Kodak Camera,30
No. 1 Kodak Camera,8
No. 1 Kodak Junior Camera,52
No. 1 Kodak Series III Camera,70
No. 1 Panoram Kodak Camera,38,39
No. 1 Pocket Kodak Camera,72,73; Junior,76; Series II,68; Special,74,75
No. 1A Autographic Kodak Camera,54,55; Junior,60; Special,56,66

No. 1A Folding Pocket Kodak Camera,30; RR Type,47; Special,46,47
No. 1A Gift Kodak Camera,80,81
No. 1A Kodak Junior Camera,52,53
No. 1A Kodak Series III Camera,69
No. 1A Pocket Kodak Camera,73; Junior,76; Series II,68,69; Special,75
No. 1A Special Kodak Camera,49
No. 1A Speed Kodak Camera,46
No. 2 Beau Brownie Camera,81
No. 2 Brownie Camera,40,41
No. 2 Bull's-Eye Camera,24; Special,25
No. 2 Bullet Cameras,22,23
No. 2 Eureka Camera,36; Jr.,37
No. 2 Falcon Camera,27
No. 2 Flexo Kodak Camera,37
No. 2 Folding Autographic Brownie Camera,63
No. 2 Folding Brownie Camera,42
No. 2 Folding Bull's-Eye Camera,26
No. 2 Folding Pocket Brownie Camera,43
No. 2 Folding Pocket Kodak Camera,31
No. 2 Kodak Camera,9
No. 2 Plico Kodak Camera (see No. 2 Flexo,37)
No. 2 Stereo Brownie Camera,43
No. 2 Stereo Kodak Camera,41
No. 2A Beau Brownie Camera,81
No. 2A Brownie Camera,44,45
No. 2A Folding Autographic Brownie Camera,63
No. 2A Folding Pocket Brownie Camera,48,49
No. 2C Autographic Kodak Junior Camera,60,61
No. 2C Autographic Kodak Special Camera,66,67
No. 2C Brownie Camera,67
No. 2C Folding Autographic Brownie Camera,64
No. 2C Kodak Series III Camera,69,70
No. 2C Pocket Kodak Camera,72; Special,75

o. 3 Autographic Kodak Camera,54,55; Special,57,58
o. 3 Brownie Camera,48
o. 3 Bull's-Eye Camera,25
o. 3 Cartridge Kodak Camera,29
o. 3 Flush Back Kodak Camera,46
o. 3 Folding Brownie Camera,43
o. 3 Folding Pocket Kodak Camera,31; Deluxe,33
o. 3 Junior Glass Plate Kodak Camera (see No. 3 Kodak Junior Camera)
o. 3 Kodak Camera,9; Junior,10
o. 3 Kodak Series III Camera,70
o. 3 Pocket Kodak Special Camera,74
o. 3 Special Kodak Camera,49
o. 3 Zenith Kodak Camera,36
o. 3A Autographic Kodak Camera,55; Junior,61; Special,56,65
o. 3A Folding Autographic Brownie Camera,64,65
o. 3A Folding Brownie Camera,48
o. 3A Folding Pocket Kodak Camera,34
o. 3A Kodak Series II and Series III Cameras,100
o. 3A Panoram Kodak Camera,39
o. 3A Pocket Kodak Camera,74
o. 3A Special Kodak Camera,49
o. 3B Quick Focus Kodak Camera,44
o. 4 Bull's-Eye Camera,25; Special,25
o. 4 Bullet Camera,23; Special,24
o. 4 Cartridge Kodak Camera,27
o. 4 Eureka Camera,37
o. 4 Folding Kodak Camera,11,12; Improved,12
o. 4 Folding Kodet Cameras,18,19
o. 4 Folding Pocket Kodak Camera,35,36
o. 4 Junior Glass Plate Kodak Camera (see No. 4 Kodak Junior Camera)

No. 4 Kodak Camera,10; Junior,10,11
No. 4 Kodet Camera,18
No. 4 Panoram Kodak Camera,38
No. 4 Screen Focus Kodak Camera,41
No. 4A Folding Kodak Camera,34
No. 4A Speed Kodak Camera,36,46
No. 5 Cartridge Kodak Camera,28
No. 5 Folding Kodak Camera,12,13; Improved,12,13
No. 5 Folding Kodet Camera,19; Special,19
No. 6 Folding Kodak Improved Camera,13
Ordinary Kodak Cameras,14,15
Panoram Kodak Cameras,38,39
Partytime Instant Camera,165,166
Pleaser Instant Camera,163,164
Petite Camera,78
Plico Kodak Camera (see No. 2 Flexo Kodak Camera,37)
Pocket Instamatic Cameras,158,159
Pocket Kodak (Models 1895-1899,Model D),21,22
Pocket Kodak Camera,Nos. 1,1A,2C,3A,74-76; Junior,76; Series II,68,69; Special,74,75
Pony Cameras,II,IV,131; 135,122; 828,121
Pupille Camera,86
Quick Focus Kodak Camera,44
Ranca Camera,85
Recomar Cameras,87
Regent Cameras,94
Retina Cameras
(Type 117),91
(Type 118),91,92
I (Type 010),115
I (Type 013),116
I (Type 119),92
I (Type 126),92
I (Type 141),102,103
I (Type 143),106
I (Type 148),106
I (Type 149),107
Ia (Type 015),123
Ib (Type 018),127
IB (Type 019),130
IBS (Type 040),143

IF (Type 046),143
II (Type 011),115,116
II (Type 014),116
II (Type 122),92
II (Type 142),102,103
IIa (Type 016),123
IIa (Type 150),107
IIc (Type 020),126
IIC (Type 029),133
IIF (Type 047),144
IIS (Type 024),135
IIIc (Type 021),127
IIIC (Type 028),134
IIIS (Type 027),134
S1 (Type 060),151
S2 (Type 061),151
Retina Automatic Cameras,141
Retina Reflex Cameras
 (Type 025),128
 III (Type 041),141,142
 IV (Type 051),142
 S (Type 034),135
Retinette Cameras
 (Type 012),116
 (Type 017),124
 (Type 022),127
 (Type 147),107
 I (Type 030),134
 IA (Type 035),135
 IA (Type 042),141
 IA (Type 044),144
 IB (Type 037),136
 IB (Type 045),144
 II (Type 026),133
 II (Type 160),107
 IIA (Type 036),135
 IIB (Type 031),133,134
 F (Type 022/7),133
Screen Focus Kodak Camera,41
Senior Six-16 and Six-20
 Cameras,101
Signet Camera,30,129; 35,124;
 40,128,129; 50,80,129
Six-Three Kodak Cameras,51,52
Six-16 Brownie Cameras,87,88,104
Six-20 Boy Scout Brownie
 Camera,82
Six-20 Brownie Cameras,87-89,104;
 Model D,124
Six-20 Bull's-Eye Brownie
 Camera,103

Six-20 Flash Brownie
 Camera,111,112
Special Glass Plate Kodak
 Camera ("C"),16
Special Kodak Cameras,49
Special Six-16 and Six-20
 Cameras,101,102
Speed Kodak Cameras,45,46
Starflash Camera,132
Starflex Camera,132
Starlet Cameras,130
Starmatic Camera,136; II,142
Starmeter Camera,140
Starmite Camera,139,140;
 II,144,145
Startech Camera,132,133
Stereo Brownie Camera (No.
 2),43
Stereo Camera (Kodak-
 35mm),127
Stereo Kodak Model 1 Camera,67
Stereo Kodak Camera (No. 2),41
Stylelite Pocket Camera,169
Super 27 Camera,142,143
Super Kodak Six-20 Camera,104
Suprema Camera,103
Target Brownie Cameras,112,113
 (see also Brownie Target
 Cameras,116,111)
Tele-Ektra Cameras,167,168
Tele-Ektralite Cameras,170
Tele-Instamatic Cameras,159,160
Tele-Stylelite Pocket Camera (se
 Tele-Ektralite 20,170)
Tourist Cameras,120,121
Trimlite Instamatic
 Cameras,160,161
Twin 20 Camera,136,137
Vanity Kodak Camera,77;
 Ensemble,77
Vest Pocket Autographic Kodak
 Cameras,62,63
Vest Pocket Kodak Camera,50;
 Model B,71; Series III,71;
 Special,51,72
Vigilant Cameras,109,110
Vollenda Camera,86
Winner Pocket Camera,160
World's Fair Flash Camera
 1964-1965,145,146
Zenith Kodak Camera,36